Vodun in Coastal Bénin

Vodun in Coastal Bénin

Unfinished, Open-Ended, Global

DANA RUSH

Vanderbilt University Press

NASHVILLE

© 2013 by Vanderbilt University Press
Nashville, Tennessee 37235
All rights reserved
First printing 2013
First paperback printing 2017

This book is printed on acid-free paper.

Text design and composition by Debbie Berman
Cover design by Cheryl Carrington

Library of Congress Cataloging-in-Publication Data on file

LC control number 2012035737
LC classification number BL2470.D3R87 2013
Dewey class number 299.675096683—dc23
LC record available at lccn.loc.gov/2012035737

ISBN 978-0-8265-1907-8 (cloth)
ISBN 978-0-8265-1908-5 (paper)

This project was awarded the 2009 inaugural Anna Julia Cooper Prize by
"Issues in Critical Investigation: The African Diaspora" for the best
unpublished, single-authored manuscript in the humanities.

For my mother.

In loving memory of my brother, John Rush,
who remains forever in my heart.

Contents

List of Illustrations

All photos are by the author unless otherwise noted.

Map of region on page 8 designed by Eric Benson.

Gallery 1 following page 14

Gallery 2 following page 94

Gallery 3 following page 126

Acknowledgments

Gbèdokpɔ wɛ nô wa nu

Literally, this Fon proverb translates as "It is the union of languages/voices that constructs/makes things happen." These words of wisdom, however, refer to the union of something bigger than simply "languages" and "voices." *Gbèdokpɔ* represents a merger of diverse thoughts and ideas from far and near. This is a proverb of cooperation and working together toward a common goal. Reflecting this proverb, this book could not have been researched and written without the combined effort of many different voices, funding sources, and institutions, all of whom I gratefully acknowledge.

I am indebted to the generous support of a number of grants, fellowships, and awards from the Social Science Research Council, Fulbright IIE, the University of Iowa's Project for the Advanced Study of Art and Life in Africa (PASALA), the J. Paul Getty Foundation, and the Research Board at the University of Illinois.

It is impossible to write a definitive list of all of the kind and giving individuals in Bénin and Togo who made my fieldwork possible. I list here many of the people who helped and guided me through the years: Joseph Adandé, Joseph Ahiator, the Alapini family, Mamadou Amadou, Gilbert Atissou, Simonet Biokou, Alfred Chodaton, Christophe Chodaton, Gaudens Chodaton, Mathias Chodaton, the Dakpogan brothers, Baba Egbe (also known as Kolé Mami), Balbi Gadoh, Colette Gonou, Joseph Guendehou and sons, with a special thanks to his wife, Maman Tony, Guy and Christian Hounon Houna, Felix Iroko, Kpassenon, Kpatenon, Jean Mehinto, Naagbo, Yves Pede, Karim da Silva, Elisée Soumonni, Hermann Taiwo, Tchabassi, and Cyprien Tokoudagba. Thanks to Stanislas Pascal Dagba at Radio Gbetin in Ouidah for help in writing the Fon language accurately. A special thanks to Koaume Akpaglo and his family for years of kindness and help in Bénin and Togo. An extra special thanks to Daagbo Hounon Houna who welcomed me into his home and shared his vast knowledge, deep wisdom, and infectious laughter with me through the years. I also thank the kind people in Haiti, Brazil, and Cuba who served as teachers and friends during my transatlantic research.

I thank all the market women at Ahouanjigo market in Ouidah who taught me a range of skills from bargaining in the market to knowing which leaves can be used for various forms of healing. I thank all of the *zemidjan* (motorcycle taxis) and taxi drivers who made travel easy and interesting along the whole coastal area. I also thank the Tourism Office and the Mayor's Office in Ouidah.

Beyond Beninese and Togolese guidance, I have gained insights from the work of numerous scholars and intellectuals: Donald Cosentino and Robert Farris Thompson must be singled out for their willingness to take intellectual risks that continue to expand the field of the Black Atlantic. My gratitude to Edna Bay extends beyond her vast and deep knowledge of Dahomey history and its literature, but encompasses her willingness to share this with me. Finally, Henry Drewal's insightful work on Mami Wata opened many doors that led me into the world of this incredible water spirit.

I thank Allyson Purpura whose skill in transforming abstract ideas into intelligible prose helped me considerably. I acknowledge Marion Osman for seeing value in this writing, and for helping turn the weaker parts into strengths. I thank Ed Huddleston for his quick responses and detailed help on some fine points of book preparation. And I thank Michael Ames for his editorial help and great sensitivity to my subject matter.

Other individuals who must be mentioned in gratitude are: Merle Bowen, Anne Burkus-Chasson, C. Daniel Dawson, Bob Drummond, Samuel Babatunde Ero-Phillips, Mark Leo Félix (for whom I wish I had more objects than chromolithographs and temple paintings in this book), Kathleen Harleman, Ogaga and Alissa Ifowodo, Alex Jean-Charles, John Jennings, Chris Knight, Adrienne Maiers, Elizabeth Mosley, Eileen Moyer, Eileen Nock, David O'Brien, John Peek, Roldan in Havana, Barrie and Paula Rush, Greg Spinner, Paul Smith, Sam Smith, Jay Sosa, Hans Vermaak, and Nancy Willamon. My camaraderie with each one of these individuals helped bring this book to fruition—either directly or indirectly—and I am grateful. I also thank Eric Benson for realizing the map at the beginning of the book.

With distinct recognition, I thank Allen F. Roberts, who has guided and encouraged me from the earliest moments of my graduate education to the present. I am also grateful for the additional support that Polly Roberts provided me through the years.

The support and guidance of Andoche Adjovi are inestimable. He was at my side in Ouidah, Bénin, and Lomé, Togo, during the final editing stages of this book. He helped with double-checking Fon translations, interpreting proverbs, and clarifying obscure Fon concepts. Sometimes when I found myself at my wit's end with Beninese and Togolese cyber-infrastructures, he

encouraged me to practice patience. All of this and much more, I acknowledge here with gratitude. *Akpe kaka.*

My mother provided me with unwavering emotional support during the research and writing of this book. She came to visit me twice in Ouidah, Bénin, and once in Lomé, Togo, and to this day people ask of her. She has read just about everything I have ever written, and she gave me some very good ideas regarding this book. I also thank my grandmother, Nunu. Although no longer with me, I am grateful to her for teaching me to be kind and fair to all people.

I thank all Vodun priests, priestesses, chiefs, healers, and diviners past/present/future who opened their homes and shared their lives with me. However, I must end by acknowledging Vodun itself, not just for providing me a subject matter, but for guiding me through the research and writing of this book. For this, and for all that has given me the strength and patience to reach this point, I am indebted.

Orthographic Note

Fon, Mina, Ewe, and related languages are distinguished by three tonal levels as well as vowel and consonant combinations unfamiliar to the English speaker. This makes it difficult at times to write a number of these sounds in English. In transcribing words or phrases, I had the benefit of assistance from a friend who teaches Fon writing, so I have spelled the Fon words according to the standard spellings taught in school. For the most part, I have noted the high and low sounds, leaving the middle tones unmarked. Words with the same vowel sound doubled are marked as one vowel with either a circumflex or an inverted circumflex:

û A vowel with a circumflex is pronounced as one briefly extended sound that mounts and then descends.

ǔ A vowel with an inverted circumflex is pronounced as one briefly extended vowel sound that descends and then mounts.

For pronunciation purposes, the most commonly used sounds in the text that need to be differentiated are four different vowel sounds, o/ɔ and e/ɛ, and the letters ɖ and x:

o pronounced as in *snow*

ɔ a half-opened labial velar vowel pronounced as in *ought*

e pronounced as in *pay*

ɛ a half-opened vowel with the tongue on the hard palate pronounced as in *get*

ɖ "d" sound pronounced retroflexively with the tip of the tongue against the ridge behind the upper teeth

x pronounced as a fricative "h" sound

For easier pronunciation, there is an exception in which I use a phonetic English spelling instead of standard Fon: the letter "c" is pronounced "tch" in Fon, but I used the phonetic spelling of "tch." In cases of a familiar proper noun, like the name of a kingdom or country such as Dahomey, I spelled it according to its common international spelling, instead of Daxomɛ.

Introduction

Ouvre les yeux, étranger, et sache où poser tes pas.
Ici, un arbre n'est pas un arbre, une source n'est pas une source.
Tout est mystère et mystique.

> Open your eyes foreigner, and know where you step.
> Here, a tree is not a tree, a stream is not a stream.
> Everything is mysterious and mystical.

> Eustache Prudencio, "Ouvre les yeux, étranger," *Vents du lac*

In the summer of 1993 I traveled to the former slave port city of Ouidah, Bénin (formerly Dahomey), in West Africa, to investigate the contemporary manifestations of the early to mid-nineteenth-century repatriation—from Brazil to Bénin—of a distinguished group of manumitted former slaves known commonly as the "Brazilians." I spoke with members of many Brazilian families—de Souza, da Silva, Gomez, Conceição, d'Almeida, Lima, and Olympio, among others—from whom I learned a great deal regarding Brazilian family histories. I was able to document Brazilian architecture, masquerade, and food preparation. Within West African Brazilian culture, I anticipated finding a mélange of African-Brazilian religious art and expression returned to Bénin and reintegrated into the local traditions. I found nothing of the sort. Brazilians I spoke with were either Catholic or Muslim. The Brazilian histories, arts, and customs were interesting, but I sought something with a larger spiritual focus. Because I was in the heartland of Vodun, I did not need to look very far to find "spirit." In fact, I could not help but notice the very public display of Vodun arts punctuating the Ouidah landscape and informing the religious expression of the majority of the city's inhabitants.

It became clear that Vodun was Ouidah's pulse. People said that the trees in Ouidah were "watching" and that Ouidah's earth was "breathing." In my Western mindset, I started asking direct questions about Vodun, which were met with resistance. For example, the first time I asked my research assistant for an explanation of a Vodun shrine in the street, she looked the opposite direction and responded "Why should I look at that? Do I want to become blind?" Why, I wondered, were African Brazilians so pleased to talk about

their histories, but most other people from Bénin were resolute in their unwill-ingness to discuss Vodun? I was compelled. I needed to learn more.

This book is inspired by wonderment, perplexity, and admiration. The source of this inspiration is Vodun, the predominant religious system in south-ern Bénin, Togo, and extending into southeastern Ghana. It is the origin of Haitian Vod*ou*, which is the foundation of Hollywood's Voodoo. However, both African Vodun and Haitian Vodou have next to nothing in common with Hollywood's exaggerated caricature of a sinister faith entangled with false ideas of human sacrifice, cannibalism, sorcery, and zombification.[1]

African Vodun revolves around healing and community. It is organized around a single divine creator and an uncountable number of spirits who gov-ern the forces of nature and society. As an orientation to the world, however, Vodun is much more all-encompassing. It is a religious system that permeates virtually all aspects of life for its participants in Africa and in African diaspora regions where its transatlantic manifestations are found.

Within Vodun there is a palpable belief in the reality of spirits, ancestors, and the forces of nature. Vodun is not separate and removed from quotidian life. Rather, devotion and everyday life are coterminous. Spiritual, ancestral, and natural forces fully inform the social world and are responsible for what happens in both nature and society. As a comprehensive and multidimensional system, Vodun generates hope as well as guidance when its practitioners are confronted with life's daily uncertainties and obstacles. The core purpose of Vodun is to maintain the well-being of its constituents, both earthly and beyond. To do so, Vodun coalesces around the active, participatory presence of both practitioners and spirits. For this symbiotic relationship to work, there must be a consciousness and an experience in which the participant(s) and spirit(s) are mutually engaged. There is no permanent closure in this relation-ship, which perseveres through an ongoing negotiation of the benefits and promises of the past, present, and future, over all of which Vodun has reign.

The all-encompassing nature of Vodun affects everyone who lives in com-munities where it is practiced, but most directly impacts the priests, priest-esses, and practitioners who teach and learn from each other. Vodun devotees, like most people, seek health, happiness, prosperity, and security for them-selves, their families, and their communities. This process is not unidirec-tional, but reciprocal. The spirits also have needs and desires. They want to be actively involved in and recognized for the work they do for their devotees. This can be accomplished through devotional offerings of a combination of song, dance, prayer, and nourishment, which might take place in accordance with spiritual consultation or divination. People growing up in this atmosphere have a basic understanding of the system. For meaningful interactions with

spirits, however, practitioners must learn, among other things, the origins and histories of their spirits; the associated Vodun languages, songs, dances, and prayers; and the spirits' likes and dislikes—concepts and practices from the most abstract to the most concrete. This schooling is accomplished through initiation, which can last from a few months to a few years. Once initiated, an adept will continue the process of learning and must follow strict rules of veneration. Different spirits necessitate different types of schooling, and most of it remains secretive. The bottom line is that spirits need human beings to stay alive, and human beings need spirits to help them navigate the unknown.[2]

I learned a lot about initiation, but this book is not about revealing secrets. This book is meant to introduce the reader to an intelligent and practical way of living in a world where spirits and associated arts and aesthetics help individuals and communities negotiate the opportunities and challenges in their lives. Neither is this book about defining or codifying Vodun spirits. Vodun and its spirits defy conventional categorization. Vodun does not formulate fundamental principles by which it acts; rather, it prioritizes action. Instead of abiding by philosophical tenets and devising or following doctrine like most religions, Vodun's focus is on making things happen and getting things done. Vodun places high value on efficacy, which infuses Vodun and thrusts Vodun arts and aesthetics into everything from problem solving and conflict resolution to protection and healing.

Moreover, Vodun has no sacred, all-encompassing, definitive text like the Torah, Koran, or Bible of the Judeo-Islamic-Christian worlds. Rather than following written doctrine, Vodun functions through ongoing consultations among Vodun practitioners, spirits, and ancestors. These interactions *write* Vodun's sacred text. That is, Vodun's essence is its active ability to compose its own narrative through both oral and unspoken spiritual interactions, grounded in a nonlinear sense that the past/present/future all function at the same time. Vodun is unscripted and open to continual "editing" in that every time a new situation arises needing spiritual intervention, a new solution can become part of the liturgy. This capacity for ongoing revision allows Vodun to be perpetually up-to-date.

Like the religion, Vodun arts are narrative, interactive, and open to modification, making them difficult to define. Vodun artistic expression can be viewed within a broad conception of what art *can* be. In fact, it is inaccurate to define all Vodun expressive culture as art because in local interpretation much of it is *beyond* art. A large part of these Vodun arts are "processual" in that the construction process itself *is* the artistic expression. Or, as Arnold Rubin (1974,10) wrote in the 1970s, arts are "means to ends rather than ends themselves." This concept is discussed further in Chapter 1. Both sacrifice and

performance are examples of this processual expression, or means to ends, that could be described as art. Most important is the fact that Vodun artistic expression is never completed. There is no such thing as a final offering to a Vodun shrine or a final brushstroke in a Vodun temple painting. Indeed, this type of artistic expression must finish, in a sense, but only temporarily in that it remains open to change, if and when necessary. Artistic "unfinished-ness" is the crux of Vodun's aesthetic power, introduced here and addressed throughout the book. Unlike much Western art, Vodun artistic expression is not inaccessible, rarified, and unique. Vodun expression is common and every-where. But it is sacred, which adds significantly to how Vodun is and is *not* discussed.[3]

Understanding Vodun

The Vodun religious system is best understood as a network that is open-ended and incorporative, and thus "unfinished." The receptive, in-progress quality of Vodun exists in tandem with an endless influx of influences from imme-diately local environs, neighboring and distant African regions, Europe, the Caribbean and the Americas, and Asia. For centuries coastal West Africa has been a global matrix within which the religious system of Vodun has flour-ished. Vodun has not been subdued or tamed by foreign interventions such as exploration, trade, colonialism, missionary work, or modernity. Rather than repressing or stifling the practice, most such global encounters have in some form or other strengthened Vodun's reservoir of power to help its practitioners confront problems and opportunities in a quickly changing world. This centu-ries-old international cultural interchange not only demonstrates Vodun's abil-ity to function within a global milieu, but also suggests the necessity of global encounters for its survival.

Grasping Vodun: Open-Ended/Global Dialectic

The tension and traction emerging between Vodun's joined forces of open-endedness and globality—two different though equally important components—can be visualized as follows. Consider your two hands. Imagine your left hand as the structure of Vodun and your right hand as Vodun's sources. Vodun's "left hand" (structure) is open-handed and recep-tive to change, with its five digits representing the five structural character-istics: protean/unfinished, agentive/active, welcoming/accepting, filled with

capability/capacity, and overflowing with potential/possibility. Vodun's "right hand" (sources) includes wide-ranging religious, spiritual, cultural, and linguistic customs, beliefs, symbols, ideas, gods, spirits, objects, prayers, songs, and so on, with its five digits representing the extensive geographic origins of these sources: immediately local environs, neighboring and distant African regions, Europe, the Caribbean and the Americas, and Asia. Add to this the multiple layers of symbolism each source embodies, grounded in a variety of local and distant interpretations.

The structurally open left hand welcomes, grasps, and makes its own the global sources of the right hand. When the two hands lock fingers, the grip is tight but fluctuates in intensity. Sometimes it is the structure that sustains the variety of diverse sources, but other times it is the sources themselves that fuel, motivate, and maintain the structure. The pulse of Vodun shifts back and forth between and among the ten digits, maintaining a unified whole that is always on the verge, always ready for the next component, from far and wide and right next door.

Put another way, Vodun has survived by adopting and then adapting foreign elements into its visual culture and aesthetics. The converging point of Vodun's "open-endedness" and "globality" is its pulse. That pulse is sustained by Vodun's flexible structure, its refusal to become stagnant, and, as a consequence, its ability to incorporate what it needs from local and global sources. The condition of open-endedness suggests that an ongoing state of anticipation is a primary factor of Vodun's make-up, constantly reinvigorating old ideas and components while welcoming newly arriving ideas or components—local and international. That is, the open-ended, flexible nature of Vodun joins forces with and negotiates the global histories of coastal Bénin, resulting in a system that expands and contracts in accordance with a dialectical rather than a linear trajectory. This dialectical struggle heightens at the moment of Vodun's contact with new ideas in what may appear to be, but is not, a process of assimilation. Rather, Vodun's open-ended structure engages newly arriving components as *already* having been part of the system. Perhaps they were not known before the moment of contact, but they already had a place and a home just waiting to be recognized. The immanence of the next encounter reinforces the anticipatory environment and is the crux of this book.

How, then, does one come to understand a complex, centuries-strong belief system that adopts and adapts as situations arise, and which is based on an ongoing exchange with unseen yet very present spiritual entities? In other words, how can this book represent a subject and be true to the people, spirits, and beliefs surrounding it, if the subject cannot be known in any definitive sense? This introduction seeks to begin to answer these questions.

Component One: Open-Ended and Unfinished

The logic of Vodun is one of process, which is decidedly non-Cartesian in that it does not create value or meaning by producing finished, discrete things. The process nature of Vodun implies ongoing, never-finishing trajectories. But in modern Western assessments of value, something that is "unfinished" or "in process" tends to be viewed as unpolished, fragmentary, or rough. If "*unfin-ished*" implies deficiency, how then does one describe something in which *un*finishedness is not only requisite, but compulsory; not only desired, but de rigueur? This book does not resolve these questions, but rather engages them.

As open-ended and unfinished, Vodun's ongoing receptivity to new ideas reifies what philosophers Gilles Deleuze and Félix Guattari (1987, 25) call the "logic of the and." This is a logic of conjunction and connection, a logic that seeks to situate thought and action in the anticipatory realm of immanence, a logic that corresponds to infinite growth and growth potential. Vodun's capac-ity to carry on exists because its logic is always slightly beyond reach. Its pragmatics are linked to the realities of life, which do not sit still. Vodun's open-endedness allows it to persevere in time and space, through genera-tions, and across oceans. Postcolonial theorist Achille Mbembe's (2001, 8–16) assessment of the failure of social theory to account for "time as lived not synchronically or diachronically, but in its multiplicity and simultaneities" may be a useful caveat in interpreting Vodun. Accepting the concept of open-endedness as a stream into which local and foreign elements flow may help account for the multiple, simultaneous, synchronic, and diachronic lifelines within Vodun.

In large part, Vodun and all of its intersecting elements survive due to their opacity, a concept I borrow from Edouard Glissant, the Martinican writer, poet, philosopher, and literary critic who is widely recognized as one of the most influential figures in Caribbean thought and cultural commentary. Glissant asserts that all of humanity has a right to be opaque through not suc-cumbing to outsider-imposed, objectifying, and often inaccurate "transpar-ency." Opacity, according to Glissant, is a defense *against* "understanding;" it is about the right *not* to be understood (quoted in Britton 1999, 19). In a colo-nial context, presumed "understanding" has historically gone hand in hand with subjugation and objectification. The border of the opaque, to Glissant, remains "undefined and open" (156), or what I would call open-ended and unfinished.

The impenetrability of much of Vodun is resonant with Glissant's Opacity. Vodun's meanings, for example, are never transparent. Although its prow-ess in accumulation may appear arbitrary or seem to lack cohesion, it is these very characteristics that conspire to *create* Vodun's opacity. Its open-ended, unfinished sensibilities block attempts at any sort of definitive interpretation.

Another layer of opacity results from Vodun's multiple participants, both human and spiritual, many of whom can never be fully known.

Glissant's explanation of camouflaged language in a Caribbean text is consonant with the irreducible opacity of Vodun: "One cannot elucidate the obscure, there is no possible recipe, but one can bring it back to what one knows *round about*" (quoted in Britton 1999, 153, my emphasis). Like the language of a text, Vodun's elements, their histories, and their juxtapositions to each other are "ultimately less a question of understanding the words [or elements] than of understanding *through* the words [elements]—that is, understanding the Detour." (153) Because of its ineluctable indirection or "Detour," another of Glissant's concepts, Vodun can be neither readily extrapolated nor easily foreseen. However, Vodun becomes much easier to understand if done in a way that is "round about" in relation to its ever-accumulating elements from far and wide.

Component Two: Vodun's Global Milieu

Because of its particular history, Ouidah is a global city. It is called Glehwé by Fon peoples, and has been called Igéléfé by Yoruba (Nago) peoples;[4] Ajuda by the Portuguese; Ouidah, Juda, or Gregoy by the French; Whydah by the English; and Fida by the Dutch. The different names for Ouidah, originating in different languages and reflecting diverse European and African interactions, embody an eloquent example of the impact of long-standing global interactions.

The Dahomey Kingdom (1645–1900), Dahomey (1900–1960), the Republic of Dahomey (1960–1972), the People's Republic of Benin (1972–1991), and the Republic of Benin (1991 to present) represent specific geographical, historical, and political names for the country in which Ouidah is located.[5] Henceforth, I will refer to the current names of the main city and country of this project as Ouidah, Bénin, with their French spellings, unless quoting another author or referring historically to the Dahomey Kingdom. I use the French spelling for Bénin to avoid a common confusion with neighboring Benin City, Nigeria, home of the Benin Kingdom. However, I refer to people from the Republic of Bénin (henceforth Bénin) as Beninese.[6]

Although I lived in Ouidah, the geographic area represented in this writing extends, for the most part, through the sprawling cities of Cotonou, Bénin, to the east of Ouidah, and Lomé, Togo, to the west. I did, however, travel further east into Porto-Novo, Bénin, and further west into Aflao, Ghana, all the while remaining close to the coast. Instead of referring to this geographic region as "coastal Bénin, Togo, and Ghana," I usually call it "this coastal region," or state specifically the country or city in question, which most often

will be Ouidah. I also worked north of Ouidah in Savi and Allada, northeast in Abomey-Calavi, and even further north into the former Dahomean kingdom of Abomey, and conducted a short research trip to the north-central region of Tchamba, Togo. The peoples living in all of the areas I visited have traveled throughout these and outlying areas for centuries, thus extending what I saw locally into vast, centuries-strong networks of interaction, all of which play into the complex ethnic mix along the coast.

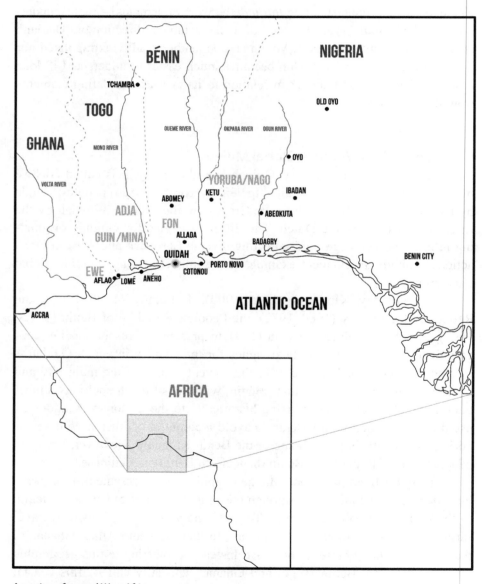

A section of coastal West Africa.

Ouidah has a population of approximately eighty thousand inhabitants. However, if the spirit population is appended to that estimate, the assessment grows precipitously. In Ouidah, Vodun spirits are living presences. Although they cannot be tallied in a population census, they are of great religious, social, and artistic consequence, and constitute a large segment of Vodun consciousness. The Vodun spirits represent and preside over every aspect of the ongoing energy of Ouidah. They come from all directions—not just from the east (Nigeria), the west (Togo and Ghana), and the north (Niger and Burkina Faso), but also from the south (the Atlantic Ocean), from above (the sky), and from below (the earth). Indeed, the entire area of coastal Bénin is the product of multi-directional histories, both earthly and spiritual, none of which can be understood to the exclusion of the others.

The area around Ouidah was inhabited sometime early in the sixteenth century by Adja and Adja-related peoples from Adja Tado, located a few miles west of the current Bénin-Togo border and sixty miles north of the Atlantic coast. Adja Tado was established as early as 1300 by peoples who may have come from the Yoruba town of Ketu, about seventy-five miles northeast of Ouidah (Adam and Boko 1983). Beginning in the early sixteenth century, waves of eastward migrations of Adja and Adja-related peoples established close interethnic ties and set the foundations for the current population mix along contemporary coastal Bénin, united under the name "Fon." This group of people, at once homogenous and heterogeneous, is comprised of Adja, Houla, and Houeda peoples (along the coast), Ayizo peoples (near Allada), and Goun peoples (near Porto-Novo), all of whom are said to have engendered "Fon" as a collective identity (Adam and Boko 1983, 30). Fon peoples are grouped among Gbe speakers who live between eastern Ghana and western Nigeria. Culturally as well, Gbe speakers share common traits.[7]

Portuguese contact in Ouidah began in the sixteenth century and added yet another dimension to the interethnic mosaic of peoples, spirits, and arts already thriving along the coast at this early date.[8] In the seventeenth and eighteenth centuries, French, British, Danish, and Dutch powers joined the Portuguese and established trading posts along this coastal area. A large proportion of these posts were located in the port city of Ouidah.

In 1727, Ouidah was conquered by the inland kingdom of Dahomey, providing the kingdom access to the sea.[9] Europeans continued to trade luxury items and firearms with the Dahomey Kingdom in exchange for slaves, mostly prisoners of war, who were then shipped to the Americas. Accordingly, this coastal region became known as the Slave Coast during the eighteenth and nineteenth centuries. The personnel of the European slave forts were mainly African, bringing Mina and Akan peoples from the west and Tchamba and related peoples from the north into the already aggregate ethnic mix (Law 2004, 30–39).

From the 1840s to the 1870s, the British led efforts to suppress the slave trade (Bay 1998, 220). These efforts, along with expansion into Africa by European colonial empires, led to alliances with some local groups and warfare with others. The early nineteenth century repatriation of manumitted Africans from Brazil, known commonly as the "Brazilians," added a significant African-Lusophone aspect to Ouidah's already global ethnic mix.

In 1892, Dahomean King Behanzin was overthrown by the French and exiled to Martinique, and his Dahomey Kingdom became assimilated into French West Africa. It remained a French colony until independence in 1960.[10]

Vodun's Composite Character

Aspects of this history of African-European and intra-African exchange are further discussed in later chapters, but the main point to emphasize here is that a major component fueling Vodun's engine is its longstanding relationships with foreigners. The active synergism between Vodun and the composite character of its milieu both in the Dahomey Kingdom and in coastal Bénin is fundamental to understanding the system itself.

Anthropologist Melville J. Herskovits ([1938] 1967, 1:3) begins his celebrated two-volume set *Dahomey: An Ancient West African Kingdom*, by quoting from Scottish slave trader Archibald Dalzel's 1793 *The History of Dahomey: An Inland Kingdom of Africa*, in which Dalzel notes in his preface that "from the Whydah beach to Abomey . . . is perhaps the most beaten track by Europeans, of any in Africa." More recently, historian Edna Bay (2008, 5) writes, "Whether invader, trader, missionary, or African returnee, outsiders in the area throughout the period of the kingdom were the subject of curiosity and study as Fon culture, itself born out of a mix of diverse people, adopted and adapted new influences."

Both Edna Bay (1998, 2008) and art historian Suzanne Blier (1995a, 1995b) have published examples of Abomey kings bringing foreign deities into local Vodun, often through warfare in which the kingdom assumed control over their conquered enemies' gods and in turn used them to their own benefit. The other primary way that foreign religious powers were introduced into the Vodun pantheon was through the marriage of kings to foreign women who brought their own local gods into the kingdom and the kingdom's Vodun (Blier 1995a, 77–79). Auguste Le Hérissé (1911, 102), who worked as a French administrator in Abomey in the early twentieth century, also explains that "the union of the kings with the women of other vanquished tribes . . . augmented the number of Vodun worshipped by the Dahomeans." Anthropologist Paul Mercier's (1954, 212n4) mid-twentieth-century scholarship attests to the idea of "foreignness" being so important in local and

regional Vodun that both were claimed as foreign in origin (see also Blier 1995a, 75–79). Because kings were looked upon as more powerful through their personal introduction of foreign Vodun, fictitious accounts of "foreignness" in local Vodun have manipulated state history (Bay 1998, 2008; Blier 1995a, 77–78). Abbé Lafitte wrote in 1875 that "a year does not pass without new divinities being incorporated into the old Dahomean pantheon" (543–45), and Mercier (1954, 212) also wrote, "the Fon are the first to admit the composite character of their religious ideas."

The kingdom incorporated more than new gods. Bay (2008, 3) writes: "The sweep of documented Fon eclecticism is vast and includes items of material culture, technologies, deities, and principles of state organization." She goes on to say that "the cultural influences from outside were without exception grafted onto a world view that is associated with Vodun." To push this idea a bit further, I suggest that these "outside influences" were not just grafted onto a particular Vodun world view, but rather were the sustenance of the world view itself, and the motivation for accumulative art and expression.

Similar complex assimilations of peoples and spirits have occurred for centuries along the coast. Although the kingdom in theory controlled, regulated, and absorbed all potentially useful components in its environs, coastal Bénin has its own legacy of global interactions that have impacted Vodun arts and aesthetics. One difference between the accumulations of foreign powers into Vodun along the coast and those in the kingdom is that along the coast Vodun was assembled, in many cases, not through warfare but instead through intercultural cooperation and trade. By the nineteenth century, the documented global mélange present in Ouidah included Europeans from Portugal, France, Holland, Britain, and Denmark; repatriated Africans from Brazil, Madeira, São Tome, Angola, Cuba, and Sierra Leone; and multi-ethnic African domestic slaves and slaves for export from what are now Ghana, Togo, Bénin, Burkina Faso, Nigeria, and likely more. All of these people brought with them and maintained their own spirits, gods, temples, churches, and mosques. Heterogeneity is commonplace in Ouidah history (Law 2004).[11]

Overview of the Book

In many ways, this book tells the story of my own journey to understand Vodun, from its abstract to its concrete dimensions, and so the following pages unfold along a similar continuum. The next two chapters further explore the conceptual underpinnings of Vodun. Given the similarities between the cosmopolitan mosaic of coastal Bénin and the historically correlative and equally heterogeneous regions of the Caribbean and the Americas, Chapter 1

addresses ideas within diasporic and Caribbean contemporary thought as a way of garnering a better understanding of the artistic, religious, and cultural make-up of coastal Bénin. This sets the stage for a discussion that investigates the aesthetics of Vodun in the larger context of African and African diaspora aesthetics and that illustrates one of Vodun's main components—its open-ended and unfinished nature—as exemplified by transatlantic Vodun shrines. By the very nature of their offerings to a spirit or god, by their assemblages of accumulated "stuff" ranging from the organic (animal, mineral, vegetable) to the mass-produced (liquor bottles, dolls, candy, flip-flops, etc.), these shrines capture the essence of Vodun aesthetics.

Chapter 2 examines that essence on a broader scale by locating Vodun in its "conceptual home," its otherworldly state of mind and being. The chapter also surveys past scholarly attempts to classify the Vodun pantheon, describes the first written source documenting a European awareness of Vodun in the *Doctrina Christiana* of 1658, and presents the various etymologies and meanings that have been suggested over the years for the word Vodun itself. All of these approaches, whether taxonomic, evangelical, or etymological, represent an effort to pin down a religious system that is difficult to define completely. Vodun is nonetheless understandable, and this chapter proposes an alternative approach by which such understanding can be achieved. It is an approach that emerged from my own effort to grasp Vodun when I first began my research in coastal Bénin. I draw on Gilles Deleuze and Félix Guattari's notion of the "rhizome" and a Fon proverb's reference to the *agbégbé*, a coastal West African parasitic vine-like plant that attaches to and grows off of tree branches and bushes, extending for miles, sharing innumerable root systems, to characterize Vodun's root-like trajectories into both spiritual and earthly realms of thinking and being. That is, I address Vodun's willingness to embrace just about everything that has ever crossed its path over many centuries—peoples, spirits, histories, ideas, and faiths. Such trajectories reinforce Vodun's open-ended structure, which creates an atmosphere open to and in anticipation of foreign interactions and influences.

Chapters 3, 4, 5, and 6 look at several of those influences in concrete detail. They not only pay tribute to the synergy of global encounters within various Vodun contexts, but also celebrate the contemporary symbiosis of these global encounters on both local and international levels.

Chapter 3 demonstrates how Europeans, Brazilians, and Africans from other parts of West Africa have directly affected local Vodun through centuries of interaction in Ouidah and coastal environs. I present examples of how Vodun has, in turn, welcomed this influence into its artistic and cultural vocabularies from the arrival of the Portuguese in Ouidah in the sixteenth century to the present.

Chapter 4 explores the profound impact of the sea and its spirits on coastal Vodun. Not only is the sea regarded as deistic, but it also brings powerful foreign spirits from faraway lands into local veneration. One such land is a mythologized "India," represented concretely by items imported from India and used in Vodun veneration, and abstractly in reference to the sea. I demonstrate this influence by considering Indian chromolithographs, examining how and why these foreign prints have been absorbed into Vodun practice, how artists and priests have adopted and adapted these images into their own local visual theologies, and how Hindu gods and goddesses, in conjunction with the sea, inform a contemporary Vodun complex called Mami Wata. I also look briefly at how Catholic chromolithographs play a role in Haitian Vodou, and how one image in particular has returned from Haiti to Bénin, showing Vodun/Vodou's globality and modernity.

Chapter 5 establishes the local significance of domestic servitude via a Vodun complex called Tchamba, with a combination of literal and conceptual origins in north-central Togo, itself considered the "foreign North" by those on the coast. The chapter shows how these Tchamba spirits of servitude have been critical in the maintenance and proliferation of histories and memories of domestic slavery, as well as influential in bringing to the fore contemporary debates among Beninese and Togolese people about the multiple roles their ancestors played in both domestic and transatlantic slavery, as either the sellers or the enslaved. I conclude with an examination of how the legacy of enslavement plays out in transatlantic, African-derived religious systems in Brazil, Cuba, and Haiti.

Chapter 6 traces the international growth of Bénin's contemporary art since the late 1980s, with particular focus on works commissioned for Ouidah 92: The First International Festival of Vodun Arts and Cultures, which was sponsored by UNESCO and the Beninese government in early 1993. Hundreds of large-scale sculptures, paintings, and appliqués were installed throughout the city of Ouidah, many by Beninese artists who are now internationally recognized. Artists from Brazil, Haiti, Cuba, and the United States also contributed to the festival with works addressing transatlantic Vodun. As such, the festival was a testament to the strength and flexibility of a belief system that is perpetually inventing, reinventing, and modifying itself through ongoing intercultural exchange.

I end with a short Coda based on wise words communicated to me by the late Daagbo Hounon Houna, which have stuck with me through the years.

Now, a quick glimpse at my first encounter—though unknowingly—with the globality of Vodun.

Global Vodun on the Mono River

In December 1994, Daagbo Hounon Houna, Bénin's Supreme Chief of Vodun at the time, invited me to attend my first Vodun ceremony outside of my new hometown of Ouidah, Bénin. At that point I hardly knew Daagbo, and I knew next to nothing about Vodun. I was, however, in Bénin to study "traditional Vodun art and thought," whatever that was. . . . Once Daagbo learned the nature of my research, he insisted on introducing me to important Vodun priests and priestesses so that I could return to meet with them on my own. I was therefore delighted that Martine de Souza, my assistant for the beginning stages of my research, and I were included in this Vodun-oriented daytrip.

We left early in the morning and traveled the coconut-tree-lined ocean road into western coastal Bénin, near the Togo border, to the compound of Tchabassi, an important Vodun priest. En route, there was talk of the imminent arrival of the cool, dry Harmattan, though all I was able to notice was the heat to which I was not yet accustomed, having spent a large part of my life within the changing seasons of the midwestern United States. When we arrived, the welcome for Daagbo Hounon Houna was overwhelming: drummers and dancers performed while people lined up to greet him and receive his blessings. Over the course of the morning, both he and Tchabassi recited prayers and made offerings to a wide array of Vodun spirits. More ceremonial dancing and drumming followed. Then everyone entered a series of flat-bottomed pirogues and traveled a short distance to an island in the Mono River to make more Vodun offerings to important spirits.

It was on this particular pirogue ride that I shot the photo shown in Figure 1. When I shot it, I did not know who anyone was or what their associations with Vodun were. As I was just starting my study of the Fon language, I asked Martine what the people onboard were saying. Rather than translate, she told me that some were speaking Fon, others were speaking Mina, and others were speaking another language she did not understand, which was likely Ouatchi or Pedah. She explained that not everyone on the boat could speak directly to everyone else. I found it perplexing that people who seemed to be close friends could not all speak directly to one another. I understand now that this question of language was my first glimpse into the heterogeneity of Vodun and the diverse origins of its constituents.

At the time I took the picture, I did not realize that in that very pirogue were some of the most important personages in coastal Bénin's Vodun history. Later, when I returned from the field and developed my slides, the photo flooded me with memories: the boat ride, the laughing, the singing, and the fact that I understood nothing that was taking place around me. But upon looking at this photo again years later, I realized that most of what I learned

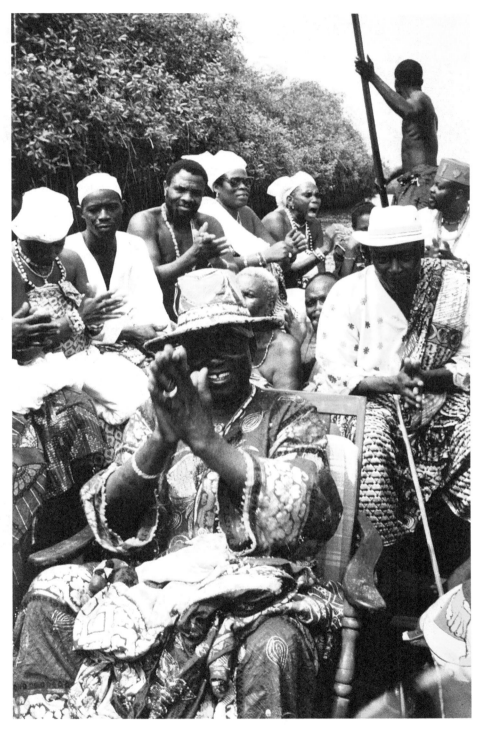

FIG. 1 Pirogue on Mono River with Daagbo Hounon Houna and other Vodun priests and priestesses. Mono Province, Bénin, December 1994.

FIG. 1.1 Xɛvioso sculpture by Cyprien Tokoudagba. Ouidah, Bénin, December 1994.

FIG. 1.2 Detail of shrine to the left of Xɛvioso sculpture in figure 1.1, on the ground below the hanging palm fronds. Ouidah, Bénin, December 1994.

FIG. 1.3 Xɛvioso shrine consisting of items that belonged to people killed by lightning. Mono Province, southern Bénin, close to Togo border, January 1995.

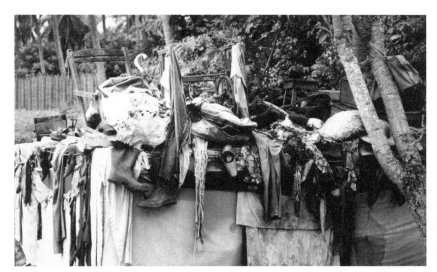

FIG. 1.4
Same shrine
as figure 1.3,
photographed
fourteen months
later. February
1996.

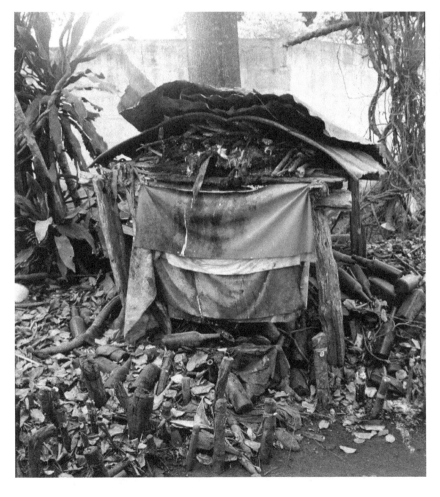

FIG. 1.5
Xɛvioso shrine
with bottles and
posts. Comè,
Bénin, January
1995.

FIG. 1.6 Another Xɛvioso shrine. Comè, Bénin, January 1995.

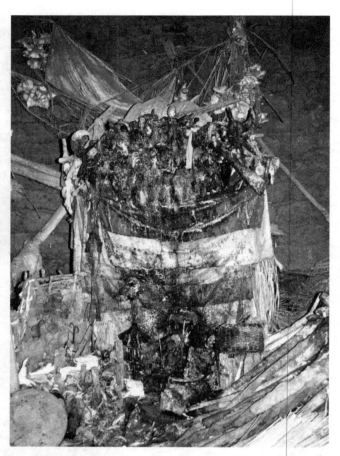

FIG. 1.7 Xɛvioso drum with human jaw bones. Near Comè, Benin, January 1995.

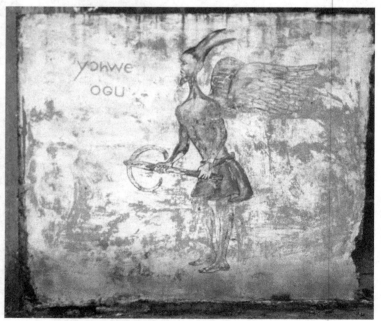

FIG. 2.1 Yɛhwe (Yɔhwe Ogu) temple painting. Sahoué-Logbogo, Bénin, 1995.

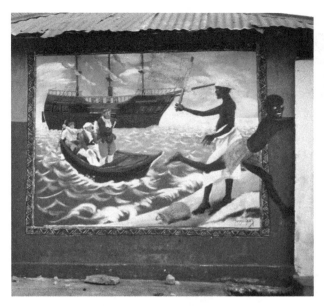

FIG. 3.1 Kpatenon wall painting. Ouidah, Benin, 1994.

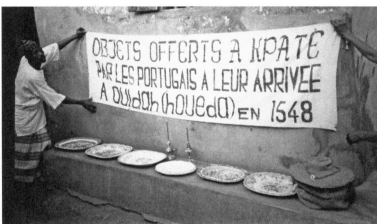

FIG. 3.2 Kpatenon's gifts from the Portuguese. Ouidah, Bénin, 1994.

FIG. 3.3 Kpatenon's gifts being marched through town. Ouidah, Bénin, 1994.

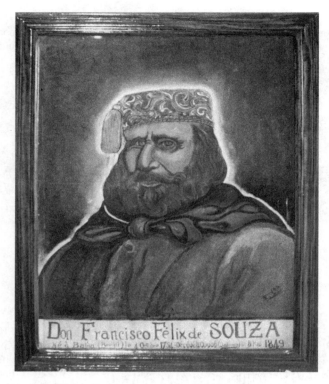

FIG. 3.4 Portrait of Don Francisco "Cha Cha" de Souza. Ouidah, Bénin, 1994.

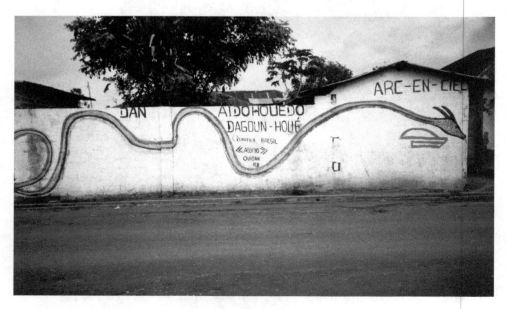

FIG. 3.5 Dagoun mural. Ouidah, Bénin, 1994.

FIG. 3.6 De Souza family Mami Wata masquerade at the beach. Ouidah, Bénin, January 1995.

FIG. 3.7 De Souza family Densu-Mami Wata masquerade at the beach. Ouidah, Bénin, January 1995.

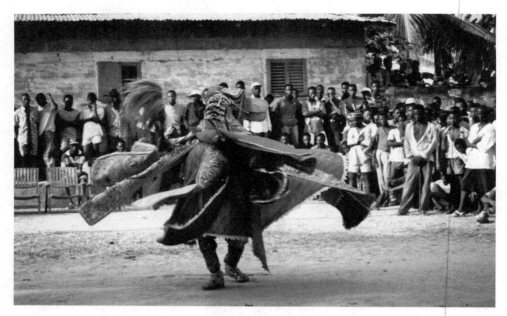

FIG. 3.8 Alapini family *agbanon* Egungun. Ouidah, Bénin, February 1995.

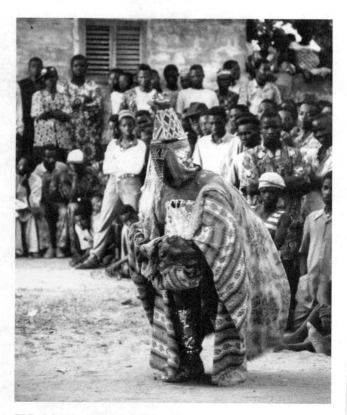

FIG. 3.9 Alapini family *weduto* Egungun. Ouidah, Bénin, February 1995.

FIG. 3.10 Adept behind cloth during initiation ceremony. Ouidah, Bénin, December 1994.

FIG. 3.11 Verger's photograph from the same ceremony forty-five years earlier. Ouidah, Bénin, 1949. Photo by Pierre Verger. Courtesy of Pierre Verger Foundation.

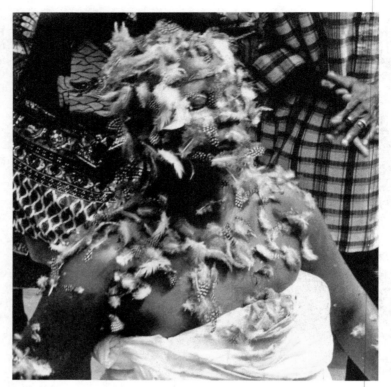

FIG. 3.12 After cloth drops, the adept is in trance during initiation ceremony. Ouidah, Bénin, December 1994.

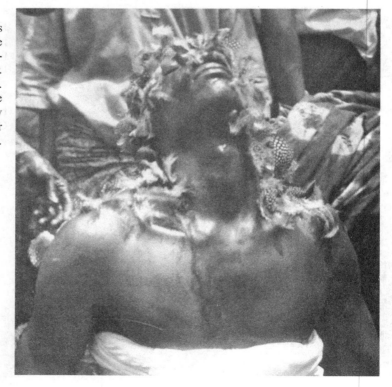

FIG. 3.13 Verger's photograph from the same ceremony forty-five years earlier. Ouidah, Bénin, 1949. Photo by Pierre Verger. Courtesy of Pierre Verger Foundation.

FIG. 3.14 Adept falls to ground during initiation ceremony. Ouidah, Bénin, December 1994.

FIG. 3.15 Verger's photograph from the same ceremony forty-five years earlier. Ouidah, Bénin, 1949. Photo by Pierre Verger. Courtesy of Pierre Verger Foundation.

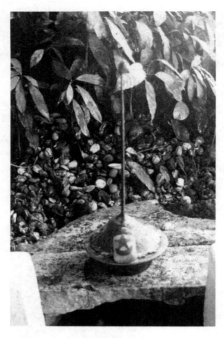

FIG. 3.16 Thron shrine item in
Guendehou's Thron temple. Cotonou,
Bénin, January 1995.

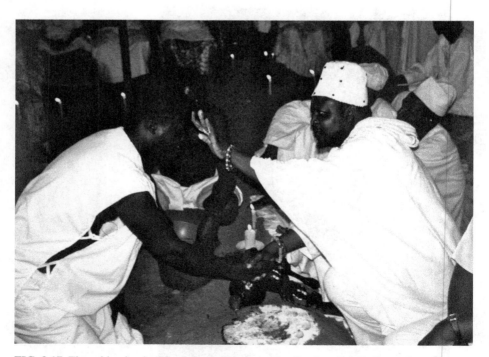

FIG. 3.17 Thron blessing in Guendehou's Thron temple. Cotonou, Bénin, December 1994.

about Vodun and its associated arts was a result of the friendships I developed with people on that pirogue. Each person had a very different and interesting association with the exceptionally diverse elements of Vodun. Because of the aesthetic opportunities Vodun offers, each priest or priestess in this boat—in his or her own way—embraced not only the traditional centuries-strong elements of veneration, but at the same time both expanded and individualized his or her spiritual and artistic means of devotion. Through the years I became very familiar with a handful of these people, their families, and associates. Each makes an appearance, in one way or another, in this book. By far, the most innovative and creative person I met during my field experience was Daagbo Hounon Houna.

- ◆ Daagbo Hounon Houna (*hou* = sea; *non* = owner of, the one with or responsible for; *na* = gives), in the center of the photo, was Supreme Chief of Vodun from 1975 until his death on March 11, 2004, when he returned to the sea to be with his ancestors. The Hounon dynasty has been the ruling family of the Hou Vodun of Ouidah since the mid-fifteenth century. I knew Daagbo for over ten years. This picture captures him at his best: in the center of everything with an enormous smile, laughing, singing, clapping, and wearing bright colors and a matching hat. Although his predecessors in the Hounon dynasty are also known for large decorative hats, Daagbo's hats surpassed those who came before him, in creativity and worldliness (discussed in Chapter 4). His Vodun temple also demonstrated this sensibility, its walls decorated with paintings and transatlantic symbols rendered by artists of Haiti, Brazil, and Cuba (discussed in Chapter 6). Daagbo had a heart of gold. He was open-minded, jovial, and welcoming with all people from far and near. His demeanor attracted people, his warmth put them immediately at ease, and his sense of humor lightened any tense situations. Daagbo did not like to talk much about Vodun, and he rarely answered my direct questions. But by welcoming me into his world, treating me as family, and introducing me to many diverse Vodun experiences, he taught me infinitely more than he could have through direct response to what began as my naïve inquiries.
- ◆ Kpatenon is on the left, wearing a white cap and shirt. His paternal ancestor, Kpate, is famed for welcoming the first Portuguese at the Ouidah beach in the mid- to late sixteenth century. His ancestor recognized the value of positive international relations and incorporated Portuguese gifts into his Vodun veneration and artistic expression. Because the name of Kpate's descendent ends with "-*non*," meaning

"owner of, the one with or responsible for," Kpatenon, accordingly, is the one with or responsible for Kpate's spirit (discussed in Chapter 3).

◆ Kpassenon, sitting directly behind Daagbo Hounon Houna's left shoulder, is "the one with or responsible for" Kpasse's spirit. Kpasse was the second king of Savi who founded Ouidah. In fact, the Fon name for Ouidah, Glehwé, is the shortened form of Glehwékpassetóme, which means "the farm of [King] Kpasse has become a country [city]" (*gle* = field, farm, *hwé* = house, *Kpasse* = the founder of Ouidah, *tóme* = country, region). Kpassenon died in April 2013, and a new king will soon be enthroned. Not only was Kpassenon the one who carried the spirit of the founder of Ouidah, but he also presided over one of the most spiritually charged spots in the region: Kpassezoumé, known as the Sacred Forest of King Kpasse, where all Vodun powers reside—good and bad, ancient and contemporary, distant and local. The Sacred Forest houses contemporary artworks representing diverse spirits and their associated powers (discussed in Chapter 6).

◆ Tchabassi, an important Vodun Chief in Mono Province, Bénin, is the one who had invited Daagbo and friends to the day's events. He is barely visible in the center of the photograph with his shaven forehead, just about to clap his hands, immediately behind Kpassenon's right shoulder. He is known throughout the Vodun world for his fierce Xεvioso spirit's ability to catch thieves (see Figures 1.3 and 1.4). His reputation is that of a very powerful priest and healer, and he is among the kindest and most learned Vodun priests. His Vodun temples and associated shrines are centuries-old artistic assemblages *par excellence*. Within his Vodun lineage, he also has the spirit of Tchamba, the Vodun of slavery (discussed in Chapter 5). Tchabassi participates fully in traditional Vodun veneration and modern capitalism, both as a priest and as a businessman dealing in fishery and public transportation via his fleets of fishing boats and taxis.

◆ Guendehou, seen in profile and wearing a red hat, appears at the far back right end of the boat. He is the founder of the original Thron Church in Bénin. Thron is a Vodun with Islamic roots. His innovative church is renowned for its seamless subsumption of multiple world religions within Vodun, all represented in his temple's décor and his diverse ceremonial repertoire (discussed in Chapter 3). I worked with Guendehou weekly over the course of my research and became very close to him and his family.

◆ The women in the boat are Mamisi, or priestesses of the Mami Wata Vodun. This spirit complex informs a large part of my work, and, in retrospect, these women represent to me the history, veneration, and maintenance of a significant and powerful coastal water spirit that had

a profound impact on my understanding of Vodun. The arts of Mami Wata are the most cutting-edge, worldly, and contemporary I have yet to experience (discussed in Chapter 4).

♦ Martine de Souza is not visible in the photo, but she was at my side not only that day but also for the beginning stages of my research. Having Martine in the boat also added another important component of Ouidah's history, through her great, great, great grandfather, Don Francisco "Cha Cha" de Souza, a Brazilian slave trader who made his home in Ouidah and controlled much of the slaving activity from the Ouidah port. The de Souza family is one of the most prominent families in coastal Bénin (discussed in Chapter 3). Martine, who was once afraid to look at a Vodun shrine, has since been initiated into the Thron Vodun and maintains a Thron shrine in her compound.

The "traditional Vodun art and thought" I had set out to study turned out to be the product of vast networks of transcultural interactions between and among parts of Africa, Europe, the Caribbean and the Americas, and Asia, revising my idea of local and traditional Vodun to an understanding of Vodun as modern, open-ended, and global, as presented in this book.[12]

Diasporas and Aesthetics

Historically, the mixes of people along coastal Bénin and the mixes of people in the Caribbean world have at least three major similarities: indigenous presence (local Africans along coastal West Africa and native Amerindians in the Caribbean); large slave populations (slaves collected from throughout West Africa, brought to the Abomey Kingdom, and sent to Bénin's coast; and slaves from large areas of the African continent dispersed throughout the Caribbean); and a significant European presence (Portuguese, Spanish, French, Dutch, and British).[1] On both sides of the Atlantic, Europeans played the roles of explorers, missionaries, slave traders, and colonizers. The archipelago of Caribbean islands is often championed as producing some of the world's first global cities. But there have been global cities in Africa for at least as long as in the Caribbean, many of which are grounded in some of the same sets of circumstances that generated Caribbean global cities.

The heterogeneous history of coastal West Africa has been documented but not theorized. African diasporas in general, and the Caribbean in particular, have been documented *and* theorized within an emerging diasporic and Caribbean literature, which offers useful interpretive frameworks vis-à-vis coastal Bénin.[2]

Caribbean Fractals

The diasporic logic of much Caribbean postcolonial literature is an especially helpful device for approaching Vodun art and thought. More specifically, Vodun's elusive multiplicities go hand in hand with Edouard Glissant's concepts of Antillanité (Caribbeanness).[3]

Scholars generally situate Glissant's writings—fiction and poetry as well as critical, political, and activist—within the context of postcolonial theory. Glissant is also lauded as the leading critic of Négritude, the literary, analytical, and political movement developed in the 1930s by a group that included the future Senegalese President Léopold Senghor and Martinican poet Aimé Césaire, among others. The Négritude activists organized around a common black identity as a means of rejecting French colonial domination. As a tool for fighting this domination, they looked to the African continent for inspiration. Glissant, however, does not locate Africa as the source of all things Caribbean. Rather, his approach allows him to contemplate and scrutinize the concept of Antillanité (Caribbeanness) over Africanness. At its foundation, Antillanité is a pronouncement of "difference" against the claims of the universal. Vodun's multidimensionality is Antillanité's "difference."

In the opening section of *Poetics of Relation*, Glissant (1990) acknowledges his debt to the work of French philosophers Gilles Deleuze and Félix Guattari from whom he adopted the notion of the "rhizome" as a critical concept in his discussion of Relation, one of his major theoretical propositions. He writes:

> Gilles Deleuze and Félix Guattari criticized notions of the root and, even
> perhaps, notions of being rooted. . . . In opposition to this they propose
> the rhizome, an enmeshed root system, a network spreading either in the
> ground or in the air, with no predatory rootstock taking over permanently.
> The notion of the rhizome maintains, therefore, the idea of rootedness but
> challenges that of a totalitarian root. Rhizomatic thought is the principle
> behind what I call the Poetics of Relation, in which each and every identity
> is extended through a relationship with the Other. (196–97)[4]

Rhizomatic thought is a strong current within local Vodun epistemologies and is discussed in more detail in Chapter 2.

As set forth in his *Poetics of Relation*, a main tenet of Glissant's writings is "relational poetics," often translated as "cross-cultural poetics." According to scholar Celia Britton (1999, 11), Glissant's theoretical work is "a complex, ramified, proliferating, and constantly evolving body of ideas. But it is all underpinned by *la Relation*." As the "irreducible difference of the Other," she explains that Relation involves equality with respect for the difference of self and other as applied to individuals and to other cultures and societies (11). Similarly, Vodun functions within a relational system that depends on cross-cultural impartiality grounded in constantly evolving global stimulations.

To Glissant, Relation is a dynamic, interrelated, and non-hierarchical system that functions within a "totality based on diversity rather than unity" (Britton 1999, 11–12). To exist "in relation," as interpreted by Britton, is to

participate in an "ever-changing and ever-diversifying process . . . to lack any permanent, singular, autonomously constituted essence" (14). Thus, Relation as a dynamic process "remains an open, constantly mobile totality" (13), not unlike Vodun. For Glissant, the development of a Creole language exemplifies Relation, in that such languages emerge from multiple and differing language collectives. Creolization, for Glissant, is "unpredictable, it cannot solidify, become static, be fixed in essences or absolutes of identity" (16). Vodun's unfinishedness is Glissant's Creolization.

Relation's respect for the other as different from oneself sets the foundation for another of Glissant's main theoretical concepts, identified in the Introduction to this book: Opacity, the right to be opaque through not succumbing to outsider-imposed, objectifying, and often inaccurate "transparency." As Glissant (1990) puts it:

> If we look at the process of "understanding" beings and ideas as it operates in western society, we find that it is founded on an insistence on this kind of transparency. In order to "understand" and therefore accept you, I must reduce your density to this scale of conceptual measurement, which gives me a basis for comparisons and perhaps for judgments. (quoted in Britton 1999, 19)

Vodun's evasive impenetrability is Glissant's Opacity. Attempting to reduce Vodun to something understandable has had an inverse effect; it enhances its Opacity. Missionaries, for example, who have tried to suppress Vodun through Christianity have had unintended results. Vodun does not refuse Christianity; rather it welcomes Jesus as another Vodun spirit. Incorporating and embracing foreign elements, like Christianity, into its global constitution and on its own terms ensures Vodun's ongoing opacity and survival.

Glissant's Opacity is intimately related to another of his major theoretical concepts, also mentioned in the Introduction: that of the Detour. As Britton (1999) explains:

> In many of its manifestations, the detour overlaps with opacity, but whereas opacity is above all an ethical value and a political right, the detour is more tactical and ambiguous. It is essentially an indirect mode of resistance that "gets around" obstacles rather than confronting them head on, and it arises as a response to a situation of disguised rather than overt oppression and struggle. (25)

Indirectness is Detour's strategy. Detour functions by skillfully evading, though not avoiding, a situation or circumstance by negotiating an effective

way around it. The functioning of a Creole language is a prime example of Detour in that through necessity such a language concurrently expresses and hides its meanings. As Glissant ([1981] 1997) proposes ". . . one never knows if this speech, while delivering one meaning, is not at the same time being elaborated precisely in order to hide another. . . . In other words, if it is a case of speech as message or, at the same time, speech as screen" (quoted in Britton 1999, 27). Such a concept is inherent to Vodun in that its symbols have multiple and simultaneously overt and covert meanings.

In his book, *The Repeating Island: The Caribbean and the Postmodern Perspective*, Antonio Benitez-Rojo (1996, 3), like Glissant, is not looking for origins within Caribbean mélange, but neither is he looking for definitive outcomes. Instead, his goal is "not to find results, but processes, dynamics, and rhythms that show themselves within the marginal, the regional, the incoherent, the heterogeneous, or, if you like, the unpredictable that coexists with us in our everyday world."

In order to do this, he turns to chaos theory, which "looks toward everything that repeats, reproduces, grows, decays, unfolds, flows, spins, vibrates, seethes." Such rhizomatic connections, he continues, "must suppose very different languages and a communication that is hardly ever direct" (Benitez-Rojo 1996, 3), reinforcing ideas of Glissant, and applicable to Vodun.

Strategic Creativity

Along the lines of a rhizomatic structure, historians Peter Linebaugh and Marcus Rediker articulate another promising framework in their 2001 book, *The Many-Headed Hydra: Sailors, Slaves, Commoners, and the Hidden History of the Revolutionary Atlantic*. The many-headed hydra is a symbol of disorder and resistance. The hydra myth itself begins with Hercules, the mythical hero of Ancient Greece who achieved immortality by performing twelve labors, the second of which was the destruction of the venomous hydra of Lerna. When Hercules severed one of the hydra's heads, two new ones grew in its place. He did eventually kill the monster with the help of his nephew Iolaus, but the very visually stimulating myth lives on. This Hercules-hydra myth was used during the colonial period to describe the difficulty of imposing order upon indentured servants, urban laborers, soldiers, sailors, and African slaves. Dispossessed people, as such, represented the ever-changing, transforming, and always regrowing heads of the monster. Most recently, academics (mainly historians) use the many-headed hydra as a means of exploring multiplicity, movement, and connections now referred to as the "hydra hypothesis" (Linebaugh and Rediker 2001, 2–4). Like a rhizome, a diaspora, and Vodun, the ever-reproducing hydra

heads multiply and expand in myriad directions. Indeed, the power of numbers (or the ever-reproducing heads of the hydra) expanded as the hydra journeyed to or was banished into diaspora communities.

The hydra and rhizome metaphors dramatize Vodun's ongoing survival strategy on both sides of the Atlantic, grounded in a strategic creativity. The word "strategic" evokes French scholar Michel de Certeau's (1984, 29–39) notorious binary definition, in which "strategy" is reserved for those in power because they dominate time and space and can thus "stockpile their winnings," which makes their power "bound by its very visibility;" while "tactics" are an art for the weak determined by an "absence of power." Weak people, according to de Certeau, do not dominate time and space like those in power, but rather they "persist over time." That is, tactics represent the sustained response of the powerless to the dominant elite.

Participants in Vodun history and culture represent people whom de Certeau would relegate to the weak, those *not* in power: the enslaved, the colonized, the proselytized, the poor. Yet I suggest *strategic* creativity as a key to Vodun's survival. Vodun's strategy is precisely de Certeau's tactic. His conception of power encompasses those for whom freedom is a given. Indeed, the free and élite can and do "stockpile their winnings." But "winnings" need not be material accumulation. Freedom and opportunity, among other things, constitute winnings. Vodun's strategists have stockpiled a wealth of winnings, many of which are non-material or difficult to quantify, but nonetheless winnings. For example, problem-solving shrines and offerings, discussed in the second half of this chapter (figs. 1.2–1.6), yield winnings that are non-quantifiably vast in time, space, and force, which are, accordingly, difficult to measure within a Western value system. Nonetheless, centuries of accumulated histories as well as strong spiritual capital must count.

Moreover, there are entirely different conceptions of time and space in African and African diasporic worlds than what are imagined in de Certeau's (2001, 8–9) binary conception. His time and space reflect ways of experiencing the world from a position of power. Recall Achille Mbembe's assessment of the failure of social theory to account for time as lived not synchronically or diachronically, but in its multiplicity and simultaneities.

In *Samba: Resistance in Motion*, scholar of performance studies Barbara Browning (1995) demonstrates the politics of cultural resistance through dance as a way to record and express history under the radar of those in power. As the national dance of Brazil, Samba incarnates resistance and reclaims power not through persistence in time or space, but through persistent motion. It was only after reading *Samba* that I recognized that movement is what is missing in de Certeau's argument. By focusing on the so-called weak's clever

utilization of time, he missed entirely their brilliant use of movement within both time and space.

Movement is Vodun's strategy, both literal and conceptual. Vodun's ability literally to adopt and adapt, to transform, and to change—that is, "to move" according to the situation at hand—is both strategic and creative, and virtually unperceivable to those in power, quite likely why de Certeau misses it. This is another example of Glissant's Opacity. Alertness, or being ready to move within and between realms, as well as an ability to merge and co-exist, constitutes a long-standing African and African diasporic aptness to participate actively in multiple worlds or realities at once. This idea builds upon W. E. B. du Bois' (1903) term "double consciousness," explained as

> . . . this sense of always looking at one's self through the eyes of others. . . . One ever feels his two-ness,—an American, a Negro; two souls, two thoughts, two unreconciled strivings; two warring ideals in one dark body, whose dogged strength alone keeps it from being torn asunder. . . . He simply wishes to make it possible for a man to be both Negro and American. . . . (2)

In the global diaspora climate, the idea of double consciousness certainly works, but it must be expanded incrementally into realms of multiple consciousnesses. Persistent movement within multiple and simultaneous realms and consciousnesses asserts an agency that transcends dominance of space and time, and actively persists as an inconspicuous strategy.

The strategy of movement is key in the work of Mexican performance artist, Guillermo Gomez-Peña. In his book *Dangerous Border Crossers: The Artist Talks Back*, Gomez-Peña (2000, 222) quotes from his 1996 *Performance Diaries*: "The only way to avoid becoming an exotic anti-hero is to constantly reinvent oneself; to disappear every now and then, and then come back with a new set of strategies, metaphors, voices, costumes and weapons."

Gomez-Peña's method is not tactical; it is strategic. It is not weakness that allows him his many successes; it is movement, transformation, and change. This strategy of movement will always remain unfinished; it is eternally open to the task at hand, which leads me to a guiding principle in my writings on Vodun: something I call an "unfinished aesthetic."

Reconfiguring Aesthetics: Art and Affect

African Aesthetics

In response to questions posed at a 1970s symposium on African art, Arnold Rubin (1974, 6) noted the hesitancy with which Africanist art historians

approached aesthetics. Now, in the twenty-first century, studies of African aesthetics remain the exception rather than the rule. Nonetheless, significant progress has been made in the literature on African art, which now contains some noteworthy studies on African aesthetics. What follows is a summary of several key examples that I believe are most relevant to Vodun aesthetics.

Process Aesthetics: Transient, Unfolding, Becoming . . .

Published in 1969, "Art as a Verb in Iboland" is what Ibo expert Herbert Cole calls "a position paper on process." In reference specifically to *mbari* houses, Cole's concern is with "*process* rather than *form*" (34, emphasis in the original). "Process," Cole continues "is the complex of interactions among people, their physical world, their artifacts, the products of their thought—i.e., their speech, song, dance, ritual, and so forth" (34–35). As such, Ibo aesthetics are all-encompassing. In his Ibo examples, and reflecting "strongly held African values," Cole explains that in African art, there is "greater emphasis on transience than on permanence. . . ." Transience, he continues, "connects with the idea that in Africa the creative process is not so focused on the completion and isolation of the object . . . but in *unfolding* and *becoming*" (41, my emphasis).

Accumulative Aesthetics: Powerful, Capable, Pragmatic . . .

In 1974 Arnold Rubin proposed the concept of "accumulation" as an important principle of African artistic expression, stressing that an object might just "begin," rather than "end," when the basic form is defined (14). In his groundbreaking essay "African Accumulative Sculpture: Power and Display," Rubin proposes aesthetic analyses of African art within two broad categories: power and display, though objects may belong to both categories. For "display," materials such as beads, bells, fabrics, and mirrors are added to enhance the objects visually. For "power," materials such as horns, skulls, and sacrificial accumulations are added to organize and concentrate "available capability" of an object.

Here, a difficulty may arise within the field of art history because these additive power materials, Rubin affirms, "represent a distinct affront to Western [aesthetic] sensibilities" (8). Another difficulty he addresses is that in contrast to the "legible exposition and orderly dialectic which [has] characterized most Western art," the additive power materials seem to be an "unorganized, overwhelming profusion." Upon closer inspection, Rubin continues, most African accumulative configurations reveal "that even those which seem most random and accidental . . . are actually developed in accordance with consistent principles." The design decisions, he states, are not "trivial aesthetic manipulations" (8), though they may appear so to Western aesthetic sensibilities.

Throughout the essay, Rubin asserts that aesthetic decisions play a decisive role in object making. However, the object-making itself represents primarily "means to ends rather than ends themselves" (10). Thoroughly informing the making and using of power objects, "pragmatism" is the primary concern in which "capability" is key.

Assemblage Aesthetics: Gathering, Importing, Uniting . . .

Suzanne Blier (1988, 137) has more recently addressed the "primacy of assemblage" in Vodun arts. She notes that "nearly all Dahomey art forms are works of assemblage, in that they are made up of numerous separate parts, of the same or mixed media, joined together to form a single unit." The "art of assemblage" is, according to Blier, "perhaps Dahomey's most important artistic contribution."

Blier presents four words used among Fon peoples to express the action of assemblage. They are *kple*, *ha*, *agblo*, and *fo*. According to Blier (1995a), these terms suggest the ideas of "bringing together," "uniting," "agglomeration," and "gathering together" (75). Such terms of action are important in understanding the active Fon industriousness in the enterprise of assemblage in both Vodun arts and the religious system itself. From her unpublished field notes, Blier quotes an informant named Agbanon who explains the process of bringing foreign gods, priests, and associative paraphernalia to the Dahomey Kingdom after a victory. He said, "One digs up the Vodun and gathers the posts, sculptures, axes, everything and brings it here [the kingdom]" (418n48). Active assemblage was key not only to the strength of the kingdom through continual additions of foreign powers, but also to an understanding of the associative aesthetic system.

Sensual Aesthetics: Seeing, Hearing, Speaking, Tasting, Touching . . .

Scholar of African and African diaspora arts Henry Drewal proposes a "sensiotic approach" to the study of African art and aesthetics, redirecting and building upon a body of literature that Paul Stoller (1997) refers to as "sensuous scholarship." Drewal's (2005, 4–6) proposal is a welcome addition to new and alternative ways of thinking about African and other art histories. His objective is to demonstrate how African artists and audiences employ the senses of sight, taste, hearing, speaking, touch, motion, and extra-sensory perception "to create and respond to the affective and aesthetic qualities of art." Motion and ESP, Drewal stresses, have an important effect on how human beings "experience things" in this world and beyond. He states outright that we must go beyond language-based approaches and explore how "art communicates and evokes by means of its own unique sensorial modes." While language is clearly one way to represent the world, Drewal points out that before language we used our senses to perceive, reason, theorize, and understand. He

concludes, "In the beginning, there was no word, only sensations." Although sensations come and go, the potential "to sense" remains and anticipates.

Suzanne Blier (2004, 11) also addresses the sensory experience of African art. Even though "multisensory attributes distinguish nearly all artistic forms," Blier notes that Western audiences have focused on the visual properties of African art at the expense of the "experiential power" these objects embrace. That is, smel*ling*, hear*ing*, touch*ing*, and tast*ing* are critical multisensory dimensions to experiencing African art. The *-ing* termination of these words elicits unfinishedness within the fleeting nature of sense perception.

Congolese Aural Aesthetics: Hearing, Seeing, Dancing . . .

In his essay, "Variations on the Beautiful in Congolese Worlds of Sound," Achille Mbembe (2006, 63–64) writes an aesthetic description of the works of several urban Congolese composers who were active in the 1990s. By "aesthetic description," Mbembe illustrates the "totality of sensations, pleasures, and energies provoked by a particular work, or set in motion in the subject listening or dancing to it." With reference to this music as poetry, dance, and prayer, he asks, "How can we understand its intimate power, its penetrating strength and energizing force, and hence its aesthetic signification?"

Although his topic is music, Mbembe (2006) identifies some of the difficulties confronted in assessing aesthetics of multisensorial art forms:

> In contrast with other [Western] artistic forms such as painting and literature, where aesthetic theory is usually based on the visual, music allows the conflation or the juxtaposition of the textual and sonoric, the aural (*hearing*), and the visual (*seeing*), with performance and motion (*dancing*). . . . To comprehend the aesthetic signification of the works studied here, it should therefore be remembered that they mobilize several senses and organs (hearing, voice, sight, touch, and further, movement and waves of energy). There is nothing more complex than verbalizing that which involves the nonverbal. (64, italics in original)

The aesthetics of Congolese urban culture must be evaluated within the governing "social epistemology," that is, the collectively recognized rules in which this music thrives (Mbembe 2006, 70). Along with the social being integral in aesthetic assessment, sensiotics are a critical element in grasping the multisensorial aesthetic sensibilities of Congolese music.

Embodied Corporeal Aesthetics: Efficacy, Sensory Immediacy, Action . . .

In his book *Art and Agency*, anthropologist Alfred Gell (1998), like Drewal, rejects a solely linguistic approach to art. Rather than dealing directly with senses, however, Gell dwells on the agency of images and the performative

aspect of art itself (12–15). He views art as a "system of action," with an emphasis on "agency, intention, causation, result, and transformation" (6). Gell, like Cole, suggests that art is about "doing."

A student of Gell, anthropologist/art historian Christopher Pinney (2004) has pushed the idea of art's agency further. In his book, *Photos of the Gods: The Printed Image and Political Struggle in India*, he argues *not* for a history of art, "but a history made by art" (8). Conventional aesthetics, he asserts, are not useful in evaluating art whose power lies in its efficacy (21). As a direct critique of traditional approaches to aesthetics, Pinney argues for the notion of 'corpothetics' defined as an "embodied corporeal aesthetics." He opposes this to "'disinterested' representation, which over-cerebralizes and textualizes the image." In short, Pinney is concerned with the efficacy of images through bodily engagement. In his work on the efficacy of Indian chromolithographs, he proposes that the relevant question is not how images look, but rather "what can they 'do?'" (8). Sensory immediacy and the desires/needs of a worshipper allow efficacy to emerge (Pinney 2001, 161–2). The efficacy of an image is grounded in its potential for ongoing output and productivity; it must act, it must work, or its continued devotion is jeopardized.

Diaspora Aesthetics

Arts of the many African diasporas are continually in process, never complete, eternally contemporary, and invariably constituted within what cultural theorist Stuart Hall (2000) calls a "diasporic aesthetic." Diasporic identities and experiences, according to Hall, are "constantly producing and reproducing themselves anew, through transformation and difference" defined by the "recognition of a necessary heterogeneity and diversity" (31). Identity as such is a matter of "'becoming' as well as of 'being.'" That is, identity "belongs to the future as much as to the past" (23). African diasporic cultural identities have longstanding, complex, and layered histories. Hall notes that like everything that is historical, cultural identities "undergo constant transformation." Far from being eternally fixed in some essentialized past "they are subject to continuous 'play' of history, culture and power" (23). Associative meaning, Hall states, continues to "unfold, so to speak, beyond the arbitrary closure that makes it, and any moment, possible. It is either over- or under-determined, either an excess or a supplement" (27).

Similar to Hall's idea of Caribbean identity unfolding as excess, Haitian Vodou scholar and folklorist Donald Cosentino (1995, 30) describes Vodou's altars and sacred objects as "aesthetically, historically, and theologically 'overdetermined' . . . single symbols enfolding multiple sources." It appears useful to apply these ideas to African and African diaspora arts in that

identity—personal, spiritual, and political—is commonly expressed through artistic expression. Cosentino's exhibition and accompanying book, *Sacred Arts of Haitian Vodou*, is exemplary in demonstrating how Haiti, Haitian Vodou arts, and associated experiences and identities prevail within Hall's "diasporic aesthetic" and its components of heterogeneity, diversity, transformation, and overdetermination.

Cosentino (1995, 28) quotes St. Lucian writer and poet Derek Walcott's model for Caribbean art: "Break a vase, and the love that reassembles the fragments is stronger than the love which took its symmetry for granted when it was made." The fragmented, reassembled, not-quite-whole conception of Caribbean art and identity resonates with his self-described way of being in the world. Walcott refers to himself as an anomaly in Hilton Als' (2004, 43) *New Yorker* essay, "The Islander." He explains, "I have to live, socially, in an almost unfinished society. Among the almost great, among the almost true, among the almost honest." Tinged with irony, he told Als that his goal is to "finish" his incomplete culture. As St. Lucia's most passionate annalist, he is clearly aware of the impracticability of such aspirations. As such, Walcott acknowledges the contradictions in ways of measuring success as completion. Much of his writing is not geared toward completeness, per se, but rather expresses the beauty and incongruity of the Caribbean on the verge.

In the same vein as Walcott's reassembled vase, Cosentino (1995, 28–29) describes the "spiritual reconstruction" of Haitian Vodou as a refashioning of fragments of Africa, Europe, and native Americas collided with twentieth century capitalism. The aesthetic system born of such a heterogeneous collision reminds Cosentino of a 2,500-year old statement by the ancient Greek philosopher Heraclitus: "a heap of rubble, piled up at random, is the fairest universe."

Blier's "primacy of assemblage" used to describe the Fon art of the Dahomey Kingdom is, according to Cosentino (1995), the principle that orders Haitian sacred art (30). "The ancient Fon aesthetic of assemblage," Cosentino states, "is the 'purest' link between the religious art of Haiti and Africa" (43). Aesthetics of heaping, piling, and assembling may have been "random" in ancient Greece, but intentionality is key to assemblage aesthetics in both Africa and the Caribbean. Such assemblage arts are the product of selection and intent coexisting with creativity and transformation. Cosentino recounts artist/musician David Byrne's description of an African-Caribbean altar as informed by an aesthetic that is "improvisational, never 'finished'" (29).

Unfinished Aesthetics

The aesthetics systems just described—process, accumulative, sensual, embodied, efficacious, etc.—have a commonality. Within these systems there

is a participatory and generative presence beyond that of the producer. For such a system to exist, the participant/s and the art/objects/performance(s) must be mutually engaged. Within aesthetic systems as such, there is no permanent closure; an open-endedness or unfinishedness is obligatory.

Indeed, Vodun's decidedly non-Western logic is mirrored in its corresponding aesthetic system. Vodun arts articulate Vodun's way of structuring knowledge within a system grounded in transformation, open-endedness, fluctuation, and change. I describe this system as one with an "unfinished aesthetic." Such an aesthetic system depends on its efficacy, or ability to work, for it to remain operational. If it does not work or is not effective, it closes down; it ceases to be; it finishes. Efficacy and unfinishedness are synergetic requisites in Vodun. Immediacy is the medium of the "unfinished aesthetic," but endurance through unfinishedness is its lifeline.

Within an art historical framework, the fluidity of this "unfinished aesthetic" challenges the logic of what an "aesthetic" is. What tools are available to deal with artistic expression that is anything but static, in terms of both form and meaning? How does one celebrate the strength and flexibility of aesthetic systems that thrive on flux and affect? A brief look at the Western fields of art history and aesthetics offers clues to these questions.

The inaugural volume of Routledge's The Art Seminar series, *Art History Versus Aesthetics* (Elkins 2006), presents ten historians and aestheticians in a vigorous roundtable discussion followed by twenty scholarly "assessment essays" and two final summarizing essays. In his commentary, "Other Values (or Is It an African or Indian Elephant in the Room?)," David J. Getsy (2006) notes a "glaring absence" from the day-long panel discussion of international experts. That is, there was next to no discussion of the aesthetics and art histories of cultures other than contemporary America or western Europe. Indeed, there was next to no mention of arts beyond the West. Yet, throughout the volume I found insightful ideas that correspond with and illuminate African and African diaspora aesthetic concerns; in particular the concept of unfinishedness.

In his essay "The Border of the Aesthetic," artist Robert Gero (2006) states that aesthetic appreciation is the consideration of "indeterminate and partial concepts that never coalesce into one privileged, conceptual 'closure.'" Indeterminate and partial, never coalescing into closure, describes precisely an aesthetic that is unfinished. He characterizes Immanuel Kant's aesthetic as a "rush of thought [that] stimulates intellectual pleasure . . . in spite of or resisting crystallization into a fixed or definite thought" (5). Unfixed, uncrystalized, indefinite, yet creating a type of gratification—these typify the requisite efficacy of the unfinished. For Kant, this is only possible if the artwork is a "dynamic mechanism operating according to a kind of complex internal

logic that both invites and eludes interpretation." Art production as such must have "sufficient complexity and sufficient openness to stimulate a rich train of thought, a set of plausible readings that must always remain indefinite" (6). Eluding interpretation and remaining indefinite—like Glissant's notion of Opacity—are necessary components of the African and African diaspora aesthetic system I am attempting to elucidate. Oddly enough, these seemingly foreign components have been recognized within Western aesthetics.

A point explored throughout the volume is whether beauty extends beyond an aesthetic attribute or illustrative term. The general consensus is that beauty is a value, like goodness or truth. Art critic/philosopher Arthur Danto, in the main roundtable discussion (Costello et al. 2006, 52–53), suggests picking "an aesthetic property out of a work of art, and ask[ing] what it means that the work has this property." That is, to obtain a deeper view of an artwork, one must explore the properties or values that inform the work and discover why. I asked myself if efficacy might be assessed as a property or value in some African and African diaspora aesthetic systems in the same way beauty is regarded in Western aesthetics. In other words, does the relationship between beauty and aesthetics correspond to the relationship between efficacy and unfinished aesthetics?

Philosopher Donald Wilson (Costello et al. 2006, 70) continues this thread of thought, "There's a growing idea that once we take away the really big claims that were made about beauty, and begin to explore the many kinds of qualities . . . then people find new aesthetic qualities in new areas." Most scholars acknowledged that aesthetics goes beyond beauty.

Danto (Costello et al. 2006) recounts an event that influenced his regard on aesthetics:

> What really got me started in aesthetics at all—not as an academic discipline, but as a living thing—were the shrines that were set up all over New York City the day after 9/11. They were put together spontaneously out of balloons, cards, and flowers. No one taught anyone how to do that, or gave anyone instructions on how to put them on sidewalks, in foyers, in stairways. I wondered why people responded not with anger but with beauty. No artist could have done better. (71)

In agreement with Danto's statement regarding the role of beauty in everyday life, Diarmuid Costello (Costello et al. 2006, 73) points out that the category of the aesthetic is far broader than the category of the artistic, which he claims is often glossed over in art-historical and theoretical debates. The 9/11 shrines, as living things as well as manifestations of loss, demonstrate that when grief and efficacy converge, relief and beauty may

emanate. This expression of beauty, as a value, has much more to do with efficacy than appearance. Allowing grief and relief to manifest hand in hand in a participatory public act of art creation defies traditional Western aesthetic interpretation.

In the introductory essay to the anthology *Aesthetics*, editors Susan Feagin and Patrick Maynard (1997, vii) address Nietzsche's dualistic aesthetic perspectives: the Apollonian and the Dionysian. The Apollonian ideal is "beautiful, ordered, something presented as if for [the viewer's] pleasure." In opposition, the Dionysian is "engaged, ecstatic, and frenzied, driven by one's individuality, energy and desire." Much African artistic expression seems to materialize at the meeting point of Apollonian "controlled forms" and "Dionysian impulses." Might 9/11 shrines intersect at the same point?

Shrines, "beautiful" in that they induce an emotional response, demonstrate the phenomenon of efficacy as an aesthetic value. In the 1914 essay "The Aesthetic Response" in his book, *Art*, Clive Bell ([1914] 2010, 17) claims that the genesis of all aesthetic systems is the personal experience of emotion. He calls the emotion provoked by a work of art "aesthetic emotion." To unravel the central problem of aesthetics, he suggests discovering "some quality common and peculiar to all objects that provoke [our emotional response]." Such a discovery, suggests Danto (Costello et al. 2006, 53), will point to the quality that differentiates art from all other object types. In another of Bell's ([1914] 2010, 39) essays, "The Metaphysical Hypothesis," he claims that seeing objects as pure form is seeing them as ends in themselves. He then asks, "What is the significance of anything as an end in itself?" Bell is looking for a common characteristic inherent in all objects that incites emotion, yet questions the value of that which ends, or finishes. Might efficacy, with its ongoing emotive potential, be this all-inclusive characteristic? Through eliciting emotion and confronting bereavement, the efficacious nature of 9/11 shrines has much in common with transatlantic shrines as efficacious assemblages created to honor, grieve, supplicate, and celebrate.

Transatlantic Shrine as Unfinished Exemplar

A Work in Progress . . .

Transatlantic shrines are works in progress, eternally under construction, and accordingly, unfinished. The static nature of a shrine is misleading. Although a shrine used in Vodun may appear "finished," it continues to change in terms of both form and meaning. The form can expand rhizomatically each time a new offering is made, ranging from organic materials such as animal blood and

parts, saliva, palm oil, fruit, and prepared foodstuffs to mass-produced items such as perfumes, powder, plastic dolls, candy, and bottles of liquor, or what Donald Cosentino (1995) calls "disparate stuff." In *Sacred Arts of Haitian Vodou*, he writes:

> To look at a Vodou altar cluttered with customized whisky bottles, satin pomanders, clay pots dressed in lace, plaster statutes of St. Anthony and the laughing Buddha, holy cards, political kitsch, Dresden clocks, bottles of Moët & Chandon, rosaries, crucifixes, Masonic insignia, eye-shadowed kewpie dolls, atomizers of Anais-Anais, wooden phalli, goat skulls, Christmas tree ornaments, Arawak celts . . . is to gauge the achievement of slaves and freemen who imagined a myth broad enough and fabricated a ritual complex enough to encompass all this disparate stuff. (27)

Of equal importance, however, are non-tangibles such as blessings, prayers, and songs, as well as vast conceptual assemblages of diverse histories, ideas, and world belief systems that accrue material, historical, and spiritual capital with each additional offering.

Transatlantic shrines reflect the complicated global histories that surround them. Just as history is ongoing and unfinished, so is the potential of a transatlantic shrine. Each new idea, new prayer, and new additive item adds another chapter to the shrine's story and a new floor to its architecture. Each addition embodies an ancillary relationship with the sacred and gives shape and form to the invisible. A transatlantic shrine is a visual and spiritual history, and a natural form of anthologizing within a logic grounded in a nonlinear way of being the world.

As a concentration of energy, a shrine is full of vitality, expanding and contracting over time. The meanings and associated powers of a shrine can change based on anything from the efficacy of the shrine itself to a dream or vision had by the shrine's owner. A shrine that appears ostensibly complete may, in fact, never be complete: not only its power but its ongoing structural revisions through use actualize its potential to adapt in response to any new problem or situation requiring spiritual guidance or intervention. The changing demands and desires of spirits and practitioners go hand in hand with the shrine's ongoing synergy of abundance and atrophy. When something "works," more will be added. When something doesn't work, a new solution—through divination, prayers, and offerings—will be explored, ad infinitum.

A transatlantic shrine must be read as cumulative and contextual rather than definitive. A shrine can be temporarily understood through its juxtapositions and combinations of objects, as well as through the ongoing results of the processes and ceremonies for which the shrine was inaugurated and used.

Potential for multifunctional, incremental growth and never-ending visual and spiritual saturation is a shrine's lifeline.

Transatlantic shrines exist in an infinite aesthetic and spiritual synesthesia in which visual impact itself induces a divine presence. Evoking more than form and function, aesthetic considerations for a Vodun/Vodou shrine have social and spiritual dimensions. Standard aesthetic assessments such as "How does it look?" and "What does it mean?" are of lesser concern. The question of critical significance is not only "Does it work?" but also "Will it continue to work?" That is, will it continue to meet the needs and demands of the shrine owner and the individuals petitioning its guidance?

The continuing efficacy of a transatlantic shrine reifies Deleuze and Guattari's (1987, 25) "logic of the and," an accumulative logic of unfinished-ness. A transatlantic shrine incarnates multiplicities, which, according to Deleuze and Guattari, are rhizomatic. The shrine has neither a beginning nor an end, but always a middle from which it grows and overspills; a process that is perpetually prolonging itself, breaking off and starting up again; ceaselessly establishing connections (20–25). Even the first addition to a "new" shrine is "in the middle," in that the location of the shrine and the spirits to be consulted are already infused with potentiality even before the shrine "begins," so to speak. The ongoing capacity for a shrine to function exists because its logic is always slightly beyond reach. Its pragmatics are linked to realities of life that do not sit still.

A shrine's proficiency for unending incremental expansion—in size and strength—is difficult to frame. That is, there is no rationale behind the perpetually unfinished Vodun shrine, growing, changing, accumulating, continually transformed and transforming, on both sides of the Atlantic, in the village, the city, or even in a museum setting. An aesthetic that is unfinished allows for the efficacy of a shrine to persevere through generations and across oceans. Recall again Achille Mbembe's (2001, 8) assessment of the failure of social theory to account for "time as lived not synchronically or diachronically, but in its multiplicity and simultaneities." An unfinished aesthetic accounts for multiple, simultaneous, synchronic, and diachronic lifelines of artistic expression.

Shrine Opacity

Elements compiled in a shrine may appear random, when in fact they are opaque. The border of the opaque, according to Glissant (quoted in Britton 1999, 156), remains "undefined and open," or what I would call unfinished. Thus, the opacity of a shrine is due to the inherent potential of its open-ended structure, its accumulative and unfinished sensibilities, which block attempts at any sort of definitive interpretation. In fact, its very unfinishedness protects

a shrine's opacity and allows it to continue functioning. Another layer of opacity results from a shrine's multiple participants, both human and spiritual, many of whom can never be fully known. Its own ongoing, accumulative, and unfinished aesthetic sensibilities both subvert and galvanize its opacity and accordingly enhance its potential.

Recall Glissant's (1993, 25) explanation of camouflaged language in a Caribbean text and apply it, too, to the irreducible Opacity of a transatlantic shrine: "One cannot elucidate the obscure, there is no possible recipe, but one can bring it back to what one knows round about." Like the language of a text— and like all the elements of Vodun itself as mentioned in the Introduction—the offerings on a shrine, their histories, and their juxtaposition can only be understood by means of Detour; that is, not through straightforward analysis of their individual component parts, but through their collective whole in the round. Any direct understanding is the death of a shrine. Awareness, appreciation, and devotion are critical, but a shrine's agency, volition, and power to make things happen resist any form of straightforward interpretation.

A transatlantic shrine is a mirror of life reflected in its requisite location within a diaspora experience. To Stuart Hall (1996, 447), a diaspora experience is "profoundly fed and nourished by . . . the African experience; the connection with the Afro-Caribbean experience; and the deep inheritance of complex systems of representation and aesthetic traditions from Asian and African culture." Cultural diasporization, as such, refers to the processes of "unsettling, recombination, hybridization, and 'cut-and-mix.'" Such processes can be witnessed in Africa, based on centuries of African, European, American, and Asian influxes. By extension a transatlantic shrine is a synecdoche of the diaspora experience. Such a shrine may be more aptly conceptualized as a microcosm of "overlapping diasporas," historian Earl Lewis' (1995) phrase to evoke layered and unfixed multiplicities and movement in regard to space, time, peoples, cultures, and languages. Overlapping diasporas within diaspora-oriented experiences are concretized within the unfinished aesthetic of a transatlantic shrine.

Cases in Point: Some Shrines in Coastal Bénin
Along coastal Bénin, shrines and other accumulative arts are commonplace. Some are maintained in public spaces, others are visible within the courtyards of private compounds, and yet others are kept hidden from public view in special compounds.

Lɛgba and Xɛvioso
In a centralized area of Ouidah, known as Daagbo Square (named after the Supreme Chief of Vodun who lives close by), two important deities are

markedly present. Lɛgba, the Vodun spirit of communication and guardian of the crossroads, watches over the comings and goings of this area much traversed by residents. Although most traditional compounds in Ouidah have their own Lɛgba guardians, this manifestation of the Vodun is meant for the whole city. To make certain Lɛgba does his job, offerings are common. Formal offerings are made during planned Ouidah-oriented ceremonies, but individuals also venerate Lɛgba of their own accord or based on advice from a diviner. The offerings are clearly ephemeral, but the ongoing potential of such a powerful deity is unfinished, and reactivated upon each new oblation.

Immediately next to Lɛgba, in the same public square, is an area dedicated to Xɛvioso, the Vodun spirit of thunder and lightning represented by a fire-spitting ram. Since 1993, there has been a large-scale cement sculpture of this deity here, created by Abomey artist Cyprien Tokoudagba (fig. 1.1).

The accumulated powers of Xɛvioso are, however, more concentrated to the left of the sculpture in the area visible between the two trees (fig. 1.2). Offerings have been made to Xɛvioso for centuries below the hanging red cloth supported by *azan*, or palm fronds.[5]

The public Xɛvioso ceremony for which the offerings shown in Figure 1.2 were made was regarded as especially propitious. In 1996, in the middle of a hot, sunny, mid-December afternoon, in the heart of the dry season and at the height of a large-scale celebration for Xɛvioso, something happened that is still remembered today. As the ram to be offered to Xɛvioso was fed leaves immediately before sacrifice, the skies darkened. The moment the ram's throat was slit and the blood touched the earth of the sacred space, the skies opened and rain fell. The rain was brief, but there was a frenzied response to Xɛvioso's tangible acceptance of the ram. It *rarely* rains during the dry season.

Along with the ram's blood, these accumulated offerings—albeit ephemeral—leave an indelible spirit presence long after they are gone. The drum seen next to the offerings is returned to safe-keeping, and the *azan*, blood, and feathers gradually disappear. The spirit is certainly present in the cement sculpture, but the land upon which it sits holds a much stronger concentration of Xɛvioso's spirit.

Although Xɛvioso is an important spirit throughout the Vodun world, there seems to be a concentration of his power in southern Bénin, immediately surrounding the town of Hèvié, along the region both east of Ouidah toward Cotonou and westward toward Lomé, Togo. *So* is the Fon word for thunder, thus the Vodun's name translates as the thunder from Hèvié. Therefore, this concentration of Xɛvioso veneration both east and west of Hèvié makes sense.

Tchabassi, a renowned priest and healer in southwestern Bénin, is known for his fierce Xɛvioso spirit and his ability to catch thieves. He is also known for a large-scale shrine overflowing with the belongings of individuals killed

by lightning (figs. 1.3 and 1.4). Such people were "chosen" by Xɛvioso, and all of their personal goods must be offered to him. Items piled upon and enclosed within the shrine include suitcases and crates filled with personal items, metal and wooden chairs, the foam interior from a chair or bed, an umbrella, a pith helmet, plates, pots, flip-flops, shoes, boots, cloth, and items of clothing. Certain items give clues to the profession of the chosen person: the sewing machine belonged to a tailor, and the nets and rubber boots were from a fisherman. Also included are ceramic and wooden sculptures and statuettes, along with drums and rattles associated with Vodun. All of the victim's belongings must be offered.

Figure 1.3 is from January 1995 and Figure 1.4 is from February 1996. In the span of fourteen months, the process of decay can be seen.[6] Not only has the cloth surrounding the shrine faded and the items accumulated begun to disintegrate, but Xɛvioso's powerful influence, represented in his will to choose his victims, continues long after their belongings are no more. The bag of clothing atop the left side of the shrine is a good example for visual comparison.

In the neighboring town of Comè, another shrine associated with Xɛvioso demonstrates quite well the tension that maintains Vodun's ephemeral/unfinished dialectic (fig. 1.5). In front of the shrine and extending left, small wooden posts are offered to solicit help from the Vodun inhabiting the space. A post represents a specific plea asked of the Vodun, which functions until the request has been met. At that point, a bottle of liquor and other petition-specific offerings are given. The empty bottles filling the shrine and extending right represent the requests that were granted. Each appeal, marked with a post, opens a dialog while each corresponding bottle closes it. Although the resolution of each request is marked with a bottle, the overall composition of the shrine projects ongoing efficacy as new posts are placed, old ones disintegrate, and bottles accumulate. For especially important or challenging work, additional help may be solicited from those who maintained the shrines in generations past. In such a situation, ancestral photographs are temporarily added.

Within walking distance of the stick/bottle assemblage, an interior shrine to Xɛvioso exemplifies the unfinishedness of accumulative aggregation (fig. 1.6). Although metal symbols for Xɛvioso (as well as other Vodun-specific offerings) can be deciphered, a linear reading of this shrine is impossible as each layer has been subsumed by the next. Nonetheless, this shrine anthologizes generations of communications, requests, problems, and solutions, all of which have come and gone. The accumulative patina exemplifies Deleuze and Guattari's unfinished "logic of the and" and is a testament to the staying power of Glissant's Opacity.

Also within the realm of Xɛvioso, the drum in Figure 1.7 is covered with human jaw bones collected for generations (likely centuries) from people killed by lightning. The opacity of such a conglomeration defies strict exegesis. Because light travels faster than sound, by the time Xɛvioso's thunderous voice is heard, his high-voltage, indeed ephemeral, presence will have already struck ground. Nonetheless, as long as darkened skies alert an imminent storm, anticipation of Xɛvioso's volition will endure. As such, although this drum may not have had any recent additions, it is and will remain unfinished.

Vɔ/Vɔ Sisa/Vɔ Diɖo

Ancillary to Vodun shrines, a more explicitly ephemeral assemblage type object called *vɔ sisa* or *vɔ ɖiɖo* is made and used daily in Ouidah. There is a familiar Fon proverb, *è nɔn do vɔ bo nô kpô do tô mɛ â*, which means "if you make a *vɔ* do not look back." *Vɔ sisa* (*sisa* = to sacrifice) and *vɔ ɖiɖo* (*ɖiɖo* = expose, display, send off), often shortened to *vɔ*, are sacrifices or offerings to particular spirits displayed in specific locations throughout coastal Bénin. Along the path to the beach, beside a road, in a crossroad or fork in the road, or near areas known to be the realm of certain Vodun spirits, offerings are often tied and bound to sticks, placed in baskets or gourds or wrapped in a mat. *Vɔ* exemplify the tension of the ephemeral/unfinished dialectic. They are made to be used once: a person who has a problem will consult with a diviner, purchase and/or find the ingredients necessary to assemble a *vɔ*, place them in a specific place depending on the consultation, and never look back. *Vɔ* are most often placed at either noon or midnight, two special times allocated to spirits during which people are rarely outside. After being placed, the *vɔ* deteriorate bit by bit until virtually nothing remains: *vɔ* are complete, but their powers continue.

The road to the Ouidah beach is the oft-prescribed place for a particular type of *vɔ* called *vɔ aligbo*, sacrifice on a main street (see cover image), or *vɔ alikpa*, sacrifice on the side of a road. *Vɔ* are also displayed in crossroads and forks in the road and are called *vɔ aliklan ɛnɛ*, and *vɔ aliklan ato* (*ali* = road, path; *klan* = to divide; *ɛnɛ* = four; *ato* = three), respectively. On the main road to the beach, there are a few spots where *vɔ* accumulate into large assemblages existing in an infinite progressive/regressive, accumulating/deteriorating, amassing/decomposing, ephemeral yet never-finishing state. Many *vɔ* in Ouidah are deposited very close to the main thoroughfare leading to the ocean, a place that will never dry up. The powers of such a *vɔ* are contained eternally in the ocean, even after the physical parts of the *vɔ* are no more. For spirit-specific reasons, some *vɔ* are placed along a river associated with a particular deity. These offerings are known to work quickly, but may not endure during the dry season, if the river desiccates. The rivers rarely dry up, but the

potential for such an event makes palpable the ephemerality of river *vɔ*, which is decidedly different than the unfinishedness of the ocean *vɔ*.

The Ongoing Present of Vodun

An unfinished aesthetic system disarms standard Cartesian dualities—right-wrong, black-white, complete-incomplete—while suggesting the possibility of a circular dynamic understood only through an acceptance of a process for which the goal is not completion, but rather continuation and survival. Accepting a shrine's unfinishedness respects its Opacity. Transatlantic Vodun art and thought are process-driven and unfinished, on the verge of action in response to whatever unknown may present itself. The applications of this idea, however, extend further and wider.

In fact, this is a direct critique of the linear conquer and defeat trajectories that have defined the modern world. Deleuze and Guattari (1987, 25) assess as "useless" queries such as "Where are you going? Where are you coming from? What are you heading for?" Such questions, they believe, imply a false conception of movement. They prefer "proceeding from the middle . . . coming and going rather than starting and finishing." Seeking to "nullify endings and beginnings," they champion "the middle" as the only place things happen. Rhizomatic unfinishedness reframes, or rather "de-frames," the Western privileging of the end over the process. As both a strategy and a necessity, unfinishedness conveys future-inflected possibilities that only exist in the present moment, the most important "time" in Vodun art and thought.

Vodun's Rhizome

At once primordial and contemporary, the religious system of Vodun is in perpetual flux, where outside influences become part of its organic existence, where boundaries are permeable, where the external and the internal may be indifferentiable or synergetic. How can something that absorbs, regroups, and then reemerges be pinned down and analyzed? Vodun cannot be deciphered in a linear format, but can be understood in light of a Fon proverb and Gilles Deleuze's and Félix Guattari's concept of a rhizome.

Vodun's Potential

In Vodun's conceptual space, neither art nor life is always as it appears to be; what is seen is not necessarily what is there; what is heard may not be what was said; and—most critical for a researcher—empirical analysis is anything but reliable. To approach Vodun, Western researchers must re-theorize and re-evaluate most of what they have grown to accept and take for granted in the Western world. They must, in short, reach beyond the observable world of logical positivism to grasp what Vodun is.

To proceed within this conceptual zone, it is useful to envision Vodun as shifting within the various realms of the earthly, spiritual, and ancestral, moving from one to the other while existing in any or all realms simultaneously. The notional space within which Vodun exists is one of interaction and exchange. Some people may never enter it, others may never leave, and still others may move in and out, but may not necessarily choose entirely how, when, or why. This space is the only channel to the spirits. If you are not present within, the spirits cannot come to you; they cannot hurt you, nor can they help you. Within Vodun, one is vulnerable to the will of the spirits; outside of it, one is vulnerable to everything else.

People who fight an otherworldly calling into this space may incur personal distress and spiritual debt, which can only be redressed through formal appeasements as fundamental as a simple *vɔ* (offering or sacrifice described in Chapter 1) or as involved as an official Vodun initiation. Yet one does not have to be initiated to participate in this space, nor must one remain in its geographical expanse. For example, a Vodun adept who lives in Ouidah will still be in the conceptual realm of Vodun while visiting Chicago. While in Chicago, this individual has the protection and guidance of Vodun and is theoretically "in" Vodun's domain. Vodun has no power outside of this conceptual zone, but within it reigns supreme.

A Vodun spirit may reveal itself in a variety of ways. For example, Xɛvioso, the Vodun of thunder, lightning, rain, and associated elements, can proclaim its presence in a flash of lightning, a thunderclap, a cloudburst, a torrential downpour, a sprinkle of rain, or a raindrop; in a drumming rhythm, a swirling dance, or in the body and voice of a spirit-possessed devotee. Xɛvioso can also manifest itself in a variety of objects from traditional shrines to contemporary sculptures (figs. 1.1–1.7). Within a Vodun world view, this and much more is the presence and protection of Xɛvioso; outside of this view, a rainstorm is simply a rainstorm.[1]

Everything is questionable within Vodun. That which appears to be something might be something else. However, instead of searching for "the answer" to that which is irresolute, people within this space anticipate that there are always many answers. In turn, they tend to take in stride things that do not go "as planned," or things the outside world may consider surprises. It is precisely this openness to uncertainty that warrants their acceptance of the acts of the spirits and allows for successful spiritual interactions. That is, if it is meant to be, it will be, with no second thoughts. This does not relegate people to the mercy of fate. Quite the contrary: because of the omnipotent potential of Vodun, most circumstances that devotees may encounter in their lives can be challenged through Vodun.

Vodun is pure potential; nonquantifiable and infinite. Within Vodun's potential-infused space, one is surrounded by things that might be much more than they appear to be. Within Vodun, a rock is a rock, but might also be more than a rock. At any given moment, something ordinary can become extraordinary. Not only is there no empirical distinction between an ordinary rock and a Vodun rock, but at any given moment one can become the other. This infinite variability in the world of appearances empowers Vodun space. Correspondingly, one is never quite sure of what anything is due precisely to the inherent potential in all things. In turn, the sense of what things *could be* is highly cultivated. This open-mindedness toward potential is an aspect of Vodun that helps people deal with the perpetual uncertainty of life and of a lifestyle

where potential good and potential bad are everywhere and often indistinguishable, at once dependent upon and at the will of circumstance and mindset. The only thing that is certain within Vodun epistemologies is that nothing is certain. I learned this through my own ignorance, early in my fieldwork.

Dangbe: How Many Pythons?

In written records ranging from early travelers' accounts to current tourism websites, most visitors to Ouidah's Python Temple have commented on its powerful mystique. Visual records also document the mystique surrounding the temple and its associated Dangbe Vodun.[2] From E. Chaudoin's 1891 woodcut print, capturing the inside of the temple with pythons hanging from support beams and slithering on the floor, to a colonial era postcard of a young boy with a python draped around his neck, Dangbe, Ouidah's infamous serpent deity, has been noticed and recorded. Just about any twenty-first century travel blogger who has visited Ouidah posts photos of him- or herself in front of the "must-see" Dangbe temple with a python draped over his or her shoulders.

The Dangbe serpent deity has been revered in Ouidah for centuries and is known as the city's founding Vodun who led a group of Pedah people to Ouidah, where they have since been known as the Hueda.[3] The scarification markings of the Pedah—five sets of two parallel vertical markings on the forehead, temples, and cheeks called *ḍɛnô*—represent the marks on the face of the python and distinguish the Pedah peoples from others.[4] The importance of Ouidah's python and the blessings he can bestow is accepted without question. In fact, if a person encounters a python, it is his or her responsibility to return it safely to the temple. Multiple times I witnessed a person in town returning a python, usually draped over the end of a sturdy branch, to the temple. To learn more about Dangbe, I asked my research assistant, Martine de Souza, to make an appointment with the Dangbenon (*non* = owner of, the one with or responsible for), the elder in charge of the temple, to discuss the python.

After basic introductions, I asked Martine to ask the Dangbenon how many pythons are in the temple. She gave me a funny look, told me that my question was "not good," gave no explanation why, and did not translate my question into Fon so that the elder could answer. I did not grasp her hesitancy, so I said directly to the elder, "*Combien de. . . .*" With poise but determination, she cut me off. This exchange piqued the interest of the elder, so Martine was obliged to explain the nature of my question. The elder was silent for a moment, nodded his head, and remained silent for another long moment. His response was "all." All? The response did not satisfy my Western mind, so I asked Martine

to explain to him that if he couldn't provide an exact count, an estimate would be fine. Before she could do so, the Dangbenon said that in his temple exist all pythons that ever were, are, and will be. He said that in Ouidah, one counts neither children nor pythons. Without knowing it, this elder answered a pivotal question in the beginnings of my quest to understand Vodun.

Vodun as *Agbégbé*

Every day I heard the word Vodun many times, in many contexts, referring to an expansive, uncontainable variety of things: a shrine, a ceremony, an object, a tree, the earth, the sea, the rain, a death, a birth, a crime, a flat tire, a change of plans, a traffic jam, a noise, a breeze, drumming, whistling, the wwwhh-hhrrrrrr-ing of the wind through the trees, the screeching of the brakes of a car, the spirit-induced convulsions of a person in trance, an overturned truck stranded along the side of the road, a filled gourd in a crossroads, a bound and tied stick inserted into the earth along a river, an oddly formed shell washed upon the beach. Even with my hard-learned lesson about not counting spirits, I continually asked myself and others another naïve question: "What is Vodun?" Once again, my particular approach took me nowhere. I learned very slowly that I had to sit back and be watchful; I had to observe and absorb. I was finally forced to confront my Western yearning to figure things out. How does one, I wondered, define what appears undefinable, especially when most people are unwilling to discuss the topic?

I came to realize that although Vodun is fundamentally opposed to a complete definition and that its power, in fact, lies in its open-endedness, it can be understood. Understanding the myriad components making up Vodun— peoples, spirits, histories, ideas, and faiths—is essential to grasp the raw potential inherent in Vodun and Vodun arts. As soon as one understands the overarching all-inclusivity of Vodun, when one recognizes not only that Jesus can be but *is* a Vodun, the first step toward understanding has been taken. This particular nature of Vodun is exemplified in a Fon proverb that was recited to me many times and that ended up functioning as shrewd methodological advice that put me on a path toward learning:

> *Agbégbé kuntɔ mâ mɔ do nu agbégbé.*
> The *agbégbé* root digger does not understand *agbégbé*.

Gilles Deleuze and Félix Guattari's (1987, 7–8) notion of the "rhizome" relates directly to Vodun, and this proverb. Their conceptualization of a "rhizome" is based on a botanical model and described as a "subterranean

stem . . . absolutely different from roots and radicals." They use this term to describe any system that allows for multiple, non-hierarchical connections and extensions perceived within a horizontal plane, as opposed to an arborescent or tree conceptualization, which extends and dominates vertically and linearly. Rhizomatic trajectories are like Vodun in that they may be "broken, shattered at a given spot, but will start up again on one of [their] old lines, or on new lines . . . [and that] these lines always tie back to one another" and continue to survive. Any point of a rhizome may be connected to any other point in the system, much like Vodun's interconnectivity among the living, the dead, and the spirits. In its ongoing, outward-reaching horizontality, a rhizome resists structures of domination much as Vodun has withstood and survived centuries of transatlantic slave trade, colonization, and ongoing missionary work on both sides of the Atlantic.

Agbégbé is a parasitic vine-like plant that attaches to and grows off of tree branches and bushes, extending for miles and sharing innumerable root systems. Its intertwining rhizomatic vines and roots make it impossible to find the beginning of the plant where the root source would be located. In the proverb, the word *do* translates as "below," "hole," "source," "secret," and/or "infinite." So, the literal translation of what I have translated as "The *agbégbé* root digger does not understand *agbégbé*" suggests similarly that the *agbégbé* root digger can never discover the secret or the source of *agbégbé*. Such vines with their irretrievable roots reflected in the proverb and the religious system of Vodun are conceptually synonymous: obscure, flexible, far-reaching, resilient, continually exploring and branching in new directions, adapting to whatever crosses their paths, and ultimately surviving.[5]

Deleuze and Guattari's (1987) "rhizome" reinforces the *agbégbé* proverb as an alternative way to approach the foundations and ongoing histories of Vodun. The one who tries to arborify a rhizome is like the one who attempts to find the originary root of an *agbégbé* vine. Endeavoring to define the intricacies of Vodun is similarly problematic. Just as focusing on a search for the roots of the interminable *agbégbé* vine will not reveal anything useful about the plant, defining Vodun is not the way to understand it. In fact, more than once in response to my many naïve questions about Vodun, a recitation of the *agbégbé* proverb was the only explanation I received: I was the *agbégbé* root digger. The beauty of the proverb, however, lies in the truth that once one understands "the vine" one no longer searches for its roots. Nevertheless, enacting this proverb-turned-methodology in the field is, at first, a difficult task for a researcher (a.k.a. "root digger") raised in a society governed by logical positivism: Dig the roots? Get the shovel.

Those who understand Vodun will never be found searching for the "proverbial roots" of an *agbégbé* vine. Indeed, in approaching Vodun, it is best to

put away the shovel, for Western logic does not work in a system that is fundamentally opposed to making any empirical sense. The point at which one stops searching for the "roots" is the same point at which an understanding can begin. This proverb is useful not only in conceptualizing and visualizing the complexities of Vodun but also in suggesting a way of approaching nonlinearity. That is, no method can be employed until the nature of the object of inquiry is accepted as it is, not as something that can be forced against its constitution into a linear format or uprooted.

Nonetheless, the effort to define Vodun is centuries old. Vodun has been written about by explorers, travelers, missionaries, state officials, scholars, and others, both European and African, resulting in a variety of exegeses. These efforts range from the codification of Vodun spirits, to the translation of the term Vodun in an evangelical text, to several etymological analyses of the term—all explications that have been put forth in hopes of penetrating Vodun's essence and of pinning down its elusive nature.

Chasing Its Tail:
The Codification of Vodun

There is no definitive, agreed upon classification of Vodun, but there are ways to divide and categorize its overwhelming variety of phenomena. In the early eighteenth century Guillaume Bosman (1705, 368) wrote that the Vodun of Ouidah could be divided into three main areas: snakes, trees, and the sea. Over two hundred years later, Melville J. Herskovits ([1938] 1967, vol. 2) divided Vodun into the Great Gods (sky pantheon, earth pantheon, thunder pantheon) (101–99); the personal gods and forces (201–30); the cult of the serpent (245–55); and the cult of royal ancestors (49–69). Others have divided Vodun into state gods, city gods, and family gods.

After a summary of various ways in which Vodun spirits have been broken down in the literature, Suzanne Blier (1995, 62–72) notes that "there is little scholarly accord with regard to Vodun taxonomic orientations." In her view, "a brief look at the types of phenomena that are said to constitute the Vodun offers . . . a better sense of the nature and significance of these religious energies." In a commendable effort to communicate the vastness of Vodun, she lists the principal Vodun spirits, artworks identified as Vodun, special and mysterious humans identified as Vodun, body parts and personal attributes considered Vodun, occupational associations with Vodun, color associations of Vodun, and Vodun symbols. She also notes that Vodun govern the cardinal directions. Very well aware of the problematic nature of an overarching taxonomic system for classifying Vodun, Blier writes that

whether dividing Vodun by spatial principles (sky, sea, and earth) or by power associations (superior versus inferior, public versus private, state verses family, royal versus local, cosmological versus ancestral), these classifications leave out the full range of phenomena that designate Vodun in ongoing religious practice. The problem is further exacerbated by the fact that each of the Vodun . . . is identified with hundreds of other deity complements, each of which is unique in its identity and attributes. (66)

I, too, could attempt to break Vodun down into separate realms based on a variety of diverse criteria. It has, however, been done and redone for close to three hundred years. Because I do not conceptualize Vodun as a system that can be broken down into constituent parts, I am not comfortable listing, categorizing, or compartmentalizing Vodun as separate from each other. There is a crucial relationship lost in categorizing Vodun independently, for Vodun is a whole rhizomatic system that must be understood in terms of integration rather than separation.

The *Doctrina Christiana*

The first written source documenting a European awareness of Vodun is the *Doctrina Christiana* dated 1658. The circumstances surrounding its writing have been elucidated by Henri Labouret and Paul Rivet (1929), based on three documents found in 1925 in the National Library of Madrid, Spain. Parts of the following discussion, as indicated, are based on Labouret and Rivet's propositions.[6]

The text was translated from Spanish into the *langua Arda* (the language of Allada) by the ambassador of the King of Allada to the court of Philip IV of Spain.[7] The Kingdom of Allada, approximately twenty-four miles north of Ouidah, was known by Europeans well before 1658. Beginning in the late sixteenth century Allada was already demarcated on European maps as Arda, Arder, Ardrah, or Ardre, respectively, by the Portuguese, Dutch, English, and French.[8] In order for King Tezifon of Allada to traffic freely in the slave trade, his people needed to pass through the city of Savi, five miles north of Ouidah, and then proceed through the city of Ouidah to reach the European traders on the coast. Labouret and Rivet (1929) propose that it was the potentially undesirable political and economic consequences of passing through Savi and Ouidah that propelled King Tezifon to seek direct support from and to develop commercial relationships with European monarchs, specifically the Spanish.

In 1658, King Tezifon sent an ambassador named Bans with his assistant to the court of King Philip IV of Spain, ostensibly to ask Philip for

missionaries to help evangelize Allada. It seems, according to Labouret and Rivet (1929, 19), that Philip was unaware of the political and commercial aims of King Tezifon's request for these presumably evangelical services. In fact Philip is said to have approached this as a timely opportunity to spread Christianity in a "savage land populated by idol-worshippers."

Upon their arrival in Spain, Bans and his assistant were instructed in Catholicism and then baptized under the names of Felipe and Antonio, respectively. They participated actively in the translation of the *Doctrina Christiana* from Spanish to their local language so that the translated text could be used in their evangelical undertakings in Allada. They were able to translate from Spanish without too much difficulty due to their knowledge of Portuguese, which was a widespread European language along the coast during this time period. Upon completion of the *Doctrina Christiana* near the end of 1658, King Philip organized a mission of the Capucins Mineurs de Castille to accompany Filipe and Antonio back to Allada to begin their evangelical mission. They left Spain November 25, 1659, stopped in the Canary Islands, and then proceeded to the *rade d'Ardra* (harbor of Allada), arriving on January 14, 1660, at the modern-day Ouidah beach (Labouret and Rivet 1929, 19).

It soon became clear to the Spanish Capuchins that King Tezifon had commercial rather than religious intentions, for he refused baptism until the Spanish and then the Dutch ships in the harbor left for the Americas filled with human cargo. Not only did King Tezifon realize that the Spanish Capuchin monks were not willing to help him commercially to the extent he desired, but he learned that conversion to Catholicism would oblige him to renounce polygamy. He was dissatisfied with the unwillingness of the Capuchins to aid him directly in the slave trade, and he refused to give up his harem. Nonetheless, the Capuchins redoubled their efforts to convert King Tezifon, knowing well that if the king embraced Catholicism, his subjects would surely do the same. But he did not and neither did they (Labouret and Rivet 1929, 20).

Even though the Spanish Capuchin mission could be considered a failure in terms of evangelical goals, the resulting bilingual text of the *Doctrina Christiana* and the documentation surrounding the events of the Capuchin mission in Allada are invaluable in helping us to understand early African-European religious and economic exchanges. Documents of this sort are rare, and they give us glimpses of a very specific area of Bénin during the early era of slaving. This may also represent a very early example of the unfinishedness of Vodun, and its malleability in relation to Catholicism.

Early Vodun-Catholic "Unfinishedness"—Lisa as Jesus

The term Vodun appears in the *Doctrina Christiana* sixty times, written as *vodu, vodugue, voduno, vodunu, voduti,* and *voduto,* which are translated as

god, priest, sacrifice, saint, or sacred, depending upon the particular context in which the form of the word appears (Labouret and Rivet 1929, 4). In studying the text, one notes that the word "Lisa" was used by the newly Catholic ambassadors, Felipe and Antonio, to translate the word "Jesus" into the local language. Melville J. Herskovits ([1938] 1967, 2:292) writes, "Christian missionaries have from the earliest times used . . . Lisa for Jesus. . . . The fact that the Dahomeans have no figure who even remotely corresponds to the Jesus of European theology is patent after the most cursory investigation." It was, however, noted by Labouret and Rivet (1929, 35) that the choice of translating "Jesus" as "Lisa" was not fortuitous.

In the Vodun pantheon, the androgynous dual deity Mawu-Lisa (also known as Mawu, Se, Segbo-Lisa, Lissa) whose domain is the sky, is/are revered as the offspring of Nana-Buluku, supreme creator god (Herskovits [1938] 1967, 2:101).[9] Lisa, the male principal who commands the sun and daytime, is the male complement to Mawu, the female principal who commands the moon and the night. The color white represents Lisa, and albinos are considered one of the many incarnations of this Vodun. The fact that Felipe was born and raised within the religious system of Vodun as well as trained in Catholicism gives reason to believe that his choice of Lisa to represent Jesus was made with serious deliberation. The religious instruction he received in Spain allowed him to understand the hierarchy within the Catholic church. His knowledge of Catholicism, in turn, helped him translate the Christian son of god to a Vodun god who is also a child of god, and more specifically, a white, male son (Lisa) of god (Nana-Buluku), not unlike Jesus.

Like any good evangelist, Felipe made accessible the new religion by relating it to something already known and understood. For Felipe to have acquired such a profound yet subtle understanding of how his two religious systems were able to coexist without conflict is a testament to the adaptable unfinishedness of Vodun recorded centuries ago. The association of the white, male son of the Almighty Christian God through comparison to the white, male son of the Almighty Vodun God is an early example of what was to later proliferate into now thriving African-based religions found throughout the African Americas in which African gods are evoked and maintained through commonalities with Catholic saints.[10] Not only is it significant that the religious system of Vodun as a whole is represented in writing at such an early date, but it is also remarkable that an aspect (Lisa) of the supreme creator deity (Mawu-Lisa) is clearly identified and used in such an early Catholic-Vodun understanding.

Another important result of the *Doctrina Christiana* is that it proves that the Lisa Vodun existed in Bénin by at least 1658, and had most likely been around much longer. For Dahomean kings, the importation of "foreign" Vodun through warfare was a claim to fame. Queen Hwanjile, the wife of Abomey

King Agaja (1708–1732) and mother of his son and successor King Tegbesu (1732–1774), is credited in royal histories with bringing Lisa and other "foreign" gods into the Dahomean Vodun pantheon. Yet the multiple references to the Vodun Lisa as Jesus in the *Doctrina Christiana* in 1658 suggest that Hwanjile did not introduce this Vodun into the Dahomean kingdom, but that it existed in this region well before she did.

What's in a Word: Vodun Etymologies

Guided by Felipe and Antonio, the Capuchin translation of *vodu* as things "godly" or "sacred" is accurate. It is a very discerning transcultural translation which, some 350 years later, still captures quite scrupulously the "essence" of Vodun. Nonetheless, etymological explanations of the word Vodun testify to the inventiveness and unfinished nature of oral language arts.

Other authors have attempted to capture the "essence" of Vodun. Bernard Maupoil ([1943] 1988, 54), who worked as a colonial administrator in Afrique Occidentale Française, describes Vodun as "that which is mysterious for everyone, independent of the time and place." Indeed, this very "mysteriousness" is the basis of the ongoing inability "to define" Vodun. Le Herissé (1911, 96) explains Vodun as "all manifestations of power that cannot be defined," a phrase echoed by Melville Herskovits ([1937] 1967, 1:143) as "all manifestations that one cannot define," and by author of the Fon-French dictionary, R. P. B. Segurola (1963, 552), as "manifestations of forces that cannot be defined." That which cannot be defined remains unfinished.

Segurola (1963) asserts that the etymological roots of Vodun have been lost, but scholars have suggested a range of etymological interpretations, more recently by Suzanne Blier (1995). Two diviners with whom Blier worked in Abomey translated *vo* as "to rest" or "to relax," and *dun* as "to draw water." Thus the two syllables together, *vodun*, she reads as "to rest to draw the water." Based on the exegeses of these two diviners concerning what "resting to draw the water" signifies in Fon philosophical thought, Blier summarizes as follows:

> The essence of Vodun . . . lies in the need for one to be calm and composed. One must take time to sit quietly rather than rush through life. When women go to the spring or river to draw the daily water, they rest for a moment on the bank before filling their container. . . . Within the concept of Vodun there rests a deep-seated commitment to certain forms of human conduct in life. In this translation [of Vodun] we are made to understand in an ideal sense what it means to be human and how one's life should be lived. . . . Vodun constitutes a philosophy which places a primacy on patience, calmness,

respect, and order both in the context of acquiring life's basic necessities and in the pursuit of those extra benefits which make life at once full and pleasurable. (39–40)

Bernard Maupoil (1988, 53) suggests the following. Vodun, he was told by an elder informant in Abomey, means "things that are unknowable." Corresponding with that definition, he divides the word into its constituent parts, then interprets them accordingly: *vo*, he writes, means things "imperceptible" or "unseizable," and *du* is based on the nasalized exclamation "hu[n]," which one is said to emit after admitting defeat. Vodun, to Maupoil, then signifies "we have thought a long time, at our most profound level, we have meditated on the causes, on our origin, on the mystery of the creation of life, but unable to understand, we have cried hu[n]! this goes beyond us" (54). Although attesting to Vodun's unfinished inexplicability, this definition is one which Maupoil admits is not very convincing.

Another possible etymological interpretation of Vodun was offered to Blier (1995, 39) by Michel Bagbonon of Bohicon, a town near Abomey. He explains that *dun* comes from the *du* signs used in Fa divination, alluding to origins with the Yoruba Ifa, and that *vo* [vɔ] comes from the Fon word for ritual offerings (sacrifice), which are always prescribed and carried out in accordance with a particular *du* sign. Blier finds the interpretation of *du*, as derived from Afa or Fa divination, problematic "for it suggests that the Evhe [Fon] term *du* ultimately derives from the Yoruba word for divination signs, *odu*."

I collected similar interpretations from talking with diviners, Vodun chiefs, and friends. They invariably related the word Vodun to the individual terms and concepts encompassed in Fa, *vo* and *du*. Most often, they said that the second syllable of the word Vodun came directly from the Yoruba word *odu*, and that *du* was related invariably to the will of Fa. At first, I was bothered, like Blier, with the Yorubaness of this explanation, but then realized I needed to look at the potential of this idea as quite possible given the long history of Fon-Yoruba interconnectedness in this area (see Chapter 3).

Even if the *dun* in Vodun had never been related to the Yoruba *odu*, it is now. This is a very important consideration along coastal Bénin, an area with a long history of responsiveness to outside influences and an openness to perpetual change in the form of unfinishedness. Rather than being constrained by imaginary ethnic boundaries, we must erase these lines and open our eyes to the unending possibilities of centuries of interethnic interactions, and thus look discerningly at how this ongoing, centuries-strong phenomenon plays out in language, art, and culture. The potentially diverse origins of words, gods, arts, ceremonies, etc., must be acknowledged in that oral language arts have the same capacity to transform and change as do visual and other forms of art.

Another Etymology: Yɛhwe Vodun

Although many thought-provoking etymologies of Vodun have been suggested in the literature, I have yet to read an etymological interpretation that satisfactorily takes into account the complex history of this area. For that reason, I am compelled to put forth another etymology, constructed of concepts that have not been proposed in the literature on Vodun, as well as concepts that echo and overlap other interpretations. What I offer is meant to suggest another way of thinking about origins of the word Vodun, but is not necessarily any more "satisfying" than previous suggestions. I consider the following an "etymological possibility," not a definition.

As I was learning the Fon language, every time I heard the word Vodun in conversations and interviews, I did not pay close enough attention to the other words surrounding it. It was only after my language skills improved that I started discerning, more and more often, another word said either in conjunction with the word Vodun, or replacing it. The word I kept hearing was Yɛhwe.[11] It appears that within Vodun circles, Yɛhwe is synonymous with Vodun, but there is also a conscious Christian usage. At some point after the writing of the *Doctrina Christiana*, it seems that the apostolic context of the word Yɛhwe was severed—at least in evangelical thought, if not in actuality—from Yɛhwe-Vodun, thus leaving Vodun on its own in reference to the non-Christian spirit world, and Yɛhwe in the realm of the church. When I would ask, "What is Yɛhwe?" I was invariably told Vodun or *esprit* (spirit). I soon recognized that I was once again mired in the obvious: Yɛhwe is Vodun is Yɛhwe is Vodun. Nonetheless, I continued my line of questioning.

In March 1996, I met a Beninese man from Possotome (southwestern Bénin) named François Houssou. He was educated in France and had traveled extensively but felt strongly that his years of international education and experience could be put to best use at home. He had a tenacious interest in and extensive knowledge of Vodun culture. We had many interesting conversations, including one about Yɛhwe-Vodun.

He explained that Yɛhwe-Vodun, Yɛhwe, and Vodun are the same thing, but nowadays people tend just to say Vodun, but that Yɛhwe is "everything." I asked him what he meant by "everything." He said, "*Yɛ* is darkness. *Hwe* is sunlight." He continued with the dialectic logic that "everything" exists in either sunlight or darkness, day or night, Mawu or Lisa, the sun or the moon, male or female, and that the world as we know it could not exist without one and the other.

Mr. Houssou's French interpretation of Vodun is as follows. *Vo* represents "*ce que on a*" (that which one possesses), and *dun* are "*les règles on doit suivre*" (the rules one must follow). Thus, *vɔ* offerings represent the power one has in dealing with all circumstances, ideas, thoughts, actions,

and possibilities in things spiritual, physical, and metaphysical. That is, one has the power to use and/or give anything/everything one has (in *vɔ*, or offerings) in order to make the best of the lot one has been given in life. *Dun*, as the rules one must follow, represent the structure that lends some order to the overwhelming nature of the vastness of what one has. He related *dun* to *odu*, from the Yoruba, which he said orders and articulates all possibilities [*ce que on a*] into a science [*les règles on doit suivre*]. Vodun, he explained "permits a social order without contestation." Thus, Yɛhwe-Vodun, to him, means taking "everything" and making some sense of it. He is, however, the first to admit that this is his way of looking at it. Mr. Houssou asserts his "right" to manipulate his definition of Vodun in order to provide a personal understanding based on his own needs. This means that if his needs change he will be able to adjust his usage to meet the situations that arise. His use of etymology is similar to the way Vodun arts are used in confronting the ever-changing circumstances that arise especially in that he used *vo* and *vɔ* interchangeably.

Segurola (1963, 616) translates Yɛhwe as "spirit" or "prayer." When Yɛhwe is broken down into its two syllables, it becomes more revealing. Segurola translates *ye* as "shadow, shade, the double of someone, spirit; *ye* indicates the spiritual, immaterial and sacred; it has a notion of mystery; *ye* localizes itself and animates material beings (trees, termite mounds, animals, rivers). Belief in *ye* is the base of animism" (614).

Segurola's (1963, 614) second definition of *ye* is "the yellow or saffron colored vegetal powder coming from the 'sotin' tree which has been gnawed upon by insects and it [this powder] is used in Fa consultation. It is on the *ye* that one inscribes the signs of Fa."

Blier (1995, 191) discusses *ye* as "an ephemeral spirit component . . . which reflects the part of one's persona that both precedes one and succeeds one after life is over. . . . *ye* is the vitality or force given by god to make one's life unique; *ye* is the spiritual essence that serves to connect each person to his or her family past, present and future."

Blier (1995, 192) goes on to describe *ye* as the mirror image of a person, or a shadow. She notes that according to the Beninese scholar, Basile Toussaint Kossou (1983), the characteristics of both light and shade associated with *ye* are of great importance: "All creatures have a shadow-like *ye* . . . the unseizable form of the object projected on the ground when the object is in light (quoted in Blier 1995, 403n44).

Another Beninese scholar, Georges Guedou (1985), also stresses the importance of *ye* in terms of its shadow:

> All beings created by Mawu must have a shadow, *yɛ*, which is the reflection
> of its body. This reflection is a reduced world, a projection of their being.

> The word *yɛ* . . . means the shadow projected from the body. It is created by
> light. The Fon believe that an opaque body in the universe of light absorbs
> a part of this light and leaves to the side a projection of this being. It is the
> shadow that follows one all over. This shadow thus is but the reflection of
> the being. That is why we translate the term as shadow-reflection. (quoted in
> Blier 1995, 403n44)

As echoed by anthropologist Guérin Montilus (1972), "Where there is
sun we see the *yɛ* behind us" (quoted in Blier 1995, 192). The word for sun/
sunlight in Fon is *hwe*, as directly translated in Segurola (1963, 238). As Mr.
Houssou noted, the fact that *yɛ* and its shadow are wholly dependent upon
the sun, and that one cannot exist without the other, becomes even more tell-
ing when thinking about the word Vodun. The complementarity of this idea—
shadow as the result of sun—makes Yɛhwe (literally shadow-sun) as a whole
word encompassing "everything" (sunlight/darkness; day/night; Mawu/Lisa;
sun/moon; male/female etc.) quite revealing as a synonym for Vodun.

In the article "Le Yehwe Dan-Toxosu chez les Saxué du Sud-Ouest
Bénin," Fathers Rogatien Madokpon and Olivier Guiassou (1985, 24–25)
explain in their first footnote that instead of using the term Vodun, they "prefer
the term '*YƐHUE*' used by the Saxué of southwestern Bénin to mean the same
thing."[12] They identify the spirit of Dan Anyidohuedo as the "Yɛhue of the
rainbow," Xɛvioso as the "Yɛhue of thunder," Sakpata as the "Yɛhue of small-
pox," and Ogu as the "Yɛhue of metals," and they continue with other exam-
ples of various "Yɛhue." The general term they use for devotees of any Yɛhwe
is "Yɛhuesi," meaning wife of Yɛhwe, just as "Vodunsi" is the common term
for a Vodun adept, or "wife of Vodun." Other than in the first footnote, the
word "Vodun" is not used in the entire article, though the whole issue is on
what most people would call Vodun. Although it is certain that Saxué peo-
ples know the term Vodun, the fact that the authors employ the less commonly
used local term, not the popular term, is revealing.

It is also worth noting a wall mural in a Vodun compound (fig. 2.1). Here,
Ogu, the Yoruba appellation of Gu, the Vodun of iron, warfare, and technol-
ogy, is holding the symbol of Xɛvioso, the fire-spitting ram, and the spirit
responsible for thunder, lightning and catching thieves. However, Ogu is
referred to as Yɔhwe [Yɛhwe], rather than Vodun.

Herskovits ([1938] 1967, 2:192) pulls examples from earlier sources that
strengthen the assertion that Yɛhwe and Vodun are synonymous. He writes,
"Yɛhwe . . . was a synonym for *vodu* . . . Certainly when the Dahomean uses
the term yɛhwe in everyday parlance, his essential meaning is of *vodu*. Both
priests and laity were emphatic on this point; so emphatic, indeed, and so
explicit that there can be no room for doubt." He surmises that the term Yɛhwe

is used more commonly in Togo based on discussions in pidgin English he had with some Togolese people living in Abomey: "Yɛhwe and *vodu* be the same thing. . . . Yɛhwe *vodu* be one name. . . . Yɛhweno be the same like Voduno. . . . Yɛhwe *vodu* be no different inside" (192). He then summarizes Yɛhwe: "And as for the Dahomean yɛhwe, it cannot be regarded as anything other than what it is, namely, an inclusive term for the gods, the deified ancestors and the creatures of the forest who give magic to men" (194).

Yɛhwe is also used in various contexts outside the realm of Vodun. It seems that most often, in texts within the context of the church the word for god is most commonly translated in Fon (and Mina and Ewe) as Yɛhwe. In historian Casimir Agbo's (1959, 223–24) *Histoire de Ouidah du XVI au XX Siècle*, the word Yɛhwe is used in prayers with various interpretations. In a praise song for the Oliveira family, the sixth line reads "*Yɛhué mo do mo do,*" which literally gives praise to "the spirit who trails." At the Tercentennial of the Church of the Immaculate Conception in Ouidah (1648–1948), Mr. Agbo recorded a sung litany which includes the line: "*Mi bo ha Yɛhué nou Maria,*" "Let us pray for [our divinity] Maria" (98).

It was these two findings that made me think more critically about the context of the usage of the word Yɛhwe. Vodun chiefs said that Yɛhwe and Vodun are synonymous, yet Yɛhwe seems to be used readily by Catholic families and the Catholic Church. There must be a reason that the words Yɛhwe and Vodun, once together, have now split apart.

Christian usage of Yɛhwe was noted in the mid-nineteenth century by Richard Burton ([1864] 1966, 89–90). "The Fon name for the deity is Mau. The Roman Catholic missioners have preferred to call themselves Mau-no or Mau-mother, as opposed to Vodun-no or fetish priest. . . . The Fanti or Wesleyan missionaries . . . prefer yewhe, or Ji-wule-ye-whe."

In Segurola (1963), *Yɛhwenon* is translated as the "Father" or "Priest." Thus Father is translated literally as the "owner of, the one with or responsible for" (-*non*) Yɛhwe. Under the same heading in Segurola's dictionary is *Yɛhwenon le xosu* (the glorified one with Yɛhwe) meaning the Pope; *Yɛhwenon daxo* (the big one with Yɛhwe) as the Father Superior; *Yɛhwenon gan* (the chief with Yɛhwe) for Bishop; and *Yɛhwenon hwe* (the house of the one with Yɛhwe) for Mission. The next entry, *Yɛhwesin* (water of Yɛhwe), is translated as Holy Water, baptismal water; *le Yɛhwesin* is the verb to baptize; and *Yɛhwesinlile* (the bath of the water of Yɛhwe) is baptism. *Yɛhwexo* (room of Yɛhwe) is church; *Yɛhwexo daxo* (big room of Yɛhwe) is Cathedral; and *Yɛhwexo kpevi* (small room of Yɛhwe) is chapel. *Yɛhwexixa* (lecture from Yɛhwe) is a prayer (616; with my translations from Fon to English in parentheses).

At the house of Supreme Chief of Vodun in Bénin, Daagbo Hounon Houna, there was a standing joke. On Sundays, when a guest arrived and

asked about Daagbo's location, the response was invariably, "*E yi Yɛhwenon hwe*," which means "he has gone to church," or literally "he has gone to the house of the owner of Yɛhwe." The deliberate ambiguity and play on the idea of the Supreme Chief of Vodun attending Catholic Mass brought laughter to everyone, especially because Daagbo was most likely at home.

Aspects of the terms Yɛhwe-Vodun, Yɛhwe, and Vodun in West Africa exist to this day in Haiti, where Yɛhwe is also a name used for spirit or god in Vodou.[13] The cross-over and fluidity of these terms merit further investigation. As for the Haitian word Vodou itself, it most likely comes from the Fon word, Vodun, but Donald Cosentino (1987, 274n1) notes that "a more imaginative folk etymology was offered to [him] by the houngan Santiague Legrand: the religion and its name were derived from the worship of the Golden Calf (Veau d'Or) by the Israelites at Mt. Sinai." Cosentino rightly suspects intervention of Christian missionary doings in the proposed genesis of a Vodou service from the biblical worship of the Veau d'Or. In Bénin, I was offered, only once, the same etymology of Vodun coming from the same quasi-homonym Veau d'Or. Edna Bay was also offered the same Veau d'Or explanation in Bénin more than once.[14]

Vodun Undefined

An operable understanding of Vodun is based on the acceptance that, in order to make sense of Vodun, one must acknowledge that it cannot be fully made sense of. Recognizing its nonlinear/conceptual space and its indefinability in terms of its epistemology, classifications, and etymology leads back to *agbé-gbé* and rhizome as metaphors for conceptualizing and visualizing the complexities of Vodun. The nature of Vodun, its rhizomatic "stems"—open-ended and unfinished—and its predilections for incorporating foreign elements set the foundations for the following chapters.

CHAPTER **3**

Foreign Presence
in Local Vodun

Over five hundred years of international cultural interchange not only
demonstrate Vodun's ability to function within a global milieu, but also
suggest the necessity of global encounters for its survival. Vodun has
welcomed into its artistic and cultural vocabularies ideas, images, and be-
liefs from Europe, Brazil, and elsewhere, beginning with those linked to the
arrival of the first Europeans in Ouidah from Portugal in the sixteenth cen-
tury and extending to those emerging from a variety of commercial sources in
later centuries, such as mass-produced chromolithographs and other imported
goods (see Chapter 4). The influence on local Vodun of non-local African
peoples, systems of thought, iconographies, and languages is also evident. As
early as the eighteenth century, a Yoruba presence developed in Ouidah and
it continues to play a role in local culture. The market for the "exotic" has
brought in another foreign component: that of the tourist, who has also af-
fected both Vodun and Yoruba cultural production. Thron and Attingali Vodun
complexes, whose origins are in northern Ghana, represent another example
of the foreign-turned-local.

The European and Lusitanic Presence in Ouidah

The first Europeans to have arrived in this coastal area were probably
Portuguese, for it is known that explorers João de Santarem and Pedro de
Escobar were the first Portuguese to have traveled along the coast of what is
now Ghana from 1471 to 1473. In the same region, explorer Diego Azambuja

founded the first Portuguese fort, San Jorge del Mina, on January 20, 1482. After 1530, the slave trade began to spread eastward along the coast from modern Togo into Bénin, which soon became a highly valued area because of the abundance of slaves available there for purchase. It seems, however, that there had already been European trafficking for a while in the Popo area of western coastal Bénin before the first contact in the region of Ouidah (Cornevin 1962, 239). Most historians believe that initial European contact along the Ouidah coast could not have been earlier than the 1580s (Assogba 1990, 8), but according to local Ouidah history, it is said to have taken place more than 30 years before, in 1548, between a man named Kpate and a Portuguese captain. The earlier proposed date of this Luso-African encounter has particular spiritual importance, as I will discuss shortly.

Commercial relations with European traders became established in Ouidah during the seventeenth century, with the Dutch, French, and British all building forts to facilitate their roles in the slave trade.[1] The Portuguese followed suit with their own fort in Ouidah in the early eighteenth century.

Local tradition also speaks of a Danish fort though its existence is not certain. The idea of such a fort may have arisen from an eighteenth-century account that inaccurately mentioned the Dutch fort (Law 2004, 35). The Danish fort, if it existed, was located very close to the Zobe market in central Ouidah, and the Dutch fort was in the Sogbaji quarter close by (Sinou and Agbo 1995, 148; Assogba 1990, 26). The French fort of Saint-Louis de Gregoy was built in 1671, in what is currently the central area of Ouidah. In deteriorating condition by 1892, the fort was abandoned in 1908 and then completely destroyed (Assogba 1990, 26; Sinou and Agbo 1995, 93–96). Detailed plans of the fort have been conserved in the National Archives of France, and a miniature model of it is currently on display in the History Museum of Ouidah. A few hundred meters from the French fort was Fort William, built by the English in 1682. It was active until the early 1780s, and by 1800 its activity was greatly reduced due to the growing competition with the French and the Portuguese. Abandoned in 1807, the fort was sold a few years later to the German company Goedelt, which dealt in palm oil trade. Today nothing remains of the English fort (Assogba 1990, 26; Sinou and Agbo 1995, 96).

The only European fort in Ouidah that remains standing is the one constructed by the Portuguese in 1721 under the supervision of a Bahian captain, Joseph de Torres. It was first named Forteresse Césarienne Notre Dame de la Déliverance but ultimately became known as Fort Saint Jean-Baptiste d'Ajuda. Locally it is called Agudanhwé, which translates from the Fon language as "the house of the Portuguese" (*Aguda* = Portuguese, *hwé* = house).

In the middle eighteenth century, the fort was slipping into ruins (Sinou and Agbo 1995, 96–98).

In the years following its takeover in 1788 by the Brazilian born slave-trader Don Francisco Félix "Cha Cha" de Souza, the fort became strong again, due in part to de Souza's role in the slaving monopoly from the Ouidah port. After living in the fort for a few years, de Souza left Ouidah to expand his influence into other slaving prospects along this coastal area. Upon his return to the city in 1818 he re-established himself in another Ouidah location, collaborating closely with the Dahomean king, Gezo, in Ouidah's slaving operations. The Portuguese fort was totally abandoned at this time (Sinou and Agbo 1995, 97).

On April 18, 1861, newly arrived European missionaries turned the Portuguese fort into a Catholic mission founded by Father Borghero from Italy and Father Fernandez from Spain. In 1862 the first Catholic school in the Dahomey Kingdom opened, followed in 1866 by the first formal baptisms in Ouidah. Because of all of the religious activities in the fort, Ouidah became known as "The Door of Christian Faith." The missionaries restored the church in the fort, but other buildings were destroyed by lightning, and finally the priests moved out (Assogba 1990, 11).

In 1865, the Portuguese authorities again took possession of the fort, and it became an exclusive enclave of Portugal until 1960, when it was forcibly annexed by the Beninese government. As the Portuguese left Bénin, they burned down their "little Portugal"—their fort—destroying as well close to 240 years' worth of documents that were housed inside (V. Quenum 1982, 13). The battered, two-story structure of the fort remained as such until the end of the 1960s when the Beninese government restored and transformed it into a history museum. The History Museum of Ouidah opened officially on September 6, 1967 (Assogba 1990, 12).

In 1984, a group of Portuguese engineers proposed to restore the fort-turned-museum, this time with plans to reconstruct buildings no longer extant. Their reconstruction was based on building layouts from 1890 preserved in France. The new plans also included an open-air theater to bring more people to the museum for cultural events and festivals. Though based on original building plans, the fort and the other buildings, reconstructed with durable materials such as cement breeze-block and tiles, were rebuilt to last. The project was completed in 1990, and the museum was reinstalled and re-opened to the public (Sinou and Agbo1995, 98).

The History Museum, also known now as the "Voodoo Museum," contains a diverse array of displays. A tour of the museum begins on the second floor of the rebuilt Portuguese fort where one finds, among other things,

information concerning the fort's history, enlarged maps of Africa, and objects from the slave trade (chains, cuffs, shackles, etc.). Upon descent to the first floor one finds photographs documenting the influences of Bénin in Haiti, Cuba, and Brazil; most of these photographs are enlarged reproductions of work by the late French photographer, ethnographer, and *babalawo* (Yoruba Ifa priest) Pierre Fatumbi Verger (1902–1996).[2] There are Beninese Vodun objects on display, and there is a section dedicated to the history and material culture of the Afro-Brazilian populations of Bénin. In a side room there are two large appliqués; one illustrates the history of the Ouidah coast, and the other is composed of Fon proverbs. The chapel, located in the courtyard outside the fort, houses temporary exhibitions. Behind this courtyard is a large area where slaves were once held before being shipped to the Caribbean and the Americas. Now, this area is transformed into a souvenir boutique, a bookstore, and an artisanal center where artists make appliqués and weavings for sale to museum visitors.

The history of the Portuguese fort-turned-History/"Voodoo" Museum, as well as those of the other forts, shows how Ouidah had, early on, become a representative microcosm of Europe, superimposed on an already established intra-African presence which informed and continues to inform Ouidah's ongoing intercultural dialog. This openness to outside intercultural influences is a particularly noteworthy characteristic of Ouidah Vodun. African-Portuguese-Brazilian Vodun assemblages in Ouidah, for example, demonstrate the impact of global encounters within local religious art and expression. Vodun's welcoming, all-embracing character is what turned a sixteenth century chance meeting at the Ouidah beach into a revered centuries-strong Vodun. Over two hundred years later a not-so-fortuitous relationship between a Brazilian slave trader and a Dahomey king exemplifies how Vodun's open-endedness toward the new and the foreign can bridge religions and oceans within the local Vodun.

Kpate: Fisherman-turned-Vodun

Local Ouidah history has it that in 1548, under the reign of King Kpasse, a fisherman named Kpate was crab-hunting at the beach in Ouidah with his friend Zigbo. They noticed a large floating vessel at sea. Kpate, already having known Europeans from Popo, took off his raffia loin cloth, tied it to his walking stick, and flagged down the boat. Seeing Kpate's sign, the captain of the boat sent some men to the beach where Kpate greeted them. Zigbo, however, ran off screaming *Zo-je-age* (*zo* = fire, red; *je* = to arrive; *age* = shore), "the fire has arrived on the shore." As *zo* also means "red" in Fon, this

statement makes a direct allusion to the red skin (fire) of the newly arrived Portuguese. Or as historian Casmir Agbo (1959, 17) would have it, *zo-dja-gué* means "luminous beings have arisen from the ocean; lively and brilliant like fire."[3] The encounter was painted on a wall near Kpate's house in the 1990s, but has since been painted over (fig. 3.1).

Kpate invited the Portuguese visitors to his house where he offered them freshly squeezed orange juice, a hot meal, and a place to sleep. A few days later, he took them back to the beach, and they returned to Europe. Kpate died soon thereafter. Some years later the Portuguese ship captain returned to the Ouidah coast, bearing presents for Kpate in thanks for his warm reception a few years earlier. He learned of Kpate's death, and in the fisherman's memory he gave the gifts to the current head of the Kpate family. The gifts consisted of plates, glasses, pipes, beads, assorted cloths, a cane, a hat, and other objects, many of which the Kpate family still possess (fig. 3.2).[4]

This Portuguese-Beninese encounter, the Portuguese follow-up visit, and the gift giving had a profound and lasting impact on Ouidah Vodun. Originally, the ceremony conducted each December in Ouidah to mark the beginning of the Vodun season and to honor all of the Vodun of the city had been under the auspices of the sacred python Dangbe, the founding Vodun and protector of the city. But after the Kpate-Portuguese encounter, the Dangbe Vodun refused to be the first honored and insisted that Kpate assume that honor. Kpate was thus deified and became known as the Vodun of the first encounter between the Beninese and the Portuguese. The Vodun name of the head of the Kpate family has since become Kpatenon—that is, "owner of" or "the one responsible for" the spirit of Kpate, his deified ancestor—and the captain's gifts have since become sacred objects. The ceremony begins with all family members and guests in attendance drinking orange juice in commemoration of the drink that Kpate served his newly arrived Portuguese guests centuries ago. Orange juice is also offered to the earth, a pig is killed, and other sacrifices are made. Next, the sacred objects are marched through town to bless the whole city (fig. 3.3), after which the Vodun season in Ouidah officially begins.

The Kpate-Portuguese encounter itself, as shown in Figure 3.1, has been misinterpreted in a relatively recent writing. In the essay "In Memory of the Slaves: An African View of the Diaspora in the Americas," author Peter Sutherland (1999, 203) reproduces this very same public painting, but mis-captions it as a "street mural . . . showing slaving encounter on Whydah beach." Without having the local knowledge of Kpate's friendly encounter with the Portuguese, one could easily misread Zigbo's open-mouthed, wide-eyed running leap out of the mural frame and associate it with a more

common knowledge of Ouidah's later collaboration with the Portuguese in the overseas trade.

De Souza's Dagoun

Down the block and around the corner from Kpate's house is the de Souza compound. Don Francisco "Cha Cha" de Souza has become somewhat of a mythical personage in Ouidah history.[5] He was the inspiration for English writer Bruce Chatwin's (1980) book *The Viceroy of Ouidah*,[6] and cinematographer Werner Herzog used elements from Chatwin's book in his film *Cobra Verde*.

A mixture of Portuguese and Amerindian parentage, de Souza was born in Brazil in 1754 and died in Ouidah, Bénin, in 1849 (fig. 3.4). His involvement in the transatlantic slave trade began with his arrival in Ouidah in 1788 and spread east to Badagry (Nigeria), and west to Aneho (Togo). Once well established in coastal slaving networks, de Souza had a major disagreement with Dahomean King Adandozan (ruled from 1797–1818) concerning trade from the Ouidah port, which resulted in de Souza's incarceration. It was Adandozan's imminent successor, Gankpé, who helped de Souza escape to Aneho, where his compound still remains. From there de Souza helped Gankpé overthrow Adandozan, resulting in Gankpé's coronation as King Gezo who ruled the Dahomean kingdom from 1818–1858. Gezo appointed de Souza as Viceroy of Ouidah, and they worked very closely in the continued monopoly of the slave trade from the Ouidah port. At the height of his involvement in the slave trade, de Souza is said to have supplied hundreds of slave ships traveling between the west coast of Africa and the Americas (Law 2004, 165–72).

Although de Souza was a very well-established, respected, and feared man during his tenure as Viceroy of Ouidah, he suffered great personal misfortune: his children died, his wives fought, and his problems were so serious that he turned to his close friend and business partner King Gezo. According to local legend, the king said that de Souza's misfortune was the result of not worshipping Vodun.[7] De Souza explained that he was a devout Catholic and could not worship Vodun. Together, de Souza and Gezo found a solution in which Catholicism and Vodun need not be mutually exclusive.

King Gezo offered his friend the Vodun Dan Aida Wedo, the rainbow serpent, to bring de Souza and his family health, wealth, and happiness. King Gezo and de Souza decided to install the Vodun not in the de Souza house proper, but down the block, and to appoint a Vodun chief to maintain the Vodun for the de Souza family. In accordance with this plan, de Souza could still uphold a Catholic household and lifestyle while at the same time securing the protection of a Vodun to watch over him and his family. The rainbow

serpent reminded de Souza of the fire-breathing dragon in European folklore. He thus called his Vodun "Dagoun" (fig. 3.5).

Had Vodun been a rigidly closed religious system, open only to the established tradition, this consolidation would have been impossible. This story exemplifies the process in which a new Vodun is formed through the superimposition of foreign folklore on an existing Vodun. The original power of the Vodun is there, but it has been added to, it is accumulating, and it remains by necessity open-ended and unfinished.

I heard many slight variations of this story, but in an interview with Dagounon, the currently appointed Vodun chief of the de Souza Vodun, I learned of a different, much more "mythical" account of Dagoun's origins. Dagounon's story alleges that de Souza brought both a male and a female snake with him from Brazil and took them with him wherever he traveled. These serpents protected him and represented his powers. One day de Souza's snakes died and were buried in the bush near the de Souza compound. Three days later a termite mound appeared where the snakes had been buried. De Souza ordered the termite mound destroyed. Three days later another termite mound appeared. This continued until de Souza finally asked King Gezo about this strange, ongoing occurrence. Although Gezo undoubtedly knew that a termite mound in Bénin invariably represents the Vodun Dan Aida Wedo, he came immediately to Ouidah from Abomey with his diviners to perform a consultation for his friend. It was learned through divination that de Souza's snakes were indeed no simple snakes: They were sacred Vodun snakes and must be venerated. A temple, called Dagounhwé (the house of Dagoun), was built where the first termite mound appeared and has been maintained ever since. According to Dagounon, it was these snakes that gave de Souza his power and wealth, and the name Dagoun is simply what de Souza called his Vodun.

In a similar story, family historian Simone de Souza (1992, 99–101) asserts that when de Souza arrived in Ouidah from Brazil, he wore a gold ring in the shape of a serpent with big diamond eyes. People in Ouidah are said to have wondered if the ring was simply a piece of jewelry or if it was, in fact, a symbol of a Brazilian Vodun. They immediately related his rare and expensive serpent ring to the fortune that could be brought by the Ouidah rainbow serpent Vodun Dan Aida Wedo. Thus Dan Aida Wedo became the Vodun associated with de Souza.[8]

It is, in part, de Souza's current quasi-mythic status that allows for these interesting variations on the origins of his Dagoun Vodun. The variation in stories is consistent with the indeterminacy and openness to change and adaptation inherent in Vodun. In these stories of the genesis of de Souza's Dagoun,

the Vodun itself represents a mixture of the local rainbow serpent, Dan Aida Wedo, with the European folkloric dragon, or the mystical Brazilian snakes, or the gold and diamond serpent ring, resulting in the Afro-Euro-Brazilian Dagoun Vodun of the rainbow serpent found only in Ouidah.

De Souza's International Bouriyan

The coronation of Honoré Feliciano Juliao de Souza, the eighth head of the family, was held in Ouidah in September 1995, for which de Souzas came from all over West Africa, Europe, and Brazil. Cloth was commissioned with Cha Cha I's image on it, to be purchased, tailored, and then worn at the event by family members and friends. An Afro-Brazilian carnivalesque festival, the Bouriyan—with likely origins in eighteenth-century Brazilian masquerade traditions known as *Bomba meu Boi* (Bomba, my ox) and *Burrinha* (little donkey)—was performed. During the performance a whole international cast of figures derived from history and pop culture—including King Tut, Zorro, Sylvester the cartoon cat, George Bush, Jacques Chirac, and various other characters, human and animal, who typically make an appearance in the Bouriyan—came out and danced for the family and guests.[9] Although Vodun is said to be kept out of the de Souza house, the de Souza Bouriyan proved otherwise. With Samba music kicking in and the chorus singing to her in the Yoruba language, Mami Wata, the spirit-cum-seductress also known as Mamiyata, made her appearance.

> *Mami on kpéé o* (Mami we are calling you)
> *Mami Wata kowale* (Mami Wata come to the house)
> *Kowa charé o* (Come and have fun) (Souza 1992, 94)

This incarnation of a Vodun spirit appeared in the Catholic de Souza compound sporting the hottest, newest cloth in Ouidah, with de Souza's image all over it, and was greeted, welcomed, and celebrated in Yoruba. She wore lots of jewelry and held up in her hands two large stuffed pythons wrapped around her waist. This Mami Wata masquerade, snakes and all, is derived directly from a late nineteenth century chromolithograph of a likely Samoan snake charmer in a German circus, currently known as a "photograph" of Mami Wata (Drewal 1988, 1996; Salmons 1977).

While Bouriyan is not, according to the de Souza family, associated with Vodun, Catholic de Souza family's masquerade was part of a big Vodun festival at the beach in Ouidah. All of the typical Bouriyan characters mentioned previously were present, but the two Mami Wata masquerades were a bit

different. The first one was once again influenced by the famous nineteenth century chromolithograph of a Samoan snake charmer, though she had long blond hair and was sporting sunglasses (fig. 3.6). The second one was a mix based on the chromolithograph of the Samoan snake charmer and a chromolithograph of the three-headed Hindu god Dattatreya, known in Hinduism as the "triple giver" (fig. 3.7). Thus, this ever-transforming "de Souza-Bouriyan-Mami Wata-assemblage" is of Indian and potentially Samoan influence incarnated in an Afro-Brazilian Vodun spirit. It is, in short, a mélange of the sort that exemplifies Vodun's incorporative sensibilities. I detail the importance of the Indian chromolithographs, which have come to be known respectively as Mami Wata and her husband Densu, in Chapter 4 (see figs. 4.1 and 4.14).

Intra-African Impact upon Vodun

Not only did foreigners arriving in coastal Bénin from Europe and Brazil impact local Vodun, but so did non-local African peoples, systems of thought, iconographies, and languages. Yoruba peoples, for example, have been present in Fon locales for centuries and have made an enduring impression, as have the Thron and Attingali Vodun complexes whose origins are in northern Ghana. Within Vodun, this synergy of local and distant African thought is possible only because of Vodun's ongoing readiness to welcome, embrace, and celebrate the new.

Fon-Yoruba Interconnectedness

It is only through an understanding of the intellectual, political, and religious climate surrounding Fon-Yoruba interconnectedness that an appreciation of their interconnected arts can evolve.[10] Yoruba scholar Olabiyi Babalola Yai (1994, 109) could not have expressed the idea better: "The intellectual climate of the region [Yorubaland and surrounding areas] was and still is largely characterized by a dialogic ethos, a constant pursuit to exchange ideas, experience, and material culture." A similarly "dialogic ethos," and/or synthesis, exists along coastal Bénin within Yoruba religious art and language. Spiritually associated elements of Yoruba culture are identified as "Nago Vodun." Nago is the most common Fon word for local Yoruba people, yet Nago Vodun are conceptualized as "foreign." Ayonu is also in common usage for a Yoruba person, or "person from Oyo" with Ayo being a modification of the Oyo Kingdom and *nu* designating a person. Nagogbe and Ayonugbe are local words for the Yoruba language, *gbe* meaning language.

Early Synthesis: The Ulm Divination Tray

The most important piece of art to be connected to Bénin is quite possibly the Ulm divination tray (see Bassani 1994, 78 fig. 5.1).[11] All of the circumstances surrounding its highly unusual biography—from its commission and creation to its subsequent life-history—are not known in any definitive sense. What is known, however, allows us to understand this divination tray as an example of Fon-Yoruba synthesis in art, language, and religion.

According to art historian Ezio Bassani (1994, 79–89), the divination tray is the oldest wooden carving from sub-Saharan Africa surviving to the present in a European collection. It was part of the famous collection of the wealthy German merchant Christoph Weickmann, which was assembled in the middle of the seventeenth century. In 1659, the *Exoticophylacium Weickmannianum* catalog of this collection described the divination tray as follows:

> An offering board carved in relief with loathsome devilish images, which the
> king of Ardra, who is a vassal of the great king of Benin, together with the
> most important officers and men of the region, use to employ in fetish rituals
> or in sacrifices to their gods. This offering board was given to and used by
> the reigning king of Ardra himself. (Bassani 1994, 80)

As discussed in Chapter 2, the Kingdom of Ardra, known today as Allada, was very influential along coastal Bénin during the seventeenth century, due in part to its integral involvement in the early transatlantic slave trade; it is also known to have had strong commercial and evangelical relations with Europe in the seventeenth century (Labouret and Rivet 1929; Dapper [1686]1989, 303–5). The fact that the Ulm divination tray is found in a European collection during a period of direct European-Beninese interactions is not surprising.

According to Yai (1994, 110), this tray belonged to King Tezifon of Allada.[12] The seventeenth-century catalog description was written around the time that King Tezifon was sending emissaries to Europe for reasons economic and evangelical in nature, one of the results of which was the writing of the invaluable *Doctrina Christiana* in 1658 (Labouret and Rivet 1929). These dates corroborate that it was most likely King Tezifon himself who sent the tray to Europe.

Yai (1994, 111) argues that the king did not send this gift to Europe as a "mere gesture of kindness from an African to a European prince," nor was he "trying to convert his European counterparts to his religion since proselytizing was not a feature of his religion." Yai surmises that:

> Tezifon's gesture was one of diplomatic and cultural reciprocation. As
> European kings sent to West Africa missionaries who were perceived as the

most representative wise men and intellectuals of their respective nations, the king of Allada, in an attempt to establish an equal cultural and political exchange, must have thought of sending to European kings a divination tray that he perceived as the perfect equivalent of the text European missionaries carried with them along the west African coast . . . it was a carved text par excellence. Tezifon, therefore, was engaging the contemporary European elite in a cultural dialog and exchange of texts or discourses. (111)

Yai (1994) points out a Yoruba-Fon formal artistic synthesis. The Ulm divination tray, he notes, creolized the quintessential types of Yoruba and Fon divination trays. Divination trays in Yorubaland tend to be circular, sometimes quadrangular, and less often semi-circular, while the shape found most often among Fon speakers is quadrangular (Maupoil 1988, 184). The Ulm divination tray, Yai writes, "inscribes, so to speak, a circle within a quadrangle" (112). This observation suggests that the artist was either Yoruba or Fon, with a strong knowledge of the other. Many scholars believe that the Ulm divination tray was carved by a Yoruba hand, while others propose that "its style and elements of its iconography suggest it was probably carved by an Adja or Fon artist who was familiar with Yoruba sacred art" (Drewal, Pemberton, Abiodun, and Wardell 1989, 21, fig. 5). According to historian Robin Law (1977, 150–57), Allada was under the control of the Yoruba empire of Oyo during the seventeenth century, the time period during which the Ulm board was commissioned, made, and sent to Europe.

Fon and Yoruba: Interconnected Yet Consciously Separate

For all their interconnectedness, Fon and Yoruba peoples do sustain separate identities grounded in situationally defined politics and evidenced in religious arts and ceremonies. The autonomy of Yoruba diasporic communities in Ouidah is resolutely maintained in a variety of ways: in Yoruba families, the language spoken at home is Yoruba; Yoruba spirits and ancestors such as Gɛlɛdɛ, Oro, Abiku, and Egungun are revered through communication in the Yoruba language; and Yoruba dancing, drumming, singing, and other Yoruba cultural elements have been guarded and preserved for centuries as defined within these very particular ethnic polities of Ouidah.[13]

Yet distinct "Fon" and "Yoruba" identity is a matter of degree, which can vary from place to place, group to group, and person to person. Arts from Fon traditions remain recognizably Fon, and are identified as such, but influences from Yoruba can be discerned within. This also holds true with Yoruba traditions and associated arts: They are identified as discrete and separate from Fon traditions yet are touched upon by Fon and sometimes other African

influences. This can be seen in artistic styles such as the thoroughly integrated, typically Abomean cut-out block form appliqué sewn and sequined onto Yoruba Egungun cloth masquerades. Both difference and similarity are recognized and exploited simultaneously.

Egungun and Gɛlɛdɛ from a Fon Perspective

In Yoruba ancestor veneration, Egungun masquerades represent the continuing relationship between the living and the dead through the summoning of ancestral spirits via dance, drumming, and sacrifice.[14] Although Egungun is said to have originated in Oyo, Nigeria, this strong tradition currently proliferates throughout southwestern Nigeria, southern Bénin and Togo, and into Ghana.[15] Fon people call Egungun by the Fon word *kulito* (*ku* = death, *li* = path, *to* = the one who does the action; agent), which translates literally as "the one from the path of death" or ancestor.[16] Egungun is the "Nago [Yoruba] Vodun" of the ancestors.

Narratives circulate of how Egungun was brought to and installed in Ouidah, ranging from the story of an enslaved Yoruba man living in Ouidah who made his dead ancestors manifest themselves in Egungun, to the story of a royal Yoruba man arriving in Ouidah on a white horse followed by his Egungun ancestors. Beninese ethnographer, linguist, and playwright Julien Alapini (1952a, 146–52) recounts yet another story in his book *Les initiés*, as follows.

In the mid-nineteenth century, a man named Edoun Ikouola Okolotcho Alafin came from Oyo to Ouidah to escape from his malevolent brother who had just become king. He brought his family's Egungun with him. The people of Ouidah admired and feared this foreigner and his Egungun. Through word of mouth, news of Egungun reached King Gezo who sent for this powerful newcomer to come to Abomey. Gezo gave Mr. Okolotcho three days to make his supposed ancestors appear, and his failure would result in death. Three days later the king's courtyard was filled with people waiting for the much anticipated event. Mr. Okolotcho made a tent out of woven mats and then hit the tent with a stick seven times. Nothing happened. But then, just moments later, the king and the crowd heard some unrecognizable language in a very guttural voice, and all of a sudden beautifully dressed Egungun started appearing, dancing, and delivering messages from Mr. Okolotcho's ancestors. The king was so impressed that he praised all of the people of Oyo and gave Mr. Okolotcho the protection of the Dahomean kingdom and a plot of land in Ouidah. He and his family were then placed directly under the safekeeping and guardianship of the Viceroy of Ouidah, Don Francisco "Cha Cha" de Souza.

According to Blier (1995a, 77–79), although Egungun existed in Ouidah, it was during the reign of King Gezo (1818–1858) that it was officially

recognized in the Dahomean kingdom. The Abomey king's official recognition of Egungun in Ouidah thus becomes political history as well as religious: Dahomean kings are exalted in local histories through their formal introduction of foreign powers.

Egungun (Kulito, Nago Vodun) are still revered and feared in Ouidah.[17] Each Egungun spirit has its own personality and particular drumming rhythm, some calm, some wild, depending on the personality of the particular ancestor. The spirit and the drummer participate in a sacred dialog in which they communicate with, encourage, and provoke each other through tonal speech and corresponding tonal drumbeats and dance steps. Whereas Yoruba peoples have different names for the many different Egungun spirits, Fon peoples divide these spirits into two classifications. The first includes the aggressive spirits who spin and chase. Called *agbanon*, which means in Fon "the one with [carrying] the load," they encompass a variety of confrontational Egungun spirits who usually have some type of superstructure ("load") on their heads (a sculpture, animal horns, etc.) (fig. 3.8). One example of the many Fon-defined *agbanon* masquerades is *jagun-jagun*, which translates as "warrior" in Yoruba, or *inon*, meaning "fire" in Yoruba. The second Fon classification of Egungun is called *weduto*, which means in Fon "the one who dances." *Weduto* encompass a variety of non-aggressive spirits who dance with great poise and an exemplary demeanor reflecting the admirable personalities they had in the world of the living before entering the world of the ancestors. One example of an Egungun within the *weduto* category is *ade*, which means "crown" in Yoruba. An *ade* Egungun represents the spirit of a Yoruba person who had a successful life (fig. 3.9).

My observations of Egungun during the mid-late 1990s and early 2000s made clear that these ancestral masquerades invoked fear and respect among Fon and Yoruba peoples alike. Just the sound of Egungun's talking drums heard from afar could incite panic. Even *weduto* masquerades—albeit non-aggressive—are potent and emanate otherworldly powers. I have witnessed people run home, terror-stricken, upon hearing the approach of Egungun. Upon questioning their fear, I was repeatedly told, "Egungun are very dangerous." I would then comment on the beauty of the appliquéd, beaded, and sequined Egungun cloth. Invariably, the immediate retort was "if the cloth touches you, you will die." The dire consequence of physical contact with a Yoruba ancestral spirit was presented as unconditional.

These masquerades are not without their light moments, however. Egungun masquerades also take on the persona of Vodun practitioners through dance. When an Egungun female masquerade mimics generic Vodun dance styles by leaning a bit forward, then, with exaggeration moves her shoulders back and forth in time with her hips and buttocks thrusting back and forth,

uproarious laughter and enthusiastic clapping and whistling are guaranteed. The crowds watching Egungun performances are filled with both Yoruba and Fon people who recognize immediately the gentle fun being poked at Vodun dances, and, accordingly, share a laugh. The welcoming environment itself is what allows for this intercultural understanding and mutual appreciation.

The origin of the Yoruba masking tradition of Gɛlɛdɛ, practiced in reverence to the extraordinary power of women, is said to be Ketu, one of the oldest Yoruba kingdoms located in present day Bénin (Drewal and Drewal 1983, 223–225, Lawal 1996). Migration histories of Adja and Ewe peoples mention Ketu as an important stopping point en route to their destinations (Bertho 1949, 121–132). Like Egungun, Gɛlɛdɛ is another form of "Nago Vodun." However, I saw only one Gɛlɛdɛ performance in Ouidah, which I observed for a few short moments from the balcony of my house. I have very little information on Gɛlɛdɛ and was, in fact, told that the Gɛlɛdɛ Society of Ouidah is no longer functioning because all the masks were sold. According to Denis Dohou, former director of the History Museum of Ouidah, an effort to commission masks and rejuvenate the Society was underway. Since this interview I have neither seen nor heard of a Gɛlɛdɛ upsurge in Ouidah. For Ouidah's National Vodun Day 2011 (see Chapter 6), there was a performance troupe who danced Gɛlɛdɛ. Although the drumming, dance, and costumes were accurate within the Gɛlɛdɛ tradition, the purpose of the performance was entertainment.

Elsewhere in Bénin, however, other examples of Gɛlɛdɛ masks demonstrate separate but overlapping Fon-Yoruba interconnections. One is a Gɛlɛdɛ mask from the town of Covè. Although this mask is part of the strong Yoruba masking tradition of Gɛlɛdɛ, it has been given a Fon name and has an accompanying Fon proverb. The base of the mask is a deep orange face, with red lips, accentuated eyebrows, and a spot called *fa* between the eyebrows. The superstructure atop the carved face is a pink woman, excessively made up and coiffed. Her pink skin color does not depict a European woman, but an African woman who, I was told with disapproval, "bleaches her skin and wears too much make up." Her breasts are exposed and her skirt is open in the front. The mask is articulated in such a way that when strings hidden under the mask are pulled, the pink woman lifts up her skirt to urinate. Her name is Tâti Dadɔ. *Dadɔ* is the Fon verb to urinate. The associated proverb—"*Tâti dadɔ mâ kpɔ fin nɛ o*"—means "Tâti has urinated, do not look over there." This mask teaches by negative example what a proper Beninese woman should never do. Accordingly, this Fon proverb is recited when one sees something that is inappropriate or disgraceful. Although Tâti Dadɔ represents a Beninese woman, the association of skin lightening and excessive make-up with coarse behavior has its own political dimensions coming from a centuries-strong European presence in Bénin.

One last example of the mutability and adaptation of a Yoruba Gɛlɛdɛ mask into Fon art and life—that is, a mask of a Sarafina angel that became the symbol of an international Vodun festival, among other things—is discussed in Chapter 6.

Even though Gɛlɛdɛ is said to have originated in Ketu, Bénin, and Egungun is said to have arrived from Oyo, Nigeria, they both form a major part of contemporary Yoruba–Nago Vodun—arts in southern Bénin. The ability to keep Gɛlɛdɛ and Egungun separate from Fon traditions in this extremely plural society amplifies the fear and power associated with these foreign-turned-local Yoruba traditions.

Changing Times: Egungun at a Price?

In recent times, it is not only Yoruba-Fon interconnectedness that plays out in Yoruba Egungun performance. So does another "foreign" component, but one not grounded in centuries of intercultural exchange: international money emerging from the tenuous tourist economy (see Chapter 6 for more on tourism).

As a Ouidah resident, I made a great effort to speak my beginner's Yoruba, instead of Fon, when approached by Egungun masquerades. I did this out of respect, as I was told repeatedly that Yoruba ancestors understand only the language of their homeland, Yoruba. In response, the Egungun would bless me and then accept a small monetary gift. This was common Yoruba protocol. However, with growing government-promoted tourism, and due to the worsening economy, Egungun are exploiting the Western appeal of their decorated apparel. As recently as the high tourist season of December 2010 through January 2011, I noticed Egungun out in the streets posing for tourists, and then insisting upon payment. An Egungun once suggested to me in French that I take his photo. When I asked him in Yoruba why he was not speaking Yoruba, he left me alone. The Yoruba elders are very unhappy with this recent behavior, but told me that people are desperate for money.

It is not a new occurrence that a Ouidah visitor might commission a Vodun ceremony to record. I have, in fact, negotiated some of these types of ceremonies for visitors and film crews. A payment is usually made ranging from $200–$1500, but this includes transportation for other participants as well as offerings for the spirits, including alcohol, chickens, guinea hens, and a goat or two. The animals are also used to feed the people who travel to participate in the ceremony. I had never heard of commissioning an Egungun performance. But in January 2007, two photographers did so as part of their thirty-year-old effort to photograph African arts, peoples, and cultures. I was familiar with their work and interested in their method. I always wondered if they exploited their reception as unknowing tourists, or if they took the time and energy to get to know the people and cultures before photo shoots.

I had photographed and videotaped Egungun before, but only after spending months acquiring permission from the elders in charge. I was therefore surprised at how quickly the photographers were able to arrange a performance. They had one afternoon to spend in Ouidah and paid a large sum of money to have free access to photographing the event, including from within the performance circle, a space normally inhabited only by masquerades and drummers.

Certain Egungun spirits are known to become violent, and they may brandish large machetes or carry a flaming terra cotta bowl. Some have recently sacrificed animals draped upon them as part of their attire. As the aura of intensity grows during an Egungun performance, young men use carved wooden sticks (*tcham*) to block the Egungun from the general public, ensuring that their cloth touch no one. On this particular afternoon, in the midst of the excitement and energy of the performance, the photographers unabashedly shot film. I was amazed at how close they went to the Egungun, who, at times, appeared quite aggravated but then were settled down by the Yoruba elder in charge of the commission and held back by the young men with the sticks. As the Harmattan had just arrived, the red earth was very dry and its dust was blowing in the air. I found this odd because when I had seen Egungun during the Harmattan in the past, the ground was always prepared with a coating of water to soak up the dust. Along with the blowing dust, there were pockets of discord within the audience, and people seemed a bit riled up, but such a charged atmosphere was not unprecedented. Egungun is serious business.

At one point in the performance, the photographers tried to gesture to the masqueraders where they wanted them to perform. Then—and I still cannot believe this happened—one photographer, while gesturing, placed her hand on the shoulder of an Egungun. He backed up quickly, as shocked as everyone else, and then all of the Egungun started dancing violently. The photographers and their assistants were escorted to their van and told to leave immediately. As the van drove off, the Egungun were wildly spinning and thrashing. It ended up that the dust interfered with a crispness of imagery desired in professional documentary photography. From a local perspective, however, it was the disapproving ancestors who rendered the photographs useless.

In the United States, whenever I would show Yoruba friends my videos of traditional Egungun, they were always amazed and said that Egungun no longer exists like that in Nigeria. They felt that such performances must be what their own grandparents saw. Perhaps in Bénin, the rarer, more preserved form of a more "traditional" Egungun exists because Bénin's Yoruba diaspora has exerted a great effort to proclaim their Yorubaness, and to keep their language and traditions alive. Hard economic times have, however, opened the door to quick, money-making strategies in contradiction

to traditional Egungun ideologies. Yoruba ancestral spirits will endure and continue to provide guidance, but tourist dollars, even minor amounts, will also endure and play out in the intersections of tradition and ability to make ends meet. Tourism surrounding the minority Yoruba culture in Bénin is not directly associated with the State-sponsored tourism efforts discussed in Chapter 6. Nonetheless, even the insubstantial influx of tourists in combination with current economic difficulties has had an unintentional effect on Yoruba traditions.

Interconnection of Fon Vodun and Yoruba *Orisha* Terms

The sharing and transference of language between and among Yoruba, Fon, and related peoples is documented in early travelers' accounts and readily observable in contemporary coastal Bénin. Yai demonstrates the influence of Yoruba language throughout this area of West Africa as a significant component of its intellectual history. He points to the writings of Antonio Brasio, who noted in 1640 in his *Monumenta Missionario Africana* that a Jesuit missionary described the Yoruba language throughout this area as parallel to that of Latin in Europe: "lingua eorum est facilis, vocatur lingua Licomin et est universalis in jstis partibus sicut latinum in partibus Europa" ("their language is easy to learn, it is called the lucumi [i.e. Yoruba] language and is universal in this area as Latin is in Europe)" (quoted in Yai 1994, 109, Yai's translation). In his *Description de l'Afrique*, originally published in Dutch in 1686, world history and geography writer Olfert Dapper expressed his wonder that the people of Allada "scorn their mother tongue and hardly speak it in order to learn another language called Ulcumy [i.e. Yoruba] which they always speak" (quoted in Yai 1994, 109). Although the people of Allada most likely did not "scorn" their own language, it is clear from Dapper's early writings that many people from Allada and surrounding areas were at least bilingual and that Yoruba was a very highly regarded language to speak.

The ongoing impact of Yoruba language and culture upon Fon, Mina, and Ewe-speaking peoples can be seen in contemporary linguistic examples. Cognates of Yoruba words have been fully assimilated into these languages, in situations often connected with cultural and religious practices. Many Yoruba words and phrases have also been adopted and adapted into quotidian Fon dialog. Cognates of the Yoruba word *Ifa*, and words associated with *Ifa* divination are found in Fon, Mina, and Ewe. There is a linguistic pattern that repeats itself: a Yoruba word is changed to a Fon word by eliminating the first syllable, and then the newly formed Fon word is changed to a Mina or Ewe word by adding a new prefix of either "a" or "e." The Yoruba origin of some of these words has been lost as the words are reinterpreted into local languages.

Bernard Maupoil (1936, 32–34) states in a footnote in *La géomancie à l'ancienne Côte des Esclaves*, "The Fon intentionally suppress the prefixes of foreign words that they borrow" (34n2). He gives the example of the ancient Yoruba city of Ife being called Fe by Fon people. Ife, when pronounced aloud, sounds to Fon speakers like the sentence "*e yi Fe*," which literally translates from Fon as "s/he has gone to Fe." Maupoil explains that in Fon thought, the city of Ife is not often regarded as an ancient Yoruba administrative center, but rather is thought of more as an abstract, mystical land. Accordingly, "*e yi Fe*," meaning "s/he has gone to Fe," an abstract, mystical land, is a euphemism for death, especially the death of an albino (Lisa Vodun); for the death of a sacred python of Ouidah (Dangbe Vodun); or for the death of a very important Fon person, usually a diviner (*bokɔnɔ̀*). Taking this abstraction one step further, Maupoil also reports that Fe means "life" because in Fon thought, when one goes to the mystical country of Fe (death), one discovers life. In a circular logic, an ending is always a beginning.

Not only are Yoruba words found in Fon and related languages but lines and sometimes entire verses of Fon and related languages are found in the Yoruba Ifa "corpus" (Yai 1994, 109). Thus, the capacity to understand different languages and cultures throughout this West African region is not one-sided. In fact, as noted, not only did/do speakers of Fon and related language speak Yoruba, but Yoruba speakers were/are obliged to learn other languages as well.

From East to West: Ifa to Fa to Afa

The practice of Ifa divination stretches from lower Nigeria through coastal Bénin, Togo, and into Ghana, and can be found in various forms throughout the African-Americas. There is widespread agreement that Ifa divination originated in the ancient city of Ile-Ife (Ife) in Yorubaland. Yoruba Ifa is both a method of divination and a deity (*orisha*) (Bascom 1969). From Yorubaland westward through the areas occupied by Fon-, Mina-, and Ewe-speaking peoples, the word describing the same divination process and deity changes from the Yoruba Ifa to Fa and Afa.

The Ifa system of divination is based on 16 basic and 256 derivative figures obtained either by the casting of sixteen palm nuts or by the throw of a divining chain made of eight half seed shells, four on each side (Bascom 1969, 3). The heart of Ifa divination, however, manifests itself in the thousands of memorized verses by means of which the 256 figures are interpreted. These figures and related verses, known as *odu* and described below, form an important body of verbal arts including myths, folktales, praise names, songs, proverbs, and jokes. Art objects, such as the Ulm divination tray, and other ritual paraphernalia associated with Ifa are used in the divination process itself,

and, more recently, representations of *odu* figures, verses, and other aspects of divination have been rendered in contemporary painting and sculpture.

The word *fa* expresses at least two different ideas in Fon. It means "coolness" literally and in turn conveys ideas of mildness, softness, gentleness, or peacefulness and equilibrium. When people say in Fon "*e na fa*," it means literally "it will be cool," that is, do not worry, things will be all right. According to Maupoil (1936, 4–5), diviners say that the fact that the word *fa* is the name for the divination system and means "coolness" is not accidental, for Fa itself (the Vodun spirit) promotes coolness, peace, tranquility, goodness, and happiness, and dislikes hot things. *Fa* also means "coolness" in Mina and Ewe, though the divination system among Mina and Ewe speakers is called *Afa* (Koudolo 1991). The Yoruba concept of "coolness" (*tutu*)—although not directly associated with the word Ifa—is integral in Yoruba philosophy, informing practically all aspects of Yoruba art and life, including Ifa divination (cf. Thompson 1971, 40–43, 64–66, 89, 1983, 12–16).

According to Mr. Fandy, an important Fa divination priest in Ouidah, Fa was installed in Ouidah from Abomey because of the great divination proficiency of a certain Abomean Fa diviner named Adjomagbo. The king of Abomey was expecting an important shipload of European goods to arrive at the Ouidah beach.[18] When the goods did not arrive, the king began sending Fa diviners to Ouidah from Abomey for consultations, ceremonies, and sacrifices in order to discern why the boat had not arrived and then to redress the problem. Not one of the king's diviners was successful, and the boat did not come. Then, Adjomagbo volunteered his services to the king. He said he could make the boat come to Ouidah. All he needed from the king was three cows: one black, one red, and one white. Upon his arrival in Ouidah, the diviner performed three ceremonies in which he sacrificed the black cow in the morning, the red cow in the afternoon, and the white cow in the evening. That very evening, when the meat from the third cow was on the fire, the people of Ouidah spotted the much anticipated boat at sea.

Because of Adjomagbo's great accomplishment, the king chose him as the head Fa diviner in Ouidah. The king gave him the praise name Essa Adivo Hounwa which translates as: "He [the king] offered the sacrifice that his son [the diviner] prescribed, and the boat came." The current head of this family in Ouidah is Fandy, which he told me means "Fa tells the truth." I thought at the time, without questioning, that his chosen name was Fon in origin, but I have come to believe that it must come from the French "Fa dit" meaning "Fa says," for there is nothing close to the same meaning in Fon.

Despite the assertion that Fa divination came to Ouidah from Abomey, Maupoil (1936, 45) suggests that it is quite probable that Fa spread along coastal Bénin in the region of Ouidah before its official adaptation into the

Dahomean kingdom in Abomey. This does not discredit the history of Fandy, but suggests that Fa may have arrived along coastal Bénin much earlier than recounted in the Dahomean royal histories, which are often conceived for political reasons (Blier 1995a, 77–79).

There are many myths and legends concerning the exploits and power of Fa that are incorporated into the corpus of Fon Vodun mythology. Reference is often, though not always, given to Yoruba origins of Fa, but in many stories Fa is a Fon divination system (Herskovits and Herskovits 1958, 172–214). The fluidity of the proposed origin of Fa is due to the fluidity of peoples using Fa. Yoruba and Fon gods, symbols, myths, and art forms have become multicultural, in and of themselves, through centuries of intercultural interactions.

Following the cultural and linguistic continuum, I have found that as far west as Lomé, Togo, acknowledgment is still paid to the Yoruba origin of Afa divination. A much respected Ewe diviner and head of the Akpaglo family in Lomé, Togo, pays reverence to the origin of the Ifa divination system by professing before each and every divination he performs: "*Afa Nago nou*," which simply means "This is [I]Fa from the Yoruba peoples."[19]

Odu to Du to Edu

Odu are the innumerable verses associated with the 256 possible combinations of sixteen open and closed cowries or an eight-seeded divination chain. A Yoruba friend described *odu* to me as "a pot of information," that is, every possibility in life. Here, once again, an originally Yoruba word *odu* changes to *du* for Fon-speaking peoples and then changes again to *edu* for Mina and Ewe speakers (Koudolo 1991, 13). Unlike the examples of Ife (*e yi Fe* as "s/he has gone to Fe") and Ifa (Fa as "coolness"), in this case the meanings of *odu*, *du*, and *edu* seem to remain based on the Yoruba meaning. The *du* from *odu* is often used to explain etymologically the second syllable of the word Vodun (see Chapter 2).

Eshu-E/Lεgba

Among Yoruba, Eshu-Elεgba (also called Eshu and Elεgbara) is the intermediary communicator of the will of Ifa to other gods and humans (cf. Wescott 1962, 336–52). Eshu-Elεgba becomes Lεgba among Fon-speaking peoples and then changes to Elεgba among Mina, and Ewe speakers, once again reflective of a linguistic transition across ethnic identities. The verb *gba* (the second syllable in the word Lεgba) in the Fon language can be translated in a variety of ways: to demolish or destroy; to break, sack or fracture; to create havoc, to annihilate, obliterate, or destroy; to knock over, overturn, spill, upset, or reverse. *Lε* indicates the repetition of the verb following it, meaning "to do again" the action of the verb (Segurola 1963, 199–200, 351). I was told

more than once that Lɛgba means "to break and send away [bad things]." This may reflect what *gba* means, but it was not emphasized that the action is done "again" as the first syllable *lɛ* would indicate.

That the Fon Lɛgba most likely derives from the Yoruba Eshu-Elɛgba is often overlooked in the literature. Keeping in mind the centuries of artistic, linguistic, and cultural interconnectedness between and among Yoruba, Fon, and related peoples, scholars must use caution in properly identifying the history of Lɛgba, especially when talking about the influence of Lɛgba in the African-Americas. That is, they cannot begin to speak of Lɛgba, the Fon avatar of the Yoruba Eshu-Elɛgba (Elɛgbara), without clearly acknowledging Fon-Yoruba interconnectedness. When scholars writing about Papa Legba in Haiti refer to him as the carryover of the Fon god Lɛgba, is it important to note that Lɛgba is most likely not originally a Fon god, but a Yoruba one. This caveat holds true as well in discussing the origins of Eleggua in Cuba and Puerto Rico, and in major cities in the United States such as Miami, New York, Los Angeles, Chicago, and others where Santeria (Regla de Ocha) is practiced. The genesis of Eshu-Elɛgba to Lɛgba in Africa before becoming Papa Legba and Eleggua in the African-Americas reflects quite clearly the important concept of centuries of Fon-Yoruba interconnectedness well before the transatlantic slave trade.[20]

Ogun to Gu to Egu

The same linguistic pattern holds true for Gu, the Fon cognate of the Yoruba Ogun, god of iron, warfare, and technology, who becomes Egu among Mina and Ewe speakers. Egu is discussed in more depth in Chapter 4 in which this Yoruba-turned-Mina/Ewe god is represented by a Hindu god in a Mami Wata temple. Ogun becomes Ogou in Haiti and Ogum in Brazil.[21]

Yawotcha

Here is one slightly different example of a Fon-Yoruba linguistic combination. In November 1994, I witnessed a *yawotcha* initiation ceremony in Ouidah. Although I was told that the ceremony was for Xɛvioso, I learned later that it was actually an initiation for the Yoruba *orisha* Shango. I have since come to understand that the ceremony was, at once, for both Xɛvioso and Shango.

The Fon term *yawotcha* derives from the two Yoruba words *iyawo* (wife) and *orisha* (god or spirit) in which both Yoruba words are abbreviated and brought together to form a new word with clear Yoruba origin, but Fon-ized in both abbreviation and pronunciation.[22] The "sh" sound in the Yoruba word *orisha* changes to the "tch" sound in Fon.[23] The ceremony itself was conducted in both Yoruba and Fon.

According to Segurola (1963, 613), the word *yawocha* is from Yoruba and means "Vodun of the Yoruba Xɛvioso," a definition that is already a Fon-Yoruba conflation. In his translation, the Yoruba words *iyawo orisha*, meaning "the wife of a god," refer to a particular Fon Vodun spirit (Xɛvioso), while the translation from Yoruba refers quite clearly to the initiation process itself during which an initiate literally and figuratively becomes married to his or her spirit.

It was made clear to me that a *yawotcha* initiation had not been performed in Bénin in many years, perhaps not since Pierre Verger documented what appears to be the same ceremony in Ouidah in 1949. That ceremony was in a Shango temple in Ouidah, and Verger's description of the ceremony is very similar to what I witnessed in 1994, forty-five years later (figs.3.10–3.15). As I photographed this ceremony, I felt I was viewing Verger's familiar black and white photographs in color. Unfortunately, Verger does not give the name of the ceremony he attended, which might have revealed if *yawotcha* is a recent conflation of the two words *iyawo* and *orisha*; or if the ceremony he documented in Ouidah was also called *yawotcha* when he documented it.[24]

Vodun from Northern Ghana: Thron and Attingali

Two Vodun complexes from the predominantly Islamic northern region of Ghana represent another type of intra-African, foreign-turned-local mélange. Unlike Fon and Yoruba interconnectedness in which Yoruba peoples maintained their own spirits, language, and identities, these Vodun are practiced by people who have little or no ethnic affiliations with the original spirits. It is Vodun's open-ended temperament that has allowed foreign spirits from neighboring African regions to become local Vodun.

Thron Kpeto Deka Alaafia

Thron Kpeto Deka Alaafia translates from Mina as "Thron of One Stone in Peace." Other names and spellings include Tron, Thro, Tro, Etron, Ethron, Etro,[25] Goro, and Koundé.[26] Aside from the shortened name Thron, the most common appellation is Goro Vodun, which means Vodun of the kola nut and relates to Thron's origins.

I visited Thron temples in Bénin, Togo, and Ghana, but was told that Thron can be found all over the world. Indeed, the Thron Vodun is venerated by people of many nationalities from many countries. All members are linked by the same beliefs and observe the same general rules of conduct.[27] The underlying belief is that if an adept is sincere and serious in his or her obligations to Thron, and neither harbors bad thoughts nor wishes ill-will toward anyone, even proven enemies, then Thron will protect him/her from all forms

of harm ranging from witchcraft to snake bites to motor vehicle accidents. As for its practice, Thron is a Vodun that thrives on inventiveness and transformation, and many different Thron priests innovate within their own Vodun houses. Variations in Thron arts and ceremonies are quite common, though the common denominator through all temples and ceremonies is the use of the kola nut.

I was very fortunate to have worked closely with Hounongan Joseph Guendehou, an internationally recognized Thron chief and much respected Vodun priest. After encountering him briefly at the home of Tchabassi at the beginning of my fieldwork in 1994 (see fig. 1; he is the gentleman in the red hat), I met Mr. Guendehou weekly at his Thron compound in Cotonou through 1996. I continue to spend time with him and his family every time I am in Bénin. Through the years I became close friends with one of his wives, Maman Tony, from whom I learned invaluable lessons not just about Vodun but also about life as a woman and as a co-wife of a Vodun priest. Most of the Thron ceremonies I attended were either at Guendehou's home or at Thron temples I visited with him. He is a brilliant innovator, has initiated hundreds of people into Thron, and has installed over one hundred Thron temples throughout Bénin and Togo over the past forty-five years.

Guendehou also identifies himself as a Roman Catholic. He has been baptized and has taken communion. After his younger sister, who had suffered a serious illness, was healed by Thron, Guendehou was in a terrible car accident and barely escaped alive. The man who healed his sister told Guendehou that he must install Thron to protect himself and his family, but that he need not revoke his Catholicism. He was initiated into Thron in 1965 but maintained a Christian compound. A large plaster statue of Jesus figured prominently above his Islamic Vodun shrine to the kola. In 2001, however, he replaced the Jesus statue with a photograph of himself. His Thron adepts follow the Judeo-Islamic-Christian Ten Commandments, which are sometimes painted in both French and Fon on Thron temple walls.

I was told repeatedly that Thron originated in a city by the name of Acrachi in northern Ghana. Acrachi undoubtedly refers to the city of Kete-Krachi located at the confluence of the Otei and Black Volta Rivers in central Ghana. Although there are varying versions of Thron's origins, the following is the general idea. A long time ago, in Acrachi, the only source of water was a sacred river that was guarded by a ferocious crocodile. It was thought that the role of the crocodile was to regulate the water supply so that no one would ever be without it. Some people doubted the beneficence of the crocodile but dared not confront it. Although the river had an adequate amount of water, the people of Acrachi were known to die of thirst because they were afraid to ask the crocodile for access to the river.

One day, a traveling Hausa man stopped at the river to drink some water. In Vodun culture, "Hausa" often refers to a person with a generic northern origin (see Chapter 5). This Hausa traveler is sometimes said to have come from "Egypt, the land of Jesus." Literal geographic designation, in this case, is not the point. That northern Ghana, Egypt, the "land of Hausa peoples," and the "land of Jesus" are conflated corresponds to the perpetually shifting, ever-evolving system of Vodun, as well as reflecting the changed name of the city of origin and its "true" location in central Ghana. The traveler was warned that it was not time to collect water, and that if he dared take any his life would be in danger. The man ignored the warning and proceeded to drink the water. When the crocodile approached him, ready to attack, the man raised his left hand and the crocodile backed off and died. The foreign man announced to the city that everyone could now have access to the sacred water source at all times.

The people of the city praised the man and because they believed him to be a very powerful healer and holy man, they demanded some way to venerate him. The holy man went to the sacred river, raised his left hand, and asked for something for the people to worship. When he lowered his left hand, he found seven kola nuts that he was instructed to plant. He watered the newly planted kolas with sacred water and they grew and bore fruit. Then, when people asked how they could pray to this powerful spirit, he gave them seven kolas from his kola crop and instructed them how to worship Thron, the Goro Vodun. To this day, kola nuts are taken with the left hand in Thron ceremonies.

Thron began to spread eastward. In the middle to late nineteenth century, a "Hausa man" named Mamad Seidou, now known by his Vodun name Adjakossi, brought Thron from Acrachi, Ghana, to Zowla, Togo. There he installed it in the house of Agba Houzo Lanfion, now known by his Vodun name Tonyiviadji. Thron was then installed in 1876 in Grand-Popo, Bénin, in the house of Djehoué Noumon, and from there it dispersed all over the country of Bénin. Reverence is paid to Adjakossi and Tonyiviadji at the beginning of important Thron ceremonies.

Most practitioners agree that the original Thron shrine consisted of seven kola nuts and that is all one needs for proper veneration. As I was told many times, Thron is simply the kola nut. However, anyone with the kola can add things to it based on visions, dreams, or inspirations. The more the simple kola shrine is fed, the stronger it becomes. It is from the original seven kolas that the innovative Thron temples found throughout Bénin, Togo, and Ghana began. It is the accumulative and open-endedness of Vodun that allows Thron to flourish.

The story of Thron's genesis and arrival in southern Togo and Bénin sug-
gests other possibilities. In what is now Ghana, the main north-south route of
slave transport to the Atlantic coast passed through Kete-Krachi. Slaves from
northern Ghana and northern Togo were brought to the Abomey Kingdom
and the Ouidah slave market. Extending 300 kilometers from northern Ghana
through Kete-Krachi to slave ports in southern Ghana, the route was among
several slave routes identified in the UNESCO-sponsored "Slave Routes
Project" held in Ghana in 2003. I suggest here that another possibility for
the spread of Thron might have been through the selling of slaves from the
Kete-Krachi region for domestic use in southern Ghana, Togo, and Bénin.
Chapter 5 is dedicated to Tchamba, a Vodun of servitude with roots in north-
ern Togo, which might reflect a similar transmission of Vodun from the north
to the south. However, I have never heard mention of slave ownership within
the Thron Vodun.

Buying and installing Thron. The proliferation of Thron continues to this day.
Its main distinguishing feature in comparison to other Vodun is that the only
way to acquire it is through purchase. That is, one is not born with Thron, but
for a substantial sum of money one can have it installed and become a Thron
adept for the health, well-being, and good fortune it is famed to bring. An
installation can cost up to 750,000 to 1,000,000 CFA, which equals approxi-
mately $1500 to $2000. Having the basics of Thron installed may take up to a
year, but upkeep and the potential for upward mobility last a lifetime.

About a month before a Thron installation, the future owner is instructed
in Thron maintenance. During this training period, a Thron temple is built
near the home of the owner-to-be. The Thron priest who will install the Vodun
prepares many sacred bundles with objects that will be displayed during the
installation ceremony and then installed in the Vodun shrines or buried. The
objects are usually wrapped in red, white, or black cloth. An installation con-
sists of three days and three nights of ceremonies during which chickens,
guinea hens, goats, cows, kittens, puppies, and other animals are sacrificed;
some are prepared and eaten by the people present while others are buried in
certain consecrated rooms, below certain shrines, under doorway thresholds,
and in various other sacred locations. When blood is offered to Thron shrines,
adepts who have the Vodun spirit embodied in that particular shrine will
become possessed the moment the blood touches the shrine. There is much
spirit possession in a successful installation. Singing and dancing accompany
the ceremonies throughout the three days. After the initial installation, there
are ceremonies that must be performed annually by the new owner of Thron.[28]
Guendehou keeps detailed records of all of his adepts and of all of those for

whom he has installed Thron. I have witnessed nine Thron installations and have collected detailed exegeses of others.

Most installations are quite successful and bring the new owners of Thron much good fortune. However, sometimes installations are not successful, especially if the new owner of the Vodun does not follow its strict rules. I witnessed a three-day installation of Thron in Cové, Bénin, at the house of a Yoruba man named Baba Shango. A strong and well-respected priest, Baba Shango was also a heavy chain smoker and had been for twenty years. He did not know, before the installation of Thron at his house, that Thron does not permit smoking. This caused Baba Shango all sorts of problems to the point where he was visiting Guendehou in Cotonou weekly to admit his sins (smoking) and to pray for forgiveness.

Some Thron ceremonies. Thron itself is expensive and demanding. In addition to ceremonies for Thron installations, initiations, and Fa consultations, there are ceremonies that must be performed as part of Thron's "original structure" from Ghana. Added to these are newer, innovative ceremonies such as Sunday Mass and Christ-Mass, Islamic holidays such as Ramadan and Tabaski, and the veneration of standard Beninese Vodun such as Lɛgba, Gu, Sakpata, Dan Aida Wedo, and Hohovi. Traditional Fon rituals such as *sintutun* (water spraying) and *takiklɔ* (head cleaning) are conducted annually to exorcise all evil thoughts in Thron adepts' consciousnesses. Along with obeying the many interdictions of Thron itself, many Thron adepts observe Ramadan and Lent. In all celebrations, however, much of the ritual paraphernalia in Thron is marked with the Islamic star and crescent moon (fig. 3.16).

Among the Thron ceremonies that I attended in Guendehou's house was Mass. As the founder of the original Thron Church in Bénin, he has Vodun Mass at his house on Sundays and is invited all over Bénin and Togo to lead this Sunday service. Vodun Mass is conducted in French, Fon, Mina, and Hausa, and the English word "church" is used in reference to where the Mass is held. Although much of the Mass seems to be an adaptation of a Vodun ceremony into the format of Catholic Mass, Mr. Guendehou claims that it was, in fact, the Christians who initially copied Thron because it was Thron who protected Jesus Christ.

The songs sung throughout the Vodun Mass praise Thron and denounce witchcraft. The message is clear: it is up to Thron to fight witchcraft while it is up to Thron adepts to be loyal to Thron. Near the beginning of Mass, all participants take a kola nut with their left hand, and each one talks to the kola, conveying personal messages to Thron (requests, questions, worries, etc.), and then rubs the nut over his or her body from head to toe so that the participant's essence, and, in turn, messages, can be recognized by Thron. The kolas are

then collected in a bowl and emptied upon the kola shrine. This act recalls the original planting of the seven kola nuts along the sacred river in Ghana. Communion is then taken in which the body of the Vodun, the kola nut, is eaten by all present.

Guendehou next fills his censer with a mixture of gunpowder and other powerful ingredients. He lights the censer, which emits a little explosion that lets everyone know that Thron is present. He then chases bad spirits away from the temple with the smoke from his censer. Next, he sprays Holy Water on his congregation as an act of purification. He and a few of the most important men and women present then perform a dance during which they make a procession through the crowd while brandishing a special knife called *ganvohwi* (*gan* = metal, *vovo* = red, *hwi* = knife). This dance cuts through and expels all evil spirits from the room. Money is then collected for Church maintenance.

After clearing all bad energy from the premises, Guendehou performs a Fa divination reading to see what the week has in store for his congregation. He concludes the official Mass portion of the ceremony by shaking everyone's hand and placing a spot of a special protective liquid and powder mixture on each person's forehead or chest. The congregation then sings and dances in praise of Thron. A spirit of Thron will usually possess at least one adept who will deliver Thron's messages to the congregation. This is a very lively and cheerful part of the ceremony. Afterward, a meal is served.

Christ-Mass, held annually at Guendehou's house the 24th and 25th of December, is the all-night New Year's celebration of Thron. The culminating ceremony begins around 11:00 p.m. the night of the twenty-fourth. People come to Guendehou's home for this celebration from all over Bénin, Togo, and sometimes Europe and the United States. The ceremony is very much like a Vodun Mass, but with more praying, more dancing, and more singing. The structure also follows the same order: adepts deliver their messages to Thron via kola nuts and take communion. Bad spirits are chased away, and everyone is blessed for the year to come (fig. 3.17), rather than just the upcoming week as in the Sunday Mass.

Everyone participating in Christ-Mass dresses in white and carries a white candle. For Christ-Mass 1995, the first adept in the procession to enter the temple carried and then placed on the ground a Santa Claus candle called Papa Noël by Thron adepts. While Santa is called by his French name, the ceremony itself is called and spelled Christ-Mass in English, not Noël in French. As for the hyphen, Mr. Guendehou states that "it is a Mass for Christ, thus Christ-hyphen-Mass." Although Mr. Guendehou acknowledges that December 25th is, indeed, the date celebrated internationally for the birth of Christ, he claims that the Thron New Year was celebrated on that date long before Christ was born. One must remember, Mr. Guendehou adds, "Christ was a

Thron adept." That Christ was born on Thron's New Year is an opportunity for Guendehou and his congregation to venerate both Thron and Christ at once.

Interdictions. A major interdiction for Thron adepts is the consumption of pork. One may assume that this is due to the Islamic grounding of the Vodun. However, the reason behind this avoidance seems to be more entangled than an Islamic prohibition. Guendehou's version of the story brings together Jesus Christ, the sacred kola, and the pig.

For days Jesus Christ was being chased through the forest by a group of bandits who wanted to rob and kill him. Jesus kept running, but the bandits kept pursuing him. One day, he instructed a group of pigs to erase his tracks on the forest floor in order to throw off the bandits, thus enabling him to escape without detection. Although this scheme worked, Jesus found himself very lost deep in the forest. For days he did not eat or drink. In desperation, he raised his hands to the heavens and cried, "Oh my father, give me strength," and in his hands appeared seven kola nuts, which he consumed. This gave Jesus the strength to continue to safety where at once he began worshipping the kola and praising the pig.

Such a story is a common device in Vodun practice to introduce innovative ways to enrich Vodun histories and lore. All Thron observances, however, are individualized by the Vodun priest performing them, allowing for great creative ingenuity. In the case of Mr. Guendehou, his version of this story is in keeping with his own particular style of conflating without contradiction a hand-picked selection of Muslim and Christian symbols, ceremonies, holidays, and beliefs under the panoply of Vodun.

Attingali

Like Thron, Attingali is an Islamic Vodun that originated in northern Ghana and continues to spread eastward into Nigeria. It is also known by abbreviated names such as Tigere in Ghana, Attinga and Tinga in Bénin, and Alatinga (*al* = owner of in Yoruba) and Tingare in Nigeria.[29]

Attingali is said to have first been worshipped in Parakou, Bénin, in 1947. Parakou is in northern Bénin where many Barriba people live, which might help explain why some Beninese claim that Attingali originated among Barriba peoples. In 1954, it was installed in the compound of Mr. Kpehoundé Adankon in the Ouega quarter of Abomey-Calavi, a city about twenty-five miles northeast of Ouidah. Since its installation, Attingali has grown and become concentrated in and around Abomey-Calavi, which is now considered throughout Bénin to be the center of both witchcraft and witch-fighting. A powerful Vodun, Attingali does many things: it fights witches and bad juju,

helps with infertility, heals insanity, and helps people succeed in work. It will also punish enemies of adepts, but never without provocation.

Attingali itself hand-picks its own adepts, and when it does so, it will possess them and let them know who their spirit is within the multitude of Attingali spirits. An individual cannot choose whether or not to be an adept because Attinga chooses the individual at will. However, an Attinga priest can recognize that someone might be killed by witchcraft, so he can tell his Attinga spirit to choose this particular person in order to save his or her life.

After an individual is chosen by Attingali and learns who his or her spirit is, the ensuing initiation takes about four weeks during which the chosen one learns how to pray, sing, dance, and respect the Vodun. The initiate then becomes either Konfo or Ablewa, generic terms for male and female adepts, respectively. During initiation the adept receives a three-page list of suggestions and prohibitions that must be followed, among them: adepts of Attingali must have total faith in the religion; they must attend Attingali service every Sunday and give their Sundays completely to their spirit; they must not lie or kill anyone; they must never eat pork; men must not covet the wives of other adepts (yet they are permitted to pursue young unmarried women); and so on. Individual punishments for breaking each rule are also listed. For example, adepts who disobey the rule against mixing or eating a variety of food items on certain days usually must make amends with offerings of alcohol, soft drinks, candles, perfumes, specific fruits, and/or monetary fines to particular Attingali spirits.

After initiation, Attingali adepts have the privilege of either scarifying their faces with a scar beginning at the side of the mouth and gradually curving upward along the jaw line, or painting this mark on their faces temporarily for ceremonies. These marks, believed to mimic scarification patterns found in northern Bénin, identify adepts as "wives of the Attinga." For ceremonies, the adepts usually wear either white or red clothing with crosses, hooks, tridents, and mirrors sewn to the cloth, representing the fighting powers of the Vodun. The colors of the cloth reflect both the acknowledged and claimed origins of the spirits: red refers to a spirit from Barriba country and white from northern Ghana. Twice I saw an adept wearing pink, which I was told represents the spirit of Mami Wata.

Islamic holidays are celebrated in Attinga, reflecting its Islamic heritage in northern Ghana. Dance is another element that asserts the northern origin of the Vodun. The adepts learn a dance called *brekete* in which they bend at the hips, shuffle their feet back and forth, and perform small kicking gestures low to the ground, which does not resemble dance along coastal Bénin but corresponds to dancing styles in the north.

Europe + Intra-Africa + India

This region of coastal West Africa was and is a plural society comprised of a mixture of African and European ethnicities, resulting in a constantly shifting mosaic of diasporas. In the next chapter, India enters the global mix. Vodun's open-ended structure allows India spirits—arrived via the sea—to enter and become fully absorbed in spirit veneration. Among other aspects of India, I briefly discuss a particular Attingali temple in relation to a Hindu chromo-lithographic image that has been integrated into its veneration.

"India," Chromolithographs, and Vodun

É nɔn zlɔ agbâ, bo nɔ i kpɔ xŭ ɖo domɛ â.
One does not contemplate the ocean with empty hands.

Fon proverb

Globalization is often thought of in terms of rapid advances of information technology and worldwide economic interdependence. Not as often are cultural or spiritual influences considered in this global equation. Seldom if ever are such influences imagined to exist between India and West Africa. Indian chromolithographs, however, exemplify the spiritual power of "India" when incorporated into contemporary Vodun art and practice.

The "India" Connection: Chromolithography

Lithography, or the process of making prints from a metal plate or a flat surface of stone, was invented in 1796 by Aloys Senefelder of Prague, and color lithography was in use in Europe by the middle of the nineteenth century (Smith 1997, 6). In India, however, there was a long history of text printing before the advent and spread of lithographs. In 1556 the Portuguese intended to send the first printing press—via Goa, India—to missionaries in Abyssinia. After the Abyssinian emperor changed his mind about welcoming missionaries, the press remained in Goa where the first book was published on Indian soil in 1556 (Babb and Wadley 1995, 21). From that point on,

printed texts were used extensively by missionaries to spread Christianity in India. In the nineteenth century print technology became a major factor in the transmission of Hindu and Muslim religious traditions through written text. Chromolithograph presses were operating in India by the late nineteenth century, and color prints, generated from multiple stone blocks, began circulating throughout the subcontinent around the same time. Raja Ravi Varma (1848–1906), a south Indian portrait and landscape painter, is usually cited as the principal influence in the emergence of India's popular religious poster and calendar art. He not only painted popular portrayals of gods, goddesses, and legendary Hindu tales, but he is also credited with setting up the first chromolithographic press in Bombay in 1891 (Inglis 1995, 58). In fact, before 1900 India had several chromolithographic presses, including the press of Hem Chander Bhargava and Company in Chadni Chowk, Dehli, which had been continuously printing chromolithographs of religious subjects for over one hundred years (Babb and Wadley 1995, 22).[1]

Indian commodities in West Africa date back to the fifteenth century when Portuguese sea commanders and merchants of the British and Dutch East India Companies began trading and selling Indian cloth between India and coastal West Africa (Eicher and Erekosima 1996). Consequently, the sea bordering this coast has been associated with foreign wealth and power since the fifteenth century. The institution of colonial empires and increasing trade connecting Africa with both East and West brought about the quick spread of images that have been incorporated into West African artistic and religious expression beginning as early as the late nineteenth century. According to Henry Drewal (1988, 174–76), when Indian merchants set up firms along the West African coast around World War II, West African peoples began observing aspects of Hindu religious practice such as that of the Gujeratis, devotees of Lakshmi, the Hindu goddess of wealth and patroness of merchants. The appeal of Indian gods to West Africans led to a burgeoning African market in Indian prints, although the availability of these images in the marketplace declined in the late twentieth to early twenty-first centuries.

Elaborately detailed Indian chromolithographs have been incorporated into the religious system of Vodun precisely because of the open-ended structures and richly suggestive imagery that allow them to embody wildly diverse ideas, themes, beliefs, histories, and legends in Vodun art and thought. The prints themselves serve as both instructions and vehicles of divine worship; they suggest rules of conduct, recount legendary narratives, and act as objects of adoration. The specific animals, foods, drinks, jewelry, body markings, and accoutrements depicted in these chromolithographs have become sacred to the Vodun spirits represented. Although at some point these images were new to the West Africans, they have been treated by Vodun as something that was already known and understood, as something already familiar within the

Vodun pantheon. These Indian gods have not been *combined with*, but rather they *are* local gods.[2]

Form and Meaning in Vodun Chromolithographs

In a discussion of how people in the village of Bartisuda in Madya Pradesh, India, are able to access divine energy by the "mere possession of visual forms," Christopher Pinney (2001, 66–67) borrows playwright Brian Friels' description of a "syntax opulent with tomorrows" to attest to Hindu devotees' active contribution to the potential inherent in mass-produced images. Similarly, a mass-produced image such as the chromolithograph in Vodun art is "opulent with tomorrows" in that the image's meaning has the potential to undergo many transmutations in the future.

In the world of Vodun, the seemingly static nature of a mass-produced image is misleading. Although a chromolithograph used in Vodun may appear "finished," it continues to change in both form and meaning: it can expand in form from a two-dimensional image into a three-dimensional spiritual and artistic presence in shrines and sculptures, and a three-dimensional shrine can be represented by a chromolithograph as an ethereally collapsed, ready-made, two-dimensional shrine. Visual and spiritual saturation in an economical and portable form is the open-ended potential of chromolithographic art.

Chromolithographs in Vodun exist in an aesthetic and spiritual synesthesia in which visual impact induces godly presence, taking advantage of Vodun's unfinished aesthetic. For much Vodun art "completion" is not the point, and the chromolithographic art form is no exception. Even if the outward form of a mass-produced chromolithograph seems complete, within Vodun the name can change, the meaning can change, and the power residing within it can change depending on how it is used. Not only its uses but also its visual form when reproduced in temple paintings, shrines, and sculptures actualizes the potential of a chromolithograph to adapt in response to a new problem or situation that needs spiritual guidance or intervention, and/or in acknowledgement of the changing demands and desires of the spirits.

Because chromolithographs are easily reproduced and transported, they proliferate quickly. They reach second and third audiences, which makes for new interpretations beyond the first-order Hindu reading of the image. Although various gods in separate Vodun compounds may derive from the same Hindu image, the gods, the images, and the practitioners' interpretations take on lives of their own. Similar images appear in different Vodun settings with different names. In most cases, the images are unrelated in any way other than appearance. Vodun priests and priestesses in different Vodun compounds can argue over "correct" appellation and use of images in religious practice,

while the images in dispute are hardly, if ever, local in origin. Admittedly there is overlap and grounds for potential confusion. However, what appears at first glance to be confusion can and likely will become multi-layered fusion.

The Sea = India

To the people living along the Atlantic coastline of Bénin and Togo, the sea—with its force and intensity, potency and vigor, and unpredictable temperament—is more than anthropomorphic: it is deistic. The sea gives and takes; it sustains life, and it can kill. Most importantly, the sea offers the most fervent spiritual authority along the whole of this coastline. It is home to important primordial spirits such as those within the Hou/Agwe Vodun complex, as well as to newly emerging spirits, such as those within the Mami Wata Vodun complex and its associative grouping of India Spirits. Veneration of such sea spirits is reliant upon imported chromolithographs, which in their extravagant proliferations and transformations reveal the open-endedness of Vodun and its unfinished aesthetic in action.

In Vodun thought, India Spirits are invariably from the sea and associated with an idea of India, rendering "India" and the sea synonymous; they are known yet unknowable, a paradox mediated through art. Because the sea is as deep as one's own imagination, and vice versa, the breadth of India Spirits, associated India arts, and India experiences is inexhaustible. At the same time, this very coastline—liminal as it may be—is a gateway to centuries of very real transatlantic interactions and exchanges during the slave trade (see Chapter 5). In effect, along this West African seaboard, two simultaneous processes have occurred in which the sea functions as both a passageway to vast cultural and spiritual potential and an exceedingly lucrative portal to centuries of travel and commodities exchange.

"India," therefore, does not always refer to the peninsula region of South Asia, south of the Himalayas and between the Bay of Bengal and the Arabian Sea, where Hindus and others live and revere their gods. In West African Vodun art and thought, the idea of India goes beyond geography or theology. Rather, "India" offers myriad aesthetic and spiritual opportunities.

The Search for India Spirits

Henry Drewal has documented the earliest evidence to date of the incorporation of a foreign printed image into a local religious vocabulary in West Africa. He has traced the history of the most popular representation of Mami Wata (fig. 4.1), the African water spirit-*cum*-seductress. The image was based

on a late nineteenth century chromolithograph mentioned previously, of a European painting depicting a snake charmer, likely Samoan, in a German circus (Drewal 1988, 1996; Salmons 1977). Dating circa 1885, the chromolithograph was reprinted in large numbers in India and England and distributed widely in sub-Saharan West Africa. The edition that Drewal (1988b, 169 fig. 7) published was printed in Bombay by the Shree Ram Calendar Company in 1955 as a copy of an earlier version provided by a trader in Kumasi, Ghana. Between 1955 and 1956 twelve thousand copies of the 10″ × 14″ print were sent to this and another trader in Kumasi (Drewal 1988b, 183n6). The image has since been reproduced even more widely and has been found in the Dominican Republic and Haiti (Houlberg 1996, 30–35, 101), as well as in botánicas throughout the United States in the form of printed images, statues, candles, and pendants.

Although by far the most popular chromolithograph, the image of the snake charmer is by no means the only print found in West African religious practice. Also common are chromolithographs of figures from the ancient Indian epic the *Ramayana* and other lore and world religious histories, including prints of Rama, Sita, Hanuman, Shiva, Dattatreya, Shirdi Sai Baba, Sathya Sai Baba, the Buddha, Guru Nanak, and al-Buraq, as well as the Pope, Eve, Jesus Christ, the Virgin Mary, and various Christian saints. Secular images such as animals and floral arrangements are common as well (fig. 4.2).

Indian chromolithographs remain quite significant in contemporary Vodun practice despite the fact that they are no longer as readily available for acquisition as they once were. The difficulty in finding sources for India Spirit artistic proliferation, namely chromolithographs, surely adds to their appeal and their market value. During my field work and on a postdoctoral return to the field, I actively sought sources for the Hindu images. In Bénin, Togo, and Ghana, I visited and spoke with Indian merchants, local market people who sold the images, Vodun practitioners, and artists who incorporated the images into their work. I also frequented Hindu temples in this search.[3] Although I learned a lot of very valuable information (e.g., about who buys these images and about their prices), I was never able to pinpoint any sources or to find a local distributor. The images had to come from somewhere. Why were people so hesitant to discuss this? Or did they really not know the answers to my questions? Below I abbreviate several field studies to animate some of the diverse local personalities who helped me on my quest.

Mama Sikavi

In the mid-late 1990s, a particular market stand in the Asigamé Market in Lomé, Togo, within view of the Atlantic coast, was a "hot spot" for purchasing Indian prints.[4] People used to travel there from the bordering countries of

Bénin and Ghana to seek out India spirit prints from Mama Sikavi, the very discerning market woman who kept her stand full to overflowing with wide varieties of constantly changing images (fig. 4.3).

It was Mama Sikavi who helped me begin to understand that along this coastal area the sea is not just an apt metaphor for India; the sea is India, or an idea of India. When I asked her where she located her images, she would respond either "the sea" or "India." Initially, I thought she was being evasive, but I grew to recognize that "the sea" and "India" are synonymous, and represented to her a place that is unknowable yet a place with which she felt at one because it offered her spiritual and monetary security.

Mama Sikavi also sold decorative promotional calendars that were originally created as a form of advertising within both Indian communities in the sub-continent and Indian diaspora communities in West Africa. She removed the images from the calendars appended to the bottom of the print, though the name of the business was still visibly printed on the images themselves. In Figure 4.4, for example, the super-abundance of flowers, gold, jewels, coins, and other luxurious items surrounding the spiritually charged deities function as links into particular Vodun sensibilities, especially those of Mami Wata, the Vodun of wealth and beauty who commands the sea and serves as a source of potential wealth, both religious and economic.[5]

Indeed, the images of Indian spirits that Mama Sikavi sold were all interpreted as Vodun spirits. In Figure 4.3, above the chromolithograph to which the young man points, is a Hindu print that I thought depicted Krishna with his principal paramour Radha. Mama Sikavi corrected me, stating that I was looking at Mawu-Lisa, the androgynous dual deity in the Vodun pantheon. She also said that the print to the left is Ablòlisodji, or "liberty on a horse," *not* what I recognized as the Sikh image of Guru Gobind Singh Ji. The print to the right is Edan, the serpent Vodun,[6] *not* the Hindu image that I incorrectly identified as Krishna playing a flute while dancing on the dangerous snake Kaliya. During another of my visits with Mama Sikavi, she pointed out the Vodun spirit Confusci from an image of the Buddha, as well as a print of Mami Sika, close to her own name meaning "Mother of Gold," from the Hindu image of the Durga.[7]

One day while I was talking to Mama Sikavi, she signaled for me to look down the overcrowded market street as a chauffeur-driven, brand-new Mercedes slowly approached. She said quietly *kpon*, or "watch this" as she gestured with her eyes toward the upcoming car. I stepped aside and watched. The car pulled up in front of the market stand, and the Togolese chauffeur stepped out and opened the back doors. A magnificently adorned Indian woman stepped out of one side and her well-dressed husband stepped out of the other. They quickly examined the chromolithographs on display. The man

removed two images of Ganesh, handed them to his wife, and walked over to Sikavi, giving her a 10,000 CFA bill ($20). Usually customers haggle for a price between 500 CFA and 1500 CFA (500 CFA = $1) for one print. From the arrival of the car to its departure, the whole transaction was completed in less than five minutes.

Mama Sikavi later explained to me that Indians are very wealthy, and that they paid whatever price she asked because they needed the powers of their gods to remain wealthy. She said that Indians were the only people in the world who can control the sea. She attempted to clarify this by explaining that they had very important ritual ceremonies at the beach. The normally quiet Mama Sikavi continued excitedly without being prompted. She said that she knew when they had "made ceremony" [sacrificed animals] at the beach because they wore a red spot of animal blood on their foreheads (the traditional Indian *bindi* spot, which is not from blood). The way she exoticized the Indians was very similar to how Europeans, from early travelers' reports to the present-day guidebooks, have been known to exoticize Vodun. When I returned to Lomé in 2005, Mama Sikavi was gone. After successfully working the same market stand for close to twenty years, she had retired in 2004.[8]

Edouard and the Pastor's India Prints

I did find a little stand, though, directly facing the ocean, around the corner from where Sikavi used to sell posters and tucked back between shoe merchants, where chromolithographs could be purchased. I spoke with Edouard, the Togolese merchant who was very happy to answer my questions regarding his India prints. In his display, Edouard pointed to a print of Krishna standing on top of snakes that formed a wave over his head. As with Sikavi, he called the spirit Edan, the snake Vodun. However, when Edouard pointed to another lithograph of a four-armed Krishna with crossed legs sitting on Kaliya in the form of a throne of coiled snakes, he called the spirit Aida Wedo, shortened from Dan Aida Wedo, the rainbow serpent Vodun. He then pointed to the Mexican Virgin of Guadeloupe. He explained that such an image is often bought by Christians because they believe that she is the mother of Jesus. I asked him what he thought. He explained that she might very well be Jesus' mother, but so too are Mami Wata and Lakshmi. Clearly, Lakshmi retained her Indian name, though she is sometimes conflated with Mami Wata.

When I asked Edouard the source of his posters, he became quiet. Once I assured him that I was interested in his supplier purely for research purposes, he told me of "the pastor" whose church was in the Hedjranawoê neighborhood on the outskirts of Lomé proper, also known as Lomé 2. Edouard whispered that the pastor had been to India many times and was the only person in

Lomé who could exorcise India Spirits that became too powerful. He added that the pastor had great healing powers. Edouard also noted that the pastor traveled a lot and was difficult to pin down.

I had never been to Lomé 2, so I enlisted a friend who had been born and raised in Lomé to help me in my exploration of Lomé 2. No one we questioned knew anything about the so-called pastor. We decided to stop at the market to look around and maybe find some India prints. No prints. After a hot, dusty, unsuccessful, exhausting day, we felt lucky to find an empty taxi to take us back into the city. We were joking about the mysterious pastor "qui n'existe pas" when the taxi driver interrupted us and asked if we were looking for the "Le Pasteur de Nouvel Jerusalem?" We were not quite sure what we were looking for but decided to let the driver take us to this pastor.

This pastor's house was marked with a large sign painting covered with Christian iconography plus the promising exhortation: "*Pour Tous Vos Problemes Consultez Le Pasteur de Nouvel Jerusalem*" (For All of Your Problems, Consult the New Jerusalem Pastor). We were not encouraged by the absence of Hindu iconography on his sign, but we still opened the heavy gate and walked inside. Several people in the outdoor courtyard of his compound were waiting to see the pastor. We learned that some people had been waiting for a consultation since morning. We sat down and were immediately served water. About an hour later, as evening approached, we decided to head back to Lomé and to return early the next morning.

We arrived early, but it was not until three o'clock that the pastor was ready to see us. His office was filled with books, images, and statues, mostly Christian, but there was a small Hindu and Muslim presence, which he refused to address when questioned. We talked for over an hour, yet he continually refused to acknowledge anything having to do with India, India Spirits, Indian posters, or travel to India. He also refused to grant me permission to take photographs. I told him about the chromolithographs I had been investigating, and he perked up momentarily, but his enthusiasm was short-lived.

He invited us back multiple times, though we continued to make little progress. During one visit I commented on a small image in his office: that of Sathya Sai Baba, the enormously popular Indian guru, religious leader, and philosopher. The pastor seemed shocked, and immediately said, "How do you know [about] Sai Baba?" I explained that I had a read a few books, but I did not know much. Unexpectedly, he opened his desk drawer and pulled out a thick stack of glossy posters he had just received from India, all of Shiva, one of the oldest gods of India. He still would not tell me anything about the prints except that they were shipped to him from India.

He then stood up, opened the back door, and told us to follow him down an open-air hallway leading to the far end of his compound. He stopped to

FIG. 4.1 Mami Wata
lithograph. Private
collection.

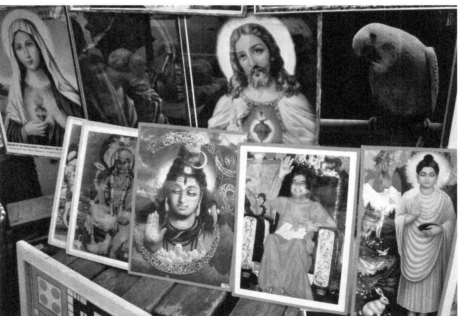

FIG. 4.2 Market stand with image of Sathya Sai Baba to the right of Shiva. Asigame market,
Lomé, Togo, January 2000.

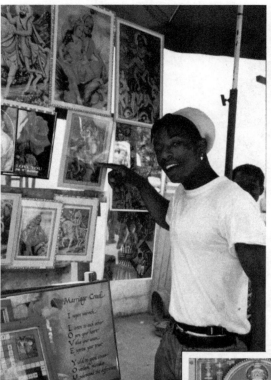

FIG. 4.3 Mama Sikavi's market stand. Asigame market, Lomé, Togo, January 2000.

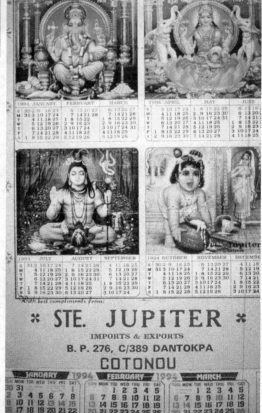

FIG. 4.4 Calendar Societé Jupiter. Private collection.

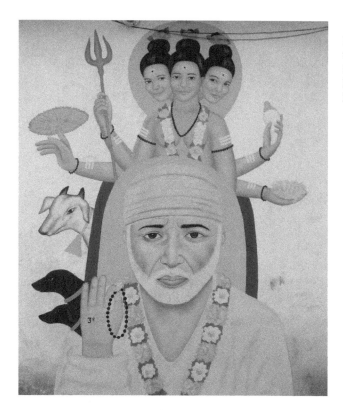

FIG. 4.5 Densu temple painting from image of Shirdi Sai Baba. Comè, Bénin, 2010.

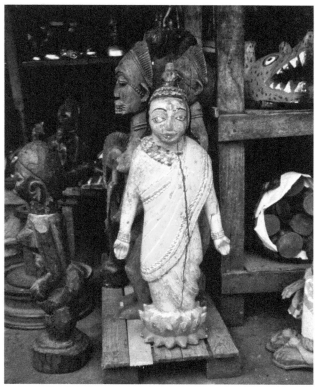

FIG. 4.6 Lakshmi sculpture. Ganhe market, Cotonou, Bénin. March 1996.

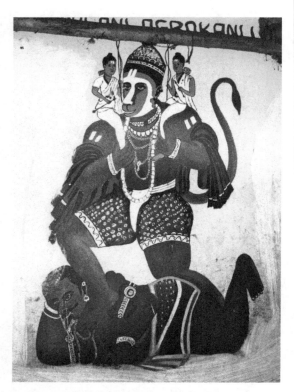

FIG. 4.7 Attinga temple painting of Foulani Agbokanli. Abomey-Calavi, Bénin, December 1994.

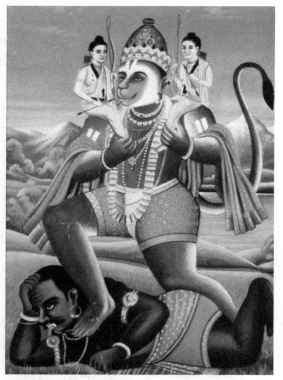

FIG. 4.8 Hanuman chromolithograph. Private collection.

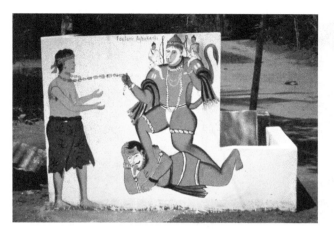

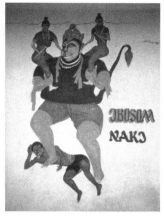

FIG. 4.9 Attinga temple painting with Foulani Agbokanli catching a "witch." Abomey-Calavi, Bénin, December 1994.

FIG. 4.10 Fante Hanuman wall painting. Between Accra and Cape Coast, Ghana, January 1996.

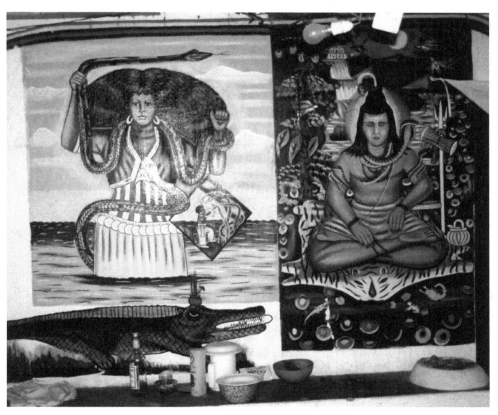

FIG. 4.11 Wall mural with Mami Wata and Shiva, painted by Joseph Ahiator. Lomé, Togo, December 1999.

FIG. 4.12 Shiva lithograph. Private collection.

FIG. 4.14 Dattatreya lithograph. Private collection.

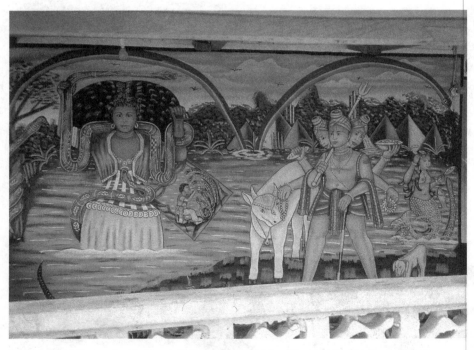

FIG. 4.13 Wall mural with Mami Ablò and Densu, painted by Joseph Ahiator. Lomé, Togo, December 1999.

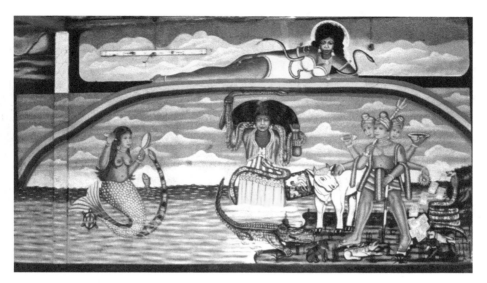

FIG. 4.15 Wall mural with Mami Wata and serpent spewing Ghanaian currency (Cedis), painted by Joseph Ahiator. Lomé, Togo, December 1999.

FIG. 4.16 "India Spirit" wall mural painted by Joseph Ahiator in Mami Wata temple. Cotonou, Bénin, January 1995.

FIG. 4.17 Hanuman lithograph.
Private collection.

FIG. 4.18 To the right of the "India Spirit" wall mural painted by Joseph Ahiator in Mami Wata temple. Cotonou, Bénin, January 1995.

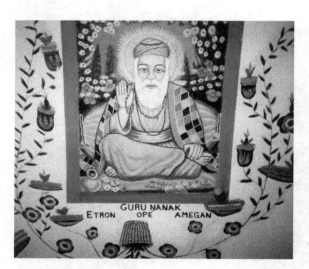

FIG. 4.19 Painting of Guru Nanak on ceiling in front of "India Spirit" wall mural painted by Joseph Ahiator in Mami Wata temple. Cotonou, Bénin, January 1995.

FIG. 4.20 Shiva/Guru Nanak conflation painted by Joseph Ahiator. Lomé, Togo, January 2000.

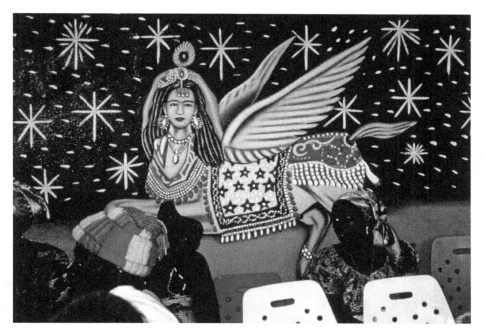

FIG. 4.21 Wall mural of Mami Sodji stemming from an image of al-Buraq in Thron temple painted by Joseph Ahiator. Lomé, Togo, January 2000.

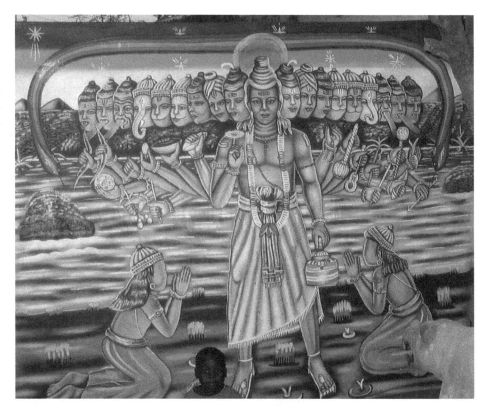

FIG. 4.22 King of Mami Wata, painted by Joseph Ahiator. Aflao, Ghana, January 2005.

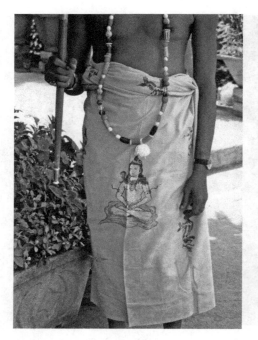

FIG. 4.23 Gilbert Atissou wearing his Shiva cloth. Aneho, Togo, February 2000.

FIG. 4.25 Yoni/Shiva shrine in Gilbert Atissou's Mami Wata temple. Aneho, Togo, February 2000.

FIG. 4.24 Rhada wall painting at entry of Gilbert Atissou's Mami Wata temple. Aneho, Togo, February 2000.

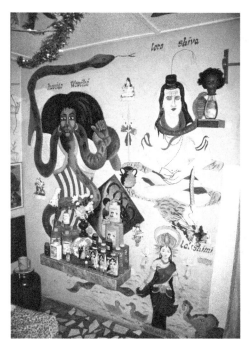

FIG. 4.26 Wall painting in Gilbert Atissou's Mami Wata temple. Aneho, Togo, February 2000.

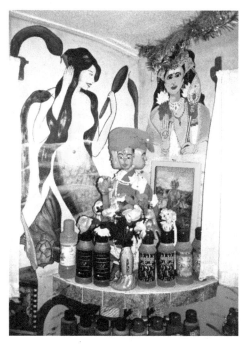

FIG. 4.27 Mami Wata wall painting and Densu shrine inside of Gilbert Atissou's Mami Wata temple. Aneho, Togo, February 2000.

FIG. 4.28 Detail of one shrine inside shrine room in Gilbert Atissou's Mami Wata temple. Aneho, Togo, February 2000.

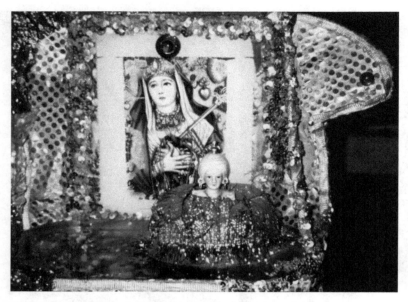

FIG. 4.29 Pierrot Barra's Ezili sculpture. Port-au-Prince, Haiti, July 1997.

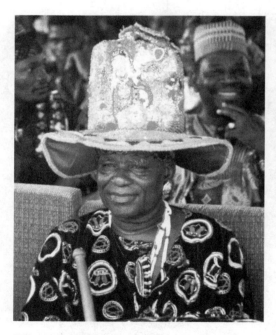

FIG. 4.30 Daagbo Hounon Houna, National Vodun Day 1996. Ouidah, Bénin.

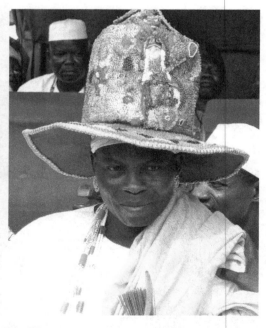

FIG. 4.31 Daagbo Hounon Houna's son wearing his late father's hat, National Vodun Day 2011. Ouidah, Bénin. Photo by Andoche Adjovi.

open a door that had multiple bolt locks, reached in to turn the lights on, and invited us to follow him in. He led us into a sitting room devoted entirely to Shiva but very dimly illuminated by strings of multi-colored lights. There were chromolithographs framed and hung next to larger-than-life wall paintings of Shiva on the bluish-green walls; there were large vases filled with peacock feathers and bright artificial flowers, a multitude of Shiva statues, stuffed animal tigers, and carved tigers, as well as other objects I was unable to see very clearly. He did not invite us to sit down, but rather escorted us out, turned off the lights, re-bolted the door, and took us back into his office.

I was able to ask at least a few questions about his devotion to Shiva, his Shiva room, and his chromolithographs in general. The pastor was indeed a healer, but he was also an international businessman who traded goods with India and visited there often. He fell sick one time while traveling in India and was healed in a Shiva temple. He had never known Shiva before, but he decided to devote his life to Shiva veneration, albeit with more Vodun precepts than either Hindu or Christian. In parting, I asked him what he planned to do with his large stack of Shiva prints. He said that they were all for Shiva, and politely told me that I had enough information for one day. That was the last time I spoke with him. He left the country on an extended business trip, and I was never able to catch up with him again. The point of this extended story is simply to demonstrate that the power surrounding the idea of India is difficult to penetrate in any concrete way, as are most things Vodun.

After my multiple attempts at reaching out to the pastor, I returned to the Asigamé market in Lomé to visit with Edouard. I told him how difficult it was to engage in conversation with the pastor, and that he would not admit to supplying prints to local markets. Edouard said that the pastor did not have time to distribute the prints himself, but rather sent his people to do so. I told Edouard that the pastor never talked about exorcising "India Spirits." Edouard said that he had personally learned a lot from the pastor who taught him that India Spirits are the most powerful in the world—more powerful than Vodun, more powerful than Jesus. He taught Edouard that these powerful spirits come from the sea. I asked if he was referring to the Indian Ocean. He looked at me quizzically, then he pointed to the Atlantic Ocean directly across from his market stand and repeated, "They come from the sea." On my next visit to the Asigamé Market, I found a poster of Sathya Sai Baba, who, I was told, was an Indian spirit newly arrived from the sea (see fig. 4.2). The only other image I have seen of Sai Baba—this time Shirdi instead of Sathya—was on a temple wall in Comè, Bénin in 2010 (fig. 4.5). The priest of this temple explained the painting as a manifestation of "Densu," often known as the husband of Mami Wata. The image is based on a chromolithograph of Shirdi Sai Baba that I have seen on display in a handful of Indian-owned stores in Cotonou and Lomé, but never for sale.

Other India Sources

Aside from chromolithographs, another likely source for Hindu imagery is the popular Hindu movie corpus shown throughout Africa. Because Bollywood culture is a fundamental part of the Indian diasporic experience, anywhere Indians live the latest films are available. However, in the 1950s and 1960s, around the same time that the Mami Wata ur-image (fig. 4.1) was widely circulating, Indian films became popular for West African audiences. Although the African audiences did not understand the Hindi narration and song, the incarnations of Hindu deities into human form seem to have functioned similarly to how the Hindu deities in chromolithographs represent local Vodun gods. I have been told by people in their 30s and 40s that they used to see Hindu movies in excess of ten times. By the fourth or fifth viewing they would have already invented a dialog among the characters and would have been singing Vodun songs for the Hindu spirits. I, however, was only able to find a few Hindu movies in Cotonou, and the theatres were close to empty when the movies played. Since the 1990s, Hindu films in Bénin and Togo have been replaced by Hollywood action films, and movie theaters have been supplanted by homes where older VHS tapes and the latest DVDs are played to audiences at a very high volume for a nominal fee.

At a sculpture market in Cotonou, geared mainly for tourists, I found an item for purchase that had a relationship to India. In a line of market stands, among piles of tourist masks and sculptures, one cracked and quite dirty sculpture of the Hindu goddess Lakshmi stood out (fig. 4.6). The sculpture appears to have been locally carved in that it is similar in form and colors to a Gɛlɛdɛ sculptural style found between Porto-Novo and Sakete.[9] When I asked about the sculpture, I was told that it represented Mami Wata.

Hindu Images in Specific Vodun Complexes

Although iconographic idioms emerge in their mass-produced, production-line format, chromolithographs defy monolithic interpretation through the addition of human and spiritual agency. The same chromolithographic image is used to represent distinct Vodun spirits with independent origins, names, and histories, as exemplified in the following example.

Ramayana Remix

The monkey-king, Hanuman, is a popular hero who became a god in the ancient Hindu epic the *Ramayana*. Dedicated to Rama, the seventh incarnation

of Vishnu, the epic narrates the trials and tribulations of Rama and his wife Sita as they go into exile accompanied by Rama's brother Lakshmana. Sita is abducted by Ravanna, the demon-king of Lanka (now Sri Lanka), and is rescued by Hanuman, the faithful servant of Rama (Narayan 1972).

The image of Hanuman appears in Attingali Vodun, the powerful witch-fighting Islamic Vodun concentrated in and around Abomey-Calavi, Bénin (see Chapter 3). The strongest soldier in the Attingali pantheon is known as Foulani Agbokanli, "Foulani cow-animal."[10] An Attingali temple painting of Foulani Agbokanli (fig. 4.7) closely resembles a chromolithograph from the *Ramayana*, illustrating a victorious Hanuman with a diminutive Rama and Lakshmana on his shoulders (fig. 4.8). Here, the demon king Ahiravana (Ravanna's son or, in some versions, his brother) is shown prostrate under Hanuman's foot, as described at the end of the *Ramayana* episode in the netherworld of Patala Loka (Lutgendorf 1995, 3–8).[11] Yet in Abomey-Calavi, the same small shoulder-perched figures are known as Ablewa, or the "angels" of Foulani Agbokanli, who help him fight witchcraft. Another Foulani Agbokanli shrine, a five-minute walk away from the Attingali temple, displays a painting depicting the same Hindu chromolithograph, but there, Foulani Agbokanli has captured a second witch (fig. 4.9). Thus, the chromolithographic image is ever-evolving. Although they look identical, there is no relationship between Foulani Agbokanli, the Foulani cow-animal, and Hanuman, the Hindu monkey king.

Likewise, along the coast of Ghana, between Cape Coast and Accra, an outdoor wall painting derived from the same chromolithograph represents neither Hanuman nor Foulani Agbokanli, but a hero in a Fante belief system (fig. 4.10).[12] The image's breadth and influence become even more evident in an Ibibio shrine sculpture said to have been found in a Kalahari Ijo shrine in the eastern Delta region of Nigeria. The sculpture, also based on the lithograph, quite likely comes from a southern Ibibio group, such as Anang, and dates from the last half of the nineteenth century (see Arnett and Wittmer 1978, 60–61). In this case, the shrine sculpture was perhaps used in Mami Wata veneration.

Hindu Images in Mami Wata Vodun

Along coastal Bénin and Togo, Mami Wata is much more than a single spirit: she is an entire pantheon. For any new problem or situation that arises needing spiritual intervention or guidance, a new Mami Wata spirit arises from the sea. Modern day uncertainties (such as birth control, abortion, prostitution, homosexuality, and transexuality) are often embraced and made sense of through Hindu imagery used in Mami Wata religious practice.

The Mamisi, "wives" or devotees of Mami Wata (*-isi*; from *asi*, wife in Fon), not only worship their own demanding spirits from the sea and new spirits addressing the needs of a quickly changing society, but they must also venerate the principal gods found in most Vodun houses such as Gu, Sakpata, Xɛvioso, Tohosu, and Hohovi.[13] They have found an ingenious way to do so, with the aesthetic and spiritual flair that has come to be expected of Mami Wata devotees. They have incorporated parts of the Hindu pantheon into the worship of these main gods, representing them with lavish Hindu chromolithographs reproduced on temple walls and placed in Mami Wata shrines. Some examples of this process can be seen in the work of one artist in particular.

Joseph Kossivi Ahiator and His India Spirits

Exemplifying the ever-changing, flexible nature of life, the omnipotent rainbow serpent spirit, often swallowing its own tail, was set in motion at the beginning of time. Along coastal Bénin and Togo, Dan Aida Wedo continues to be revered to this day.[14] New Orleans-born Charles Neville refers to the transatlantic version of this rainbow serpent when he shouts out "Dambala Wedo!" at the beginning of the Neville Brothers' well-known song "Voodoo." Dambala Wedo is the rainbow serpent spirit that arrived in New Orleans via Haiti, where s/he is called Dambala [et] Aida Wedo, and originated in coastal West Africa.

The same transatlantic rainbow serpent arches over, unites, and connects a particular grouping of Mami Wata spirits known collectively within coastal Vodun as "India Spirits," as envisioned by Ghanaian artist Joseph Kossivi Ahiator. His rainbow serpent, for that reason, forges links between and among Africa, India, the sea, and, in turn, the Americas. In most of Ahiator's incorporations of Indian imagery into contemporary Mami Wata art and thought, Dan Aida Wedo serves as the umbrella that makes possible all of these trans- and inter-oceanic connections. That is, this rainbow serpent with its implied regenerative elasticity, allows for the inspired synthesis of "India" into the organic world of Mami Wata.

Ahiator is the most sought-after India spirit temple painter in Bénin, Togo, and Ghana. He explains his inclination toward the sea as a result of having been born with India Spirits and of visiting India often, sometimes in his dreams, sometimes while at the beach along the Atlantic coast. When commissioned to paint a Mami Wata Vodun temple, Ahiator consults his own array of chromolithographs and then elaborates the images based on his own dreams and on the dreams and desires of the temple owner. The representations of a particular set of spirits within the Mami Wata pantheon that Ahiator has envisioned and executed are all recognizably derived from Hindu

chromolithographs. He generally places a combination of deities from this particular set of spirits under the protective arch of Dan Aida Wedo. A discussion of some local-*cum*-India Spirits painted by Ahiator follows.

Under Dan's Rainbow. Under the rainbow serpent in Figure 4.11, Ahiator unites the ur-image of Mami Wata, known here as Mami Ablò (Mother of Liberty),[15] with her husband, called here Ako Ado, based on a chromolithograph of Shiva.[16] In the chromolithograph (fig. 4.12), the bird is a parakeet, which is a*ko* in Mina. Although the parakeets in the lithograph are not reproduced on the temple painting, the namesake (*ako*) implies Ako Ado's deep spiritual attachment to parakeets. Their children are represented in the snakes that the helper figure on Mami Ablò's left side is calling as well as the snakes around Ako Ado's neck and arms. The alligator in the foreground, called Ajakpa, is their "chauffeur." Protruding from a little clay pot on Ajakpa's head are his "spiritual weapons"—the ancient Vodun symbols for Xɛvioso (the Vodun of thunder, lightning, and associated elements) and Dan Aida Wedo. To maintain his strength, Ajakpa has his favorite food, an egg, in his mouth.

Ako Ado (Shiva), an integral member of the Mami Wata pantheon, is highly associated with the sea, and therefore also with India. Thus, while traveling outside of the sea, as seen here in the forest, he is protected by the sea, which is eternally spouting out of the top of his head. He is known for having "all spirits" with him, demonstrated by the Islamic prayer beads in his right hand and the Holy Bible under his left elbow. He uses his ever-present drum to call other spirits to come dance, pray, and celebrate with him. The temple owner, Mamisi Ablosi Tsipoaka, explained that she was having recurring dreams of Ako Ado (Shiva). She commissioned Ahiator to paint him exactly as she had described to him from her night visions.

In another India Spirits mural, Ahiator reformats the composition with a bilaterally split rainbow serpent, demonstrating Dan Aida Wedo's multitudinous potentiality (fig. 4.13). Mami Ablò and her children (the snakes) are on the left of the composition. Densu, on the right, comes directly from the chromolithograph of Dattatreya, the Hindu Triple Giver (fig. 4.14). Although commonly known as Mami Wata's husband, in this case, Densu is both male and female and shows the path to riches (gold items in his hands) from Egypt (the abstracted pyramids in the background). A new Mami Wata India spirit is introduced on the right, emerging from the water and combing her golden-black hair while gazing into a mirror. This spirit, known often as Mami Sika (Mother of Gold), is even more "Indianized" with the Hindu *bindi* spot on her forehead, and slightly darkened skin. This spirit originates in an image of a very fair-skinned, golden-haired mermaid found on the popular Mammy

Water brand perfume and powder bottles, once produced by Dralle company (Drewal 1988). The temple owner, Mamisi Amegashie Tsabashie, stresses that her wealth is directly from Dan Aida Wedo, Mami Ablò, and their helpers.

In one more temple mural with similar spiritual components, Ahiator adds a reminder of the wealth to be gained by strict devotion to Mami Wata: on the bottom right is a coiled snake spewing out bills in the Ghanaian currency (fig. 4.15). Mami Ablò's serpent, merging with the overarching rainbow, separates her from her earthly doppelganger lounging seductively on top of the rainbow. Although no longer under Dan Aida Wedo's protective arch, this "temporarily human" avatar of Mami Wata wraps herself in some miniature *dan* (serpents) for security. She also dons a Hindu *bindi* spot on her forehead, connecting her to India and the sea.

Hanuman/Gniblin. Figure 4.16 shows the right side of a large Mami Wata mural that was one of the first multiple India spirit murals Ahiator ever painted, in Cotonou in the early 1990s. I will discuss only the images on the right side of the mural here, because the left side does not include India Spirits.[17] The powerful half-animal, half-human super-being called Gniblin Egu, known as a "cow-person" of Egu, is near the center of the mural, on the left side of Figure 4.16.[18] Gniblin is famous for his power of Egu, the Mina cognate of the Yoruba Ogun, and the Fon Gu, deities of iron, war, and technology. Gniblin Egu is credited with teaching iron technology to people. Although Gniblin Egu comes from the sea, Mami Wata adepts hold that he lives on the road and is associated with traffic accidents. He can travel anywhere and his fiery tail can be seen as he flies through the air. If he is angry, he can burn a whole city, and he can use his tail to beat enemies.

The temple painting of Gniblin Egu is based upon a chromolithograph (fig. 4.17) showing Hanuman responding to the challenge that he does not have the power to carry the essence of Prince Rama and/or Sita with him wherever he goes. Hanuman has torn open his chest and, to the bewilderment of onlookers, revealed Rama and Sita within. Similarly, as shown in the Ahiator mural, Gniblin Egu tore open his chest to demonstrate that he carries his deceased parents with him at all times, thus proving his eternal respect for them. Given the importance of ancestral veneration among Fon and Mina peoples, Gniblin Egu is both a Vodun spirit and an ancestral shrine. Hanuman, in this Vodun context, is interpreted as bovine rather than simian, as in Foulani Agbokanli in Attingali (see figs. 4.7–4.10).

Ganesh/Tohosu. Tohosu Amlima is to the right of Gniblin Egu (in the center of fig. 4.15). Tohosu is the Fon Vodun of royalty, human deformations,

lakes, and streams. Amlima means "strange" or "mysterious" in Mina. The painting of Tohosu is based upon a Hindu chromolithograph of Ganesh, the elephant-headed, pot-bellied Hindu god of thresholds, beginnings, and wisdom who removes obstacles. Although he has only one tusk, he has four arms in which he holds a shell, a discus, a club, and a water lily. His means of transportation is a rat, here depicted in front of him. The image of Ganesh visually encapsulates the Fon spirit of Tohosu: royal (surrounded by wealth and corpulent from luxurious dining) and super-human (a human with an elephant's head and four arms).

The chromolithographic image that inspired this painting has directly influenced the Mami Wata worship of Tohosu Amlina. That is, a Mamisi with the spirit of Tohosu Amlima may never kill rats, for this creature—painted on the mural but originating in the chromolithograph—has become sacred to the spirit's devotees. So, not only do Hindu chromolithographs suggest and reify characteristics already inherent in local gods, but they also introduce, influence, and change already established, albeit organic, religious practice, attesting to the profundity of "visual piety" (see Morgan 1998).

Shiva/Mami Dan. To the right of Tohosu in Ahiator's mural is Mami Dan,[19] also called Ekpon, which means panther in Mina. He is known to be as old as the sea, and it is his job to clear the path for Mami Wata. Mami Dan was born with and is always depicted with snakes draped around his neck. This depiction comes directly from one of the best known illustrations of Shiva, called Shiva-Dakshina-Murti or Mahayogi (fig. 4.12). In Brahmanic theology, Shiva is the third member of the divine Trinity of Creator-Preserver-Destroyer, and although his name means "the friendly one," he is also the Lord of Destruction.

The Hindu chromolithograph shows Shiva as an ascetic in deep meditation atop the Himalayas. He is wearing a simple loincloth and is seated on a tiger skin, which Mamisi say is the panther (*ekpon*) who clears the path for Mami Dan, and in turn, Mami Wata. In northern India, Shiva always has a cobra around his neck and a trident, drum, and water jug nearby, all of which also surround Mami Dan in the Mami Wata temple painting. Mamisi call the trident *apia*, which can be reproduced as a protective tattoo pattern and drawn on the earth with sacred powders. *Apia* tridents are also carried as ritual paraphernalia which, when not in active use, are stored in Mami Wata shrines.

Dattatreya/Densu, Mami Ablò, Mami Sika. Densu, commonly known as Mami Wata's husband, is painted at the far right side of the mural and originates directly from the Indian chromolithograph of Dattatreya, the Triple Giver seen

earlier in Figure 4.14 and on the left of Figure 4.18. Practically reaching their tongues to the disc in one of Densu's hands, the double Dan Aida Wedo in the mural also connects the land to the sea, Africa to India.

A sacred area to the right of Densu is delineated with two painted wall murals (fig. 4.18) forming a corner around an active Mami Wata shrine. Mami Ablò and Mami Sika are painted on one side, and three Ajakpas (alligators), who protect the Mami Wata from unwanted visitors who might jump the barrier, are painted on the adjoining wall. Mami Wata's head is visible on the back wall, as she calmly combs her hair and gazes into her mirror.

Sikhism and Islam within Mami Wata India Spirits. On the ceiling directly in front of this wall mural, Ahiator painted another religious entity from India based on a lithograph of Guru Nanak, the founder of India's Sikh religion (fig. 4.19). He was born into a Punjabi Hindu family in 1469 and became the voice of Akal Purakh, the Sikh name for god. However, in Ahiator's representation, he is named "Guru Nanak, Etron Opé Amegan," or big chief of the Etron Vodun. As discussed in Chapter 3, Thron is a Vodun society with Islamic origins and often associated with Mami Wata. In the 1950s, according Ahiator, Guru Nanak arrived on the beach in Ouidah, Bénin, directly from India in an underwater sea lorry. To this day, he still lives in India along the Ouidah coastline and only surfaces for important events. I also documented another of Ahiator's paintings associated with Guru Nanak (fig. 4.20). However, in this rendering Ahiator merged the print of Guru Nanak seamlessly with the print of Shiva sitting cross-legged on an animal skin, with a trident at his side and the Himalayas in the background (compare to fig. 4.12).

In addition to Guru Nanak, Ahiator brings another world religious icon into his Mami Wata/India Spirits repertoire. In an Etron temple in Lomé, Togo, Ahiator painted a very powerful Mami Wata, who not only has command of the earth and the ocean, but also has great power in the sky (fig. 4.21). This Mami Sodji (Mami on Horse) derives from a chromolithograph of al-Buraq, the winged and woman-headed horse upon which Mohammad flew from Mecca to Jerusalem.

Indian King of Mami Wata. Ahiator has more recently reincorporated two Indian images from his mental archive into his India spirit Vodun corpus. In January 2005 he had very vivid dreams of a nineteen-headed Indian King spirit dancing with a nine-headed Indian Queen spirit. He later experienced the same images of these figures swimming with him in the ocean. Compelled to paint them, he first painted the King, whom he calls the King of Mami Wata, under the ever-present rainbow serpent[20] (fig. 4.22). Unfortunately, Ahiator does not remember the India Spirit name of the nineteen-headed god, as the

image was last shown to him in 1977. However, it is possible that the print was a chromolithographic version of Virat Swaroop, or Vishnu, in Universal Form. The queen, whom he recalls is named NaKrishna, is likely derived from a multi-headed print of Ravanna.

Clearly, the integration of Indian images into Ahiator's artistic repertoire, in union with multifaceted spiritual fervor, attests to the ongoing, "unfinished," incorporative sensibilities of Mami Wata art and thought. Hindu influence, mixed into local religious systems and combined with other foreign inspirations, also extends well into Nigeria. Anthropologist Joseph Nevadomsky (1997, 58 fig. 4) photographed a chromolithograph of Shiva in a Mami Wata shrine in Benin City, Nigeria, as well as a two-headed, double-haloed female Jesus with a snake around his/her waist held up in two of four arms. The foreheads of Jesus are graced with Hindu *bindi* spots.

Mami Wata and Dan: Serpent Appeal

According to one of Herskovits' ([1938] 1967, 2:253n3) informants, "Da[n] is the oldest *vodu* of Whydah [Ouidah] and Porto Novo, the first inhabitant of these places." In a myth recorded by Herskovits, Dan is primordial: "When the Creator began forming the world as it exists today, he was carried everywhere in the mouth of Aido-Wedo, the serpent" (248–249). It is clear that Dan Aida Wedo existed long before Mami Wata and her proliferation of images surfaced. How, then, did they merge so immaculately? They both possess numerous analogous characteristics, but most noteworthy is that both Dan Aida Wedo and Mami Wata embody the arbitrary nature of power and wealth. They are fickle; that is, they may bestow riches in a manner that appears haphazard, or they may seize what they had given with no warning. The ever-present iridescent serpent in the most widespread image of Mami Wata *is* Dan Aida Wedo. The visual conflation is seamless.

Not only does this ubiquitous rainbow serpent link coastal West Africa with India via the sea, but the African Dan Aida Wedo also inextricably joins West Africa with the Caribbean and the Americas. The reflection of the arching rainbow serpent over the Atlantic Ocean continually re-creates Dan Aida Wedo eternally swallowing its own tail. Karen McCarthy Brown (2001, 274), an anthropologist specializing in Haitian Vodou, notes, "In Haiti, Aido Hwedo has become Ayida Wedo, the wife of Danbala. Together, the two (both are serpents and rainbows) arch over the broad ocean. Alternately, the rainbow and its reflection in the water below turn the serpent into a circle" (2001, 274). According to Brown, this ceaselessly circling rainbow serpent connects Haitians, inextricably, to their long lost transatlantic ancestors. The snake swallowing its own tail has become a transatlantic trope for protection,

regeneration, and connection. That is, every time one witnesses a multicolored arc formed by the refraction of sunlight in a rainfall's mist, one is witness to and protected by Dan Aida Wedo's majestic instantaneity on both sides of the Atlantic.

Deja Vu: Aneho's Mami Wata India Priest

The Hindu presence in Mami Wata Vodun sometimes comes not only from a lithographic imagistic influence but also directly from objects imported from the country of India, which I first noticed in Togo. Aneho, Togo, a coastal town known for its high concentration of Mami Wata devotees, boasts a strong and longstanding tradition of India Spirits associated with Mami Wata. After a few unremarkable exploratory visits to Aneho, I happened upon an extraordinary Vodun temple. Inside, bas-reliefs of Shiva and Lakshmi flank the doorway that allows entrance to the heart of Mami Wata Vodun priest Gilbert Atissou's compound (d. 2009).[21] He was extremely kind and welcoming, and appeared delighted to answer any of my questions about the presence of "India" in his compound. He offered me water and a chair, and told me he would be right back.

About ten minutes later, Atissou emerged from a room holding a beautiful Shiva trident, and wearing his hand-painted Shiva cloth (fig. 4.23). He then explained the history of his trident, which he referred to as his *apia*. He bought it in the early 1960s and said it was his first purchase from an Indian boutique in Lomé, Togo. He said he was always drawn to Indian gods and their power to control the sea. He bought whatever he could afford—objects and images—in Indian stores and forged friendships with the Indian merchants.[22] Atissou lamented that most of his Indian friends had returned to India long ago because of their economic troubles in Togo.

Atissou also said that during the 1960s he spent hours upon hours at the beach where he would journey to "India" and find himself surrounded by "beautiful things." He would spend months at a time in "India" during these hours at the beach. He reported these "voyages" to his Christian family, and as Atissou's obsession with the sea grew and his curious behavior increased, his family took him to a Christian Celeste church in order to exorcise these "demonic" spirits from his system. The Celestial Christians, however, deemed his India Spirits so powerful that they advised him to nurture them rather than eliminate them. Thus he began incorporating Indian items into his own Mami Wata veneration.

Atissou suggested a tour of his compound. We began with the bas-relief of Shiva outside of the main courtyard entrance (fig. 4.24). He explained that "RHADA," painted at the top of the wall composition, is one of the many names

given to Shiva because, as with most Vodun spirits, there are times when it is inappropriate to state the spirit name outright.[23]

I noticed that the background of this bas-relief was light blue with swimming fish. "Is he underwater?" I asked.

"Yes," Atissou responded, "he is in India."

We looked at various other wall paintings throughout his compound, mainly of Shiva and Lakshmi, while Atissou explained that Shiva is king of the underwater world and Lakshmi is a version of Mami Wata. Atissou then showed me his shrine dedicated to Shiva. What appeared to be a very typical Vodun shrine was, in fact, dedicated to Nana-Yo, another Vodun name for Shiva. In front of the shrine's door there was a carved yoni receptacle representing the female principal and origin of Hindu creation, which was there to receive offerings (fig. 4.25).

From there, Atissou led me across the compound into a shrine room with four fully decorated walls covered with spirit paintings that seemed to be based on some of the smaller Hindu statues and chromolithographs mounted on the walls next to the paintings. Lord Shiva and Lakshmi were present (fig. 4.26), but they were surrounded by other multi-limbed spirits in both two and three dimensions, including various renderings of Mami Wata and her three-headed husband, Densu (fig. 4.27). Atissou explained that the walls in this "India" room were blue because, once again, we were underwater.

On the blue walls of this India room, I noticed a series of nicely framed black and white photos. They reminded me of some photographs in Gert Chesi's *Voodoo: Africa's Secret Power* (1979), a coffee-table book illustrated with color photographs of Vodun practice along coastal Bénin and Togo, as well as some from Chesi's brief jaunt to Haiti. Chesi visited Mami Wata compounds along coastal Togo in the 1970s. He photographed people, ceremonies, and shrines, one of which, I remember, stood out due to its mélange of India-produced statuettes and chromolithographs of Hindu gods such as Shiva, Lakshmi, the Durga, Krishna, and Dattatreya. The photographs in this book illustrated the first Indian chromolithographs I had ever seen in a Vodun context.[24] I asked Atissou if he had ever seen Chesi's book. His eyes lit up and he said, "That is me!" as he pointed to a black and white photo. The photo we were examining, like other framed photos in Atissou's India room, was shot by Chesi in the late 1970s, though most of them did not make the final cut for the book. Atissou was delighted that I recognized him from the book. He then showed me objects in his shrines and on his walls that were also in the photos.

I followed Atissou through another doorway, which led into an even more ostentatious shrine room brimming with more posters of Indian gods; bottles of perfumes, powders, and alcohol; candles; statuettes; stuffed, plastic,

and ceramic animals; and other offerings (fig. 4.28). Mami Wata shrines may appear too obvious, repetitive, and artificial to be taken seriously by some audiences. Filled with imported objects, however, it is subtle and powerful within Vodun aesthetic sensibilities. In comparison to the vibrant colors and noises of a West African market, these images and objects appear pale yet remain potent; they have force and presence and, most importantly, they work; they make things happen. Within Vodun, these items are spiritual status symbols. This is religious imagery that has reached a high level of commodification, indeed, but on two very different levels: (1) it represents a considerable financial investment on the part of the devotee, and (2) it offers access to powers unattainable through any other means. This is a spiritual marketplace, and India Spirits themselves reflect the arbitrary nature of power and wealth.

Transatlantica:
Chromolithograph as Crux

Chromolithographs represented, and continue to represent, the potential of Vodun as a means of expression, assertion, creativity, and faith. They are adoptable and adaptable to all circumstances, from the worst to the best, on both sides of the Atlantic. Indeed, in conjunction with deep spiritual conviction, chromolithographs have been a central and critical feature in the maintenance and proliferation of African-derived religious systems throughout the Americas. The spread of chromolithographic imagery in African diasporic communities is commonly attributed to the stratagem of masking the identities of proscribed African deities from slave owners. But more than simply an ubiquitous phenomenon in response to oppression and a means of problem solving under oppressive circumstances, chromolithographs in these communities offered a mechanism for articulating deep-seated, centuries-strong African religious sensibilities in a manner stemming from a firmly established African precedent—that of the "unfinished aesthetic." For example, Donald Cosentino (1995, 253) writes that the Catholic chromolithographs of St. James, which are used to represent Haiti's Vodun Sen Jak, "constitute the single most important contemporary source for the elaboration of Ogou [Sen Jak's African counterpart] theology." While Hindu images are sometimes difficult to locate in Bénin and Togo, the pervasiveness in Haiti of various types of chromolithographic imagery—particularly Catholic—produced and continues to maintain ritual effectiveness in Haitian Vodou.[25]

The late Haitian master assemblage artist Pierrot Barra (1942–1999)[26] incorporated chromolithographic imagery into his oeuvre. In Figure 4.29, Barra honored Ezili Freda, famous in Haiti and throughout Haitian diasporas

as "the goddess of love and luxury . . . a flirtatious Creole woman who adores fine clothes, jewels, perfumes, and lace" (Cosentino 1995, 240–241). She is represented by the Catholic chromolithograph of Mater Dolorosa, Our Lady of Sorrows, which graces the background of the piece. In the foreground, however, is another representation of Ezili Freda: a miniature statuette of clearly Indian origin, recognizable by the tell-tale Hindu *bindi* spot on her forehead. Hindu imagery may have played an even larger role in the artist's work. In his description of Barra's doll-assemblage creation of the Vodou spirit Ti Jean Danto (with two extra legs and feet extending from her shoulders), Cosentino (1998, 53 plate 9) writes that the artist "has further reconfigured his doll to mirror lithographs of Shiva or Lakshmi, in whose many limbs Hindu worshippers recognize the polydexterity of their gods."

Other examples suggest that both South and East Asian imagery have a relevance and resonance in Haitian Vodou. The center of Haitian flag maker Clotaire Bazile's Petwo altar, for instance, features a white ceramic figurine of a likely East Asian god (probably Chinese), which fits—unquestionably— into the "unfinished aesthetic" of a Haitian shrine (illustrated in Cosentino 1998, 21). In Port-au-Prince, Haiti, Vodou priest Saveur St. Cyr's shrine to the Gede spirits of death and regeneration has various statues of multi-limbed Hindu deities, one of which (probably Lakshmi) St. Cyr identifies as the Virgin Mary.[27] Similarly, in his article on Catholic chromolithographs in Haitian Vodou, ethnographer Michel Leiris (1952, 206) describes Ezili as represented by an image of "Our Lady of Monserrate," which he correlates with what he witnessed in a chapel near Carangaise, an area of Guadeloupe known for its Dravidian population. The chapel, which he reports is occasionally visited by Guadeloupians of African descent, houses a statue which in Haitian Vodou would represent Ezili. In this Guadeloupean context, however, it represents Maryemen (or Madeyemin or Mayêmé or "Marie aimée"), a female Indian deity conflated here with the Virgin Mary. The white cloth that cloaks the figure except for its face, hides four arms holding a sword, a gold disc, a branch, and a trident, all of which remind Leiris of the accoutrements found in Haitian shrines dedicated to Ezili. Although obscure, his observation is worth pondering. That is, the Catholic Virgin, the Hindu Lakshmi, and the Vodou Ezili become one and many; they blur from two to three dimensions and back, literally and conceptually.

This Indian-African phenomenon is in no way unidirectional. For some Afro-Trinidadian Indians in Brooklyn, for example, an image of Yemoja, the Yoruba goddess of the river Ogun, represented in a popular chromolithograph by a fair-skinned, long-haired, crowned female figure emerging from the water, can represent Lakshmi, the Hindu goddess of wealth and beauty.[28] In Trinidad, the Indian deity Kali can merge with Shango, the Yoruba god of

thunder, lightning, and associated elements.[29] Statues and images of Indian gods are also found in botánicas in major US cities.

The potential of Hindu chromolithographic imagery continues to be recognized as something already familiar within transatlantic Vodou. In her introduction to *Mama Lola: A Vodou Priestess in Brooklyn*, Karen McCarthy Brown (2001, 13) recounts how she and a friend visited Mama Lola. Upon seeing—for the first time—Hindu chromolithographs of Krishna and Kali which Brown's friend had with her, the priestess cried, "Let me see. . . . You gonna get me some for my altar?" Mama Lola recognized instantly that there was a place for these richly suggestive images in her spiritual and religious sensibilities.

From Aziri to Ezili to Avlekete: Daagbo's Hat as Circuitous Transoceanic Equation

Back in coastal Bénin, Daagbo Hounon Houna, the late Supreme Chief of Vodun in Bénin, was known for his eccentric, intricately decorated sequined hats. For National Vodun Day 1996, Daagbo Hounon Houna wore a new sequined hat unlike any of his many hats I had seen before (fig. 4.30). Most of Daagbo's sequined and beaded accoutrements (hats, shoes, canes) were commissioned from artists living in the city of Abomey, Bénin. The new hat that Daagbo Hounon Houna wore was decorated by the sequined image of what I thought was clearly Ezili Freda, from the Catholic chromolithograph of Mater Dolorosa also featured on Pierrot Barra's creation in Figure 4.29. It made sense to me: the name for the Haitian spirit of love, Ezili, comes from the Fon name for the river Vodun Aziri. However, Daagbo said that his hat represented his riverine Vodun, Avlekete. Daagbo's sequined hat thus brings together hundreds of years and thousands of miles of transatlantic accumulation in the Catholic chromolithograph of Mater Dolorosa, turned Haitian spirit Ezili Freda coming from the Fon river goddess Aziri, then re-manifesting itself in its place of origin, Bénin, as Daagbo Hounon Houna's Vodun, riverine Avlekete. The ping-ponging of the Catholic chromolithograph of Mater Dolorosa (a.k.a. Ezili in Haiti) and the Fon river goddess Aziri (a.k.a. Ezili in Haiti), with their meanings and names changing as quickly as their geographic locations, exemplifies—transatlantically—an "unfinished aesthetic" in terms of iconography, geography, and world religious systems stemming from and perpetuated in chromolithographic imagery.[30] For National Vodun Day 2011, the son of Daagbo Hounon Houna—known as Daagbo Hounon Houna II—wore his father's hat (fig. 4.31). However, this son does not live in the

recognized home of the Hounon dynasty, where Daagbo Hounon Tomadjèlê-Houkpon, the "official" Daagbo Hounon, currently lives with his family.

Essential Chromolithographs

Because India Spirits are not currency they cannot be exchanged, yet they are undeniably the product of exchange. Imported Indian goods, traded, bought, and sold—the epitome of mass production and market exchange—become along coastal West Africa not only a means for generating income and decorating a temple. They also act as passports for travel to another world because the relationship between these goods and access to the spiritual world is immediate and unquestioned. The sea is eternal, its vastness is undeniable, and its power is transferred into Mami Wata temples via mass-produced chromolithographic images which represent at once both India and the sea.

CHAPTER **5**

Vodun of Slave Remembrance

Tchamba me so gbe nye me nya senao.

Tchamba me so gbe nye bu.

 I come from Tchamba, no one wants to hear my language.

 I come from Tchamba, my language is lost.

Mia mamawo kpɔ hotsui wo fle agbetɔ kɔɖi.

Amekle nya ne nɔanyi na ye looo. Elava kplɔm yi afiaɖi.

Baɖa baɖa nenɔanyi nam looo.

 Our grandparents were rich, and they bought people.

 I am proud of who I am, though it risks bringing me troubles.

 May bad luck stay far away from me.

Tchamba Vodun songs, collected in Vogan, Togo, February 8, 1999.

The Vodun complex known as Tchamba is a strong spirit grouping along coastal Bénin, Togo, and into eastern coastal Ghana. Its name derives from an ethnic group and region in northern Togo, where people in the south actively sought domestic slaves centuries ago. This spirit grouping has been critical in the maintenance and proliferation of histories and memories of domestic servitude along the coastal region and is sustained to the present by the progeny of both domestic slaves and their owners. Tchamba Vodun has also been influential in bringing to the fore contemporary debates regarding slave ancestry and the owning and selling of slaves. Such discussions help Beninese and Togolese people address the multiple roles their ancestors played in both domestic and transatlantic slavery, as either the sellers or the enslaved. The local significance of domestic servitude and, to some extent, the deep-seated awareness of the transatlantic slave trade are embodied in the

slave spirits of Tchamba Vodun. The legacy of enslavement also plays out in slave spirits emerging from the transatlantic African-derived religious systems of Umbanda in Brazil, Palo Monte and Spiritism in Cuba, and Vodou in Haiti. It is the open-ended, welcoming nature of Vodun that gives life to Tchamba Vodun spirits and likely to those across the Atlantic, representing slaves of generations past.[1]

Historical Background

Between the fifteenth and nineteenth centuries, an estimated eleven to twelve million slaves were purchased in Africa by American and European traders; eighty percent of these slaves left the African continent between 1700 and 1850 (Lovejoy 1982, 473–501). The town of Ouidah was a major embarkation point for slaves from the 1670s through the 1860s, accounting for over ten percent of all of the slave trade, over one million people (Law 2004, 1–2). In the 1690s, the slave trade through Ouidah reached a volume of about ten thousand slaves per year, and in the years 1700 to 1713, the exportation number reached its all-time high of approximately fifteen thousand slaves annually, perhaps accounting for up to half of all slaves leaving the continent. Most of those exported were enslaved through capture in war. However criminals, debtors, and domestic slaves also contributed to these large numbers (Law 2003; Lovejoy 1983).

The section of the West African coast between the Volta and Lagos Rivers was not only a major source of slaves for the Atlantic slave trade, but was also an area where domestic slavery was commonplace. Although there is uncertainty regarding the date that domestic slavery began, Le Hérissé (1911, 52–53) notes that in the nineteenth century it was more common for Dahomeans to purchase slaves for domestic use from the interior northern region of contemporary Bénin, Togo, and Ghana than it was for them to receive slaves as gifts from the king. Those from the king were likely obtained in warfare, and many were bound for the Atlantic trade, while Dahomean citizens who financed their own purchase of slaves from the north were participating in a different exchange system than that of the transatlantic trade.

Thus, the overseas trade amplified the already established tradition of domestic enslavement. By the 1670s the English, French, Dutch, and possibly Danish had built forts in Ouidah to facilitate their roles in the slave trade, and in 1721 the Portuguese built a fort as well. The staff of the European forts was overwhelmingly African, though most of the workers were not local in origin. A large number of the domestic workers came from about three hundred miles north of the coast. Tchamba and Kabre peoples, from northern central

Togo, seem to have been the most sought after as domestic slaves in the south (Wendl 1999, 114). In 1723, Ouidah's French fort reported a purchase of "[T] Chamba" slaves, in reference to this northern ethnicity (Law 2004, 39).

Based on the long history of domestic servitude along this coastal region, it was accepted quite simply that when a family had sufficient money, the father would purchase one or more domestic workers to work for his family. Bonifatur Foli, the primary Mina informant of Dietrich Westermann (1905, 127), the German authority on Mina/Ewe languages, likened the purchasing of slaves to capital investment: "When our forefathers bought a slave, this was just as if they put money into a bank account. If you buy yourself a slave and [s]he produces children, they will belong to you; they will till your fields and build houses for you."

Semantic Considerations: The Term "Slave"

There is only one word in English for "slave," and its meaning is unambiguous in reference to slavery in the Americas. Whether working in the house or the field, a slave in the American context was a person (or the descendant of a person) taken against his or her will from Africa, separated from his or her family, held in servitude as the chattel of another, and forced to work with no pay in a subservient relationship within a structure of master and slave. By contrast, words in the African context refer to varying types of enslavement or submission: "domestic slaves," "slaves for export," "slaves in chains," and "pawns," among others. Domestic enslavement existed alongside and overlapped with both pawnship and slavery for export.

Through a thorough analysis of Melville J. Herskovits's ([1938] 1967, 1:84) assertion that the distinction between pawning and domestic slavery in precolonial Dahomey was very clear, Robin Law (2003) demonstrates that this division was clear in principle (temporary versus permanent servitude), but tended to blur in practice. Notwithstanding, the label of "domestic slavery" is limiting in that it is used to incorporate many types of associated though distinct kinds of domestic enslavement, including pawnship. Moreover, when the African terms for these various types are differentiated, a multifaceted picture of slavery emerges. These terms have distinct etymological, connotative, and denotative differences in the dominant languages of Fon, Mina, and Ewe, in coastal Bénin, Togo, and into eastern coastal Ghana, respectively. Understanding that there are culturally defined, multivalent local meanings of the unidimensional English word "slave" will help in grasping the subtleties of what I refer to as Vodun "slave spirits." Either purchased to serve a family or as an adopted child, *amekplekple*, translated literally as "bought person,"

is, in most circumstances, the best term to describe the type of "slave" who is venerated within the Tchamba Vodun complex. This type of "bought person" relationship is exemplified in a local piece of African francophone literature.

From the Foreign North: Félix Couchoro's *L'Esclave*

In 1929, Ouidah-born author Félix Couchoro published his first novel, *L'Esclave* (The Slave), which to this day stands as an important contribution to African francophone literature. The novel is a passionate story of an inheritance dispute between a domestic slave, Mawulawoé, and his brother, Komlangan. Couchoro's character of the "slave," the relationships between the "slave" and the members of the family who bought him, and the social and economic milieu in which the story unfolds present a contextual backdrop for Tchamba veneration, referring directly to a domestic slave's presumed origins, ethnicity, and ancestry.

In fact, the novel's title is a misnomer. Mawulawoé is indisputably a "bought person," not a slave in the meaning of that English word, as the following key passage indicates:

> Komlangan's father purchased eight-year-old Mawulawoé from far, far away
> in the northern region of Okou-Okou. The slave's adorable face pleased his
> master so that he could not bring himself to disfigure it with the scarification
> of slaves. He named him Mawulawoé, which means "God will provide."
> Nothing distinguished him from Komlangan with whom he grew up. They
> shared their games and worked together as brothers. . . . The boys grew
> into men and took wives. . . . At his deathbed, the father blessed his two
> sons, preaching to them his mutual affection. They closed his eyes for him.
> (Couchoro 1929, 81; my translation)

This point in the novel sets into motion the brothers' fight over their inheritance. Komlangan, the birth son, claims that Mawulawoé, the "slave," has no rights to their father's estate. This drives Mawulawoé to pursue revenge and instigates a story of love, jealousy, hatred, and ambition that ultimately leads to multiple murders. Along coastal Bénin, Togo, and into southeastern Ghana, the theme of Couchoro's *L'Esclave* is still current, and the ramifications of domestic enslavement from the "foreign North" have a significant role in contemporary Vodun art and thought, specifically in Tchamba veneration.

When Couchoro mentions that Komlangan's father purchased an eight-year-old child from "far, far away in the northern region of Okou-Okou," he is referring to the more widespread name for the Nyantroukou ethnic group

in northern Togo (see Cornevin 1962, 44, 202–205).[2] Most of the domestic servants brought to the south came from the same region as Mawulawoé, three-hundred miles north of the Atlantic Ocean. It is estimated that as many as three million people were brought to the coast, but, much like Mawulawoé, not all of them were destined for the Atlantic trade (Piot 1996, 30). Neighbors of the Nyantroukou peoples are Bassar, Moba, Taberma, Tchamba, and Kabre. The last two populations, however, Tchamba and Kabre,[3] seem to have been the most sought after as slaves (Wendl 1999, 114). The terms *kabreto* and *tchambato* were used to designate Kabre and Tchamba enslaved peoples in the south (Wendl 114). However, only the name Tchamba and its association with memories of Vodun domestic slavery survive to the present in the region.[4]

The Spirits of Former Slaves: The Tchamba Vodun Complex

Tchamba is a town in north central Togo where slaves from many different ethnic groups were gathered together for purchase as either domestic servants or slaves for export. The name Tchamba is also an ethnonym, the name of a spirit complex, and refers to specific spirits within this spirit grouping.[5] A Tchamba spirit is either male or female, the latter of which is often called Maman Tchamba and is sometimes regarded as either the wife or mother of a male Tchamba spirit. She is also known to guard the riches of the wealthy family who owned her. Although the spirits themselves represent slaves from generations past, they are venerated by both the descendants of those who were enslaved and those who owned slaves. The songs at the beginning of the chapter address both situations: The first song communicates the sentiments of a slave who finds him- or herself in a foreign land where no one likes to listen to his or her natal Tchamba language.[6] The second song is from the perspective of a descendant of wealthy slave-owning ancestors, who acknowledges the truth of his or her ancestry but hopes that Tchamba veneration will bring forgiveness. Due to generations of intermarriage between families of slave owners and those who were enslaved, there is a complex entanglement within lineages. Complicating this further is the contemporary ambivalence associated with being descended from either side. Nonetheless, both positions of veneration call upon Tchamba spirits to advise and help with contemporary problems.

Reading the Visual: Tchamba Symbology and Ceremony

Within Tchamba Vodun, visual indicators mark people and spaces dedicated to the remembrance of slavery. The most important attribute of Tchamba veneration is a tri-colored metal bracelet. A person wearing this type of bracelet can

be recognized as being affiliated with Tchamba and associated with domestic slavery as either a descendant of slaves or slave owners (fig. 5.1). Within Vodun practice, however, the same tri-colored metal bracelet may represent an entirely different spirit, completely removed from Tchamba veneration. Because of this, context and associated symbols are important in reading Tchamba iconography.

This tri-colored metal bracelet, called *tchambagan*, has a metonymic relationship to the shackles and irons used in the transport of slaves from the north to the south. *Ga(n)* is the Fon, Mina, and Ewe word for metal itself, or something that is metal. Thus *tchambagan* translates as the "metal of Tchamba."[7] Within the family histories I collected, I was generally told that slave owners presented their slaves with such a bracelet to mark them as enslaved people.[8] Upon the death of a slave, the family who owned him or her removed the bracelet (or, in some versions, an anklet or ring) and added it to a shrine dedicated to the family's former slaves in gratitude for their lifetimes of service.

The bracelet's three colors of metal (black, white, and red) are sometimes said to represent three different northern spirits. Black, represented by iron, is called *boublou* (stranger), and is known to be a turbulent, aggressive, excitable spirit who is associated with iron, thunder, and fire. White, represented by silver, is called *anohi* (a presumed Hausa spirit, sometimes also called Fulani), and is known as a source of calm spirituality, associated with the rainbow. Red, represented by copper or bronze, is called *yendi* (a contemporary town in northeastern Ghana), and is known for its powers of healing and its association with the earth. These three spirits are likely a contemporary mixture of southern Vodun—Xɛvioso, (thunder), Dan Aida Wedo (rainbow serpent), and Sakpata (the earth, healing, and disease), for example—with romanticized northern spiritual identities. Of course, these "northern spirits" do not really exist in the north. Wendl's (1999, 116) interpretation of the southern representation of "northern spirits" is that they are "projective transfigurations, by which Mina [Fon, Ewe] have articulated their own experience with the otherness of the people from the north in symbolic and ritual terms."

Wendl explains that if a person learns, possibly through a divination, that he or she has a Tchamba spirit, that person must begin to honor the spirit by purchasing two *tchambagan* as the initial components of a shrine. Similarly, I was often told that when people learn of their Tchamba spiritual obligations, they are instructed to purchase a new *tchambagan*, add it to a generations-old shrine piled with old *tchambagan*, and then choose a replacement from among the accumulation of bracelets and rings to wear as a pronouncement of their newly affirmed Tchamba affiliation. Sometimes, I was told, a farmer will find a *tchambagan* while cultivating a field, digging a well, or constructing the foundation of a house. Such a find would be read as a sign that the family who

owns the land used to own slaves. A family meeting would be called, divination would be carried out, and the family would begin to venerate Tchamba in gratitude for the service of the now deceased slaves. Depending on the divination, a family might be obliged to host a large Tchamba celebration as an apology for years of neglect and as a harbinger of future commitment to devotion.

In most cases, after acquiring a *tchambagan* and learning of an obligation to a northern spirit, a Tchamba novice would also purchase a *tchambazikpe*, or wooden stool, to welcome the Tchamba spirit and to provide it with a seat. The stool is a direct reference to the role of the domestic slave to carry the master's stool. Cowry shells are also important to a Tchamba shrine, in that they were the currency used to purchase slaves. Wendl (1999, 116) stresses that "iron bracelets, wooden stools, and cowry shells are the focus of every Tchamba shrine, representing the slave as a chained person, a stool carrier, and a person who had been bought."

These and other symbols help identify Tchamba in mural paintings, which evoke histories, memories, and stories about domestic slavery. In these murals Tchamba is depicted in human form, sometimes accompanied by a female, Maman Tchamba, often representing his mother or wife. These murals articulate slave status and foreign (northern, often Islamic) origins through their painted details. Metal bracelets, "northern" scarification markings, clothing, stools, cowry shells, accoutrements such as horsetail fly whisks and hunting knives encased in decorated leather sheaths, Islamic paraphernalia including watering kettle and prayer beads, and "northern" food and drink are painted on the murals and included in shrines. Other items that may be included in shrines are textiles, chains, fez-like hats, and cloth that can be used to form a turban on a devotee, all of which refer to an imaginary place in the north. Kaolin chalk (*alilo*) is often found in shrines as well and is used ceremonially. Yet despite all of the Islamic symbology, most of the slaves in the south would not have been Muslim in origin. The incorporation of Muslim visual culture into Tchamba visual theology was likely based on Tchamba practitioners' twentieth-century observations of Islamized Hausa traders who set up trading posts along coastal West Africa during the late nineteenth and early twentieth centuries.

Ghanaian artist Joseph Ahiator has painted a handful of Tchamba temple murals throughout Bénin, Togo, and Ghana. His earliest Tchamba painting (fig. 5.2), which he dates to the 1970s, shows Tchamba's mother on the left with a bowl of kola nuts, some of which she is giving to her son before he journeys. Kola nuts are a key symbol commonly associated with northern Muslims and are used culturally as well as medicinally to suppress hunger, thirst, and fatigue. Between mother and son Ahiator painted an Islamic

watering kettle and a *tchambazikpe*, or stool, upon which are *tchambagan*, the tri-colored bracelets which Tchamba also wears on both wrists. His hat is decorated with abstracted cowry shells. Both mother and son have northern-looking scarification markings on their faces.

Vertical facial scarification markings are pervasive markers of a northern identity, and play an integral role in contemporary Tchamba veneration. Along the same lines as the refusal of Mamulawoé's father to have his "son" scari-fied in *L'Esclave*, coastal people in general disapprove of northern facial scar-ification markings. A Mina proverb demonstrates the extent to which enslaved people did not want to draw attention to their facial markings, and in turn, their enslaved status: *Adonko mekploa fetridetsi o*, which translates as "A slave does not draw strings while eating okra soup" (Westermann 1905, 122).[9] The proverb is a direct reference to mucilaginous texture of cooked okra (*fetri-detsi*), which, when lifted from bowl to mouth, produces long, thin, gummy vertical strings, similar to northern facial scarification markings. In the con-temporary spiritual context, when a person is seized by a Tchamba spirit, he or she will draw, or have drawn by a nearby initiate, temporary kaolin mark-ings on his or her face to mimic northern scarification. Some adepts are said to go as far as to have real markings permanently incised on their cheeks, but I have never seen this. Alternatively, adepts may use charcoal to color their faces a dark black to represent a very distant, unknowable place, that is, the north. The scarification markings are clearly "northern looking," but in reality, they are often an amalgamation of various northern ethnic markings (Bariba, Logba, Dendi, Nyantroukou) combined to communicate the idea of a general-ized northern ethnic identity.

In a painting from the late 1990s, Ahiator painted much of the same ico-nography, making Tchamba easily identifiable: tri-colored bracelets, a stool upon which the bracelets are placed, a cowry-shell covered hat, and northern-looking scarification markings (fig. 5.3).

Ahiator added Tchamba's wife and drummer to another temple mural located in Togo. The threesome is en route to the "north" (fig. 5.4). Tchamba's wife carries his stool upon her head and is dressed and adorned in a "northern" style. The only explanation Ahiator provided concerning her draped cloth, the nose ring, and the six hooped earrings (three on each ear) is that she is "north-ern." Adornment in the south does not traditionally include nose rings or mul-tiple ear piercings.[10] Thus, identifying this type of adornment as "northern" likely reflects the fact that it is *not* southern. Much like "northern" scarifica-tion, "northern" adornment is an amalgamation of multiple types of northern ethnic body ornamentation. To Joseph, "northern" represents a vast conceptual realm offering a rich reservoir of symbolism.

Two Maman Tchamba mural paintings in Aneho, Togo show simi-
lar iconography. In Figure 5.5, Mama Tchamba functions as guardian for
her family's wealth, represented in the bowl overflowing with gold. She is
adorned with a cowry shell-covered hat and gold jewelry, also attesting to the
wealth of the family who could afford to own her. Once again, facial scarifica-
tion markings refer to her "northern" identity and slave status.

The Maman Tchamba mural in Figure 5.6 comes from the Mami Wata
temple of Gilbert Atissou (see Chapter 4). Here Maman Tchamba is a confla-
tion of a Shiva lithograph with Tchamba symbology. The wealth she guards is
in the form of kola nuts.

A Tchamba shrine might be near such a mural painting, but more often
than not, the shrine is kept out of sight, to be viewed only for offerings on
certain sacred days of the week.[11] There are many types of offerings given to
Tchamba, but the ubiquitous favorites are *tchukutu*, a highly fermented north-
ern Togolese millet-based drink; *tchapkalo*, an unfermented, sugar-sweetened
northern Togolese millet-based drink; and kola nuts. Other offerings made
to Tchamba and/or associated slave spirits are combinations of gin; *sodabi*,
a locally distilled palm wine; and *linha*, a corn drink that must be prepared
by a postmenopausal woman. Other common offerings are rice, beans, yam,
and manioc prepared together; corn, millet, or cassava products; and black
chicken, black pigeon, and male goat. Sometimes there is a container of
karité butter because on occasion, based on divination, a *tchambagan* must be
anointed with this butter.

Along with bracelets, stools, and cowry shells as constituent components
of a Tchamba shrine, sometimes there is a cement grinding stone, representing
the slaves' duty to grind corn. In shrines maintained solely by former slave
owners, there is often a "spirit sac" called *abehe*, which is said to have func-
tioned as a type of bank account in which cowry shells were accumulated
and stored. The Tchamba spirit Maman Abehe represents the matriarch who
guarded the family wealth.

Ceremonies for Tchamba can be organized for a variety of reasons. The
annual Tchamba *petatrotro* ceremony (in Mina *pe* = year, *ta* = head, *tro* =
changing), or new year celebration, is of utmost importance. Tchamba prac-
titioners in southern Bénin, Togo, and southeastern Ghana set dates for
their annual celebrations, often based on their financial ability to host such
a big celebration. If financially feasible, the dates are then chosen based on
Afa consultations,[12] which can help locate the most auspicious timeframe
for the event. These large celebrations take place generally between August
and March and last from four to seven days. They serve not only to honor
Tchamba, but also as a reunion, bringing people together to exchange news.
Because most practitioners have particular spiritual or healing abilities, these

ceremonies also offer opportunities for specialists to help their friends and colleagues with personal or medical problems.

In general, a Tchamba *petatrotro* celebration begins with the Tchamba priest or priestess invoking his or her family's maternal and paternal ancestors—either slave sellers or the enslaved—as well as all of the spirits that are associated with the family, which can include Mami Wata, Dan, Xɛvioso, Sakpata, Gu and others. The ancestors and the spirits are informed of the *petatrotro* and are implored to help the ceremonies proceed peacefully. Various beverage offerings are poured onto the earth to complete this supplication. The first round of drumming then begins to call the priests, priestesses, and adepts to attention. A whole repertoire of Tchamba songs are sung accompanied by dance and spirit possession. Because Tchamba origins are northern, the performance tends to be a mixture of northern and southern rhythms and dance. The *petatrotro* can vary from one compound to the next, but there are many similarities among them.

Another type of Tchamba ceremony is based on personal problem solving. If a person finds him- or herself in a situation of ill physical or mental health, he or she will usually begin by seeking medical assistance at a local hospital. If this brings no improvement, the person may turn to the church for help. If the illness continues, an Afa consultation may be sought to seek other possible roots of the illness. If, at this point, the divination suggests that it is Tchamba who is cause of the problems, the path to resolution will be prescribed, which can range from an evening of ceremonial offerings to Tchamba to a full-scale initiation that can last years.

Tracing Tchamba Roots

Although precise details are hard to come by, contemporary stories circulating along this coastal area describe how people often learn of their slave ancestry. Most of these accounts follow a general format. The story usually begins with a group of young men, usually Catholic, walking around town. They pass a compound in which a Tchamba Vodun celebration is taking place. One young man in the group stops walking and starts shuffling his feet to the *brekete* drumming rhythm, which is known to be from the north. He is then taken over by a Tchamba spirit and starts speaking an unrecognizable language, also said to be from the north. The language is often referred to as "Hausa," the generic term for "northern." Some claim that Tchamba always sends an angel to translate the incomprehensible messages from the ancestral north, while others maintain that the person in trance is truly speaking a northern language based on his northern ancestry manifesting itself via the will of Tchamba. Whether this is a form of xenoglossy

(knowledge of a language one has never learned), glossolalia (speaking a language one does not know), or articulated mumbling is irrelevant. What matters is that Tchamba is connecting to and communicating with those who hold his spirit in a distant, decidedly foreign land. While shuffling his feet, the young man in trance might stop for a moment to draw scarification markings on his face from earth retrieved below his feet. Following this spirit encounter, the person who was in trance meets with a diviner who may prescribe Tchamba veneration.

Some people learning of their slave ancestry travel to the north in search of their roots and long-lost families. This search for family has haunting similarities to the growing popularity of heritage tourism, also known as "roots tourism," in which people of African descent in the Americas travel to former slave port cities such as Cape Coast and Elmina, Ghana, and Gorée Island, Senegal, in search of the land of their own ancestry.

In Lomé, Togo, the name Dogbe-Tomi was mentioned to me several times in relationship to a story—still in circulation—of a girl who had learned of her slave ancestry and journeyed north to find her roots. The following is based on a summary of my interview with Lomé resident Cécile Akpaglo:

> In the early 1800s, the father of a very wealthy Ewe family sent a slave buyer to the area in and around Upper Volta (contemporary Burkina Faso) to purchase a strong male slave. The slave was known by his surname Tomi. He served the Ewe family well and grew up. Through his hard work and honesty, he became a well-respected man. He married into the Dogbe family and had children . . . time passed. . . .
>
> In the 1950s, a young girl from the wealthy Catholic Dogbe family in Lomé woke up one morning in trance. She took her school chalk and drew northern scarification patterns on her face and starting speaking in an incomprehensible language. Her father was worried so he took his daughter to a very well-respected diviner for a consultation. The diviner asked questions and consulted with Afa. The diviner also recalled that there had always been talk of a male Dogbe ancestor being of Burkinabe origins. The diviner advised the girl to go to Burkina Faso to find her family.
>
> She traveled with her father to Ouagadougou. They learned that everyone in the family was dead except for a very old man. They went to meet with the old man who remembered his grandfather telling him of slavery and tearing up when he recalled the sale of one of his own brothers to an Ewe family in the south. The old man's surname was Tomi. From that point on the family adopted the name Dogbe-Tomi and began Tchamba veneration. The girl grew up, and when she died in the 1990s, the family went back to Catholicism.[13]

I also interviewed the daughter and granddaughter of an *amekplekple*, or "bought person," named Tɔnyewogbe. The interviews were conducted in 1999 in the town of Adidogome, Togo. The last surviving child of the "bought person," Adonɔ Zowaye was a frail though vibrant elder at the time. Her youngest daughter, Nɔtuefe Zowaye (b. 1952), had just begun the process of Tchamba initiation upon the advice of a diviner. The following is a summary of their story:

> In the late nineteenth century, there was a wealthy farmer named Kofi Zowaye.[14] He had no wives or children. Because of his wealth and his desire to leave it to a beloved child, he purchased a baby girl from the north whom he named Tɔnyewogbe. He raised the girl as if she were his real daughter and kept her purchase a secret so that she would not feel "different" from other family members, even though rumors of her "bought person" status circulated.
>
> Tɔnyewogbe married into the family and had three children, the youngest of whom was named Adonɔ Zowaye. Tɔnyewogbe died when she was quite young, but Adonɔ remembered that her mother had scars on her light-skinned face and stomach like nothing she had ever seen in the south. Adonɔ thought her mother might have been Peul because of her light skin, her facial features, and her scarifications. While acknowledging that her own skin is quite dark, Adonɔ pointed to her very straight nose and high cheekbones, claiming that she had features like her mother. She later learned that her mother's scarifications were likely those of Kabre peoples in the north. . . .
>
> Tɔnyewogbe was raised not knowing that she was a "bought person" until issues of inheritance cropped up. Her father wanted his daughter to inherit his estate, but once he died, his brothers refused to allow her to acquire the land and wealth of her father. Tɔnyewogbe never received much of what her father bequeathed to her, and inheritance problems continue to trouble her daughter Adonɔ and granddaughter Nɔtuefe to the present.

Nɔtuefe avoided Tchamba initiation for years, even though she knew through her dreams that Tchamba was calling her. Although she had begun Tchamba initiation at the time of our interviews in 1999, she was still gathering funds to continue the long and somewhat costly process. The discussions we had were emotional. At one point, Adonɔ began crying about the ongoing divisive effect of the inheritance issues on her family in general, and on her daughter Nɔtuefe in particular. However, since Nɔtuefe began Tchamba initiation, things have been improving in her life. She has since become very proud of her own ancestry. When she prays, she claims that it is like her grandmother

is with her; it makes her feel happy and brings her good luck. Her Tchamba shrine is quite modest, with only a *tchambazikpe* painted white and a couple of *tchambagan* (fig. 5.7).

As this story confirms, Couchoro's *L'Esclave*—with all of its drama and pain—is a "living story" in which the characters may change but the human downfalls of jealousy and greed continue to the present. Complications associated with "bought people" and inheritance have become even more nefarious in that stories currently circulate of brothers and sisters who isolate and identify a sibling born of the same parents as a "bought person" in order to deny that sibling a share of the inheritance.

Tchamba Remix

Although Tchamba veneration is grounded in old forms of domestic African servitude, there is a new Tchamba spirit with contemporary meanings derived from the growing awareness of the transatlantic slave trade. Tchamba appears to be increasingly associated with Mami Wata in two ways. One retains a connection to domestic slavery: some people relate the possession of Tchamba to the prestige associated with a family who at one time could afford to own slaves. Mami Wata is known to bring wealth, and thus if one has Mami Wata as a guiding spirit, one should have had enough money to have bought slaves. Tchamba is thus often regarded as a modern day sign of old money. But in the other association, some Mami Wata adepts who venerate Tchamba hold that they have ancestors who were sold in the transatlantic trade. Those who claim this often say that other people worshipping Tchamba (usually other Mami Wata adepts) do not always have the spirit in their families.

Vodun's open-ended structure allows for the development of an original, newly emerging type of Tchamba veneration in a Mami Wata temple in Godomey, Bénin.[15] Although I was already familiar with Tchamba iconography, at first I was unable to identify the Tchamba shrine in this temple as it was marked by a Hindu chromolithograph (fig. 5.8). The lithographic image is a recycled top portion of a calendar from "Societé Nirankor" in Cotonou, Bénin. It depicts a scene in the eleventh chapter of the *Bhagavad Gita* in which Krishna (standing) imparts his teachings to his close friend Arjuna just before the start of the main battle in the Indian epic the *Mahabharata*. Krishna, who is the incarnation of the god Vishnu, is a prince, but during the battle he serves as Arjuna's charioteer (notice the chariot in the background, and behind it the two massed armies facing each other, ready to attack). Poster images of this scene are very common, but this one, according to scholar of South Asian religions Philip Lutgendorf, is somewhat unusual in that Krishna appears in four-armed form. Vishnu is often depicted this way, but

in *Bhagavad Gita* posters it is more common to show Krishna either in two-armed (normal incarnate human) form, or in his "Vishvarupa" or cosmic form (personal communication, 1999).

The attributes of Vishnu—four arms, diadem, mace, discus, and especially the trident—are appealing to Mami Wata adepts venerating Tchamba because these accoutrements are associated with "India" and carry special prestige (as discussed in Chapter 4). Although this image looks nothing like temple paintings of Tchamba, it is described in this temple as being about a meeting not between Krishna and Arjuna but between Tchamba (standing) and a Fulani hunter in the desert in the north. The horse in the image is what distinguishes the locale as northern because there are very few horses along the coast. Tchamba's favorite nourishments from the north, such as kola nuts, *tchukutu*, and *tchapkalo*, are interpreted as being present in the image. The trident that Tchamba (Krishna/Vishnu) carries is called an *apia* in Mami Wata veneration and is placed in the associated Tchamba shrine in this temple (fig. 5.9).

However, when this particular Tchamba shrine is assembled outside for veneration, it does not contain the typical *tchambagan* or *tchambazikpe* (fig. 5.10). The Mami Wata priestess presiding over this shrine claims that she had been having dreams of her ancestors being sold in the transatlantic slave trade, and in her dreams she always saw the "photo" (chromolithograph) of Tchamba. The background sound in all of these dreams was of incessant drumming, thus she placed a drummer figure in her shrine as another manifestation of Tchamba. In this case he represents "Tchamba the Drummer," who alerted the Mami Wata priestess to the history of her own family's enslavement.

Transatlantica:
Homage to the Once Enslaved

Most enslaved people in the Caribbean and the Americas were never given a proper burial by their owners, nor were they acknowledged posthumously for the hard work and sacrifice they gave to the families who owned them. Similar to domestic slaves along coastal Bénin, Togo, and southeastern Ghana, slaves in the Caribbean and the Americas have not been forgotten. Some descendants of those once enslaved in Brazil, Cuba, and Haiti have incorporated ideas of enslavement into their different modes of spirit veneration as demonstrated in shrines and paintings, trance and performance, ceremonies and offerings, as well as literature and film.

In the African-derived religious systems throughout the Caribbean and the Americas, the open-ended and transformative quality of spiritual veneration

plays out in slave remembrance. These centuries-strong and fervently imagined memories of slavery are relived through the spirits of *pretos velhos* and *pretas velhas* in Brazil's Umbanda, Francisco and Francisca in Cuba's Palo Monte Mayombe, and Neg Lamer in Haiti's Vodou. Like the northern Tchamba spirits, these contemporary slave spirits participate in the world surrounding them. They keep the history of enslavement active, reenact accumulative memories that have endured for close to four centuries, and allow for new slave spirits to emerge, expanding their repertoires to an even wider array of slave personae.

Brazilian Slave Veneration: Umbanda's *Pretos Velhos* and *Pretas Velhas*

Umbanda is a Brazilian religious system formed from an amalgamation of varying degrees of African, Spiritualist, and Catholic elements. Some Umbanda groups are more African, others focus more on the doctrines of French Spiritualist Allen Kardec,[16] while others borrow more heavily from Catholicism. Umbanda has a reputation for being the most de-Africanized Afro-Brazilian religion. Nonetheless, in some Umbanda groups, the spirits of Afro-Brazilian slaves, known as *pretos velhos* and *pretas velhas* (old blacks), figure prominently. Umbanda, in general, is about spirituality and healing, and the *pretos velhos* and *pretas velhas* are primarily spirits who help others seeking counsel and guidance.

There is a whole range of *pretos velhos* and *pretas velhas*, each with a different personality and set of life circumstances. Although the majority of these spirits are old slave men and postmenopausal slave women, some are in the prime of life, and others are children. They range from house slaves to field slaves to mistresses. These spirits have their own individual slave life narratives about rebellion, resistance, or complicity, as well as distinctive qualities and particular strengths and weaknesses. Each slave spirit represents a lifetime's wealth of knowledge that is applicable in contemporary Brazil, especially when dealing with racism (Hale 1997).

Pretos velhos, the old slave men, are generally aged and weary, but they have centuries of accumulated wisdom with roots predating even the transatlantic slave trade in Africa. The elderly *pretas velhas* are grandmother types who are wise, patient, and loving. They fit the stereotype of what most people seek in a grandmother. They advocate forgiveness, modesty, compassion, and a general benevolence, even when dealing with unjust circumstances such as slavery in the past and racism in the present. Of course, there are *pretas velhas* spirits who do not fit this typecast, and new ones who might emerge as a need presents itself.

The most consistent counsel encouraged by slave spirits is the practice of forgiving. If slave spirits can forgive their traders, their masters, and those who repeatedly whipped and possibly raped them, then living human beings must also forgive their adversaries. That is, people living in the contemporary world must not dwell in the past, but rather they must learn from the past then focus a good part of their energies on the future. This advice seems to be precisely where the Christian overcurrents of Umbanda merge with the African undercurrents.

In Recife, Brazil, I was told that Pai Joaquim is the "boss" of all *pretos velhos*, but other named *pretos velhos* are Rei Congo, Pai Geronimo, Pai Tomás, Pai Mutamba, Pai Benedito, and Tio Chico. Among the *pretas velhas* are Maria Conga, Preta Velhana Anastacia, Avó Caterina, Ana Preta, Zefa Maroca, Azul Merinda, and Maria Redonda. Each spirit has a mass-produced statuette identified with it. Many of the slave spirits are paired with a husband or wife. The celestial pairing of Rei Congo and Maria Conga was on display in the front of a religious goods store in Salvador, Bahia, with a single Rei Congo inside (fig. 5.11). The store had a wide variety of religious statues, including a representative statue of each slave spirit described to me, along with a multitude of other religious items available for purchase.

In his article "*Preto Velho*: Resistance, Redemption, and Engendered Representations of Slavery in a Brazilian Possession-Trance Religion," anthropologist Lindsay Lauren Hale (1997, 408) not only discusses *pretos velhos* and *pretas velhas* as slave spirits, but he also introduces another type of Afro-Brazilian slave figure, the *feiticeiro*, or "sorcerer."[17] The *feiticeiro* is a slave spirit who has the prowess to manipulate "African magic" for both good and bad. Because of the *feiticeiros'* encyclopedic knowledge of African herbal medicines, the slave master precariously relied upon them for healing while also fearing their abilities to curse or poison. Some *pretos velhos* and *pretas velhas* have access to *feiticeiro* knowledge passed down through former slaves. Hale writes, "the image of the *feiticeiro* remains a shadowy threatening presence within the otherwise nonthreatening *preto velho*." In fact, it is only on very rare occasions that this "African magic" would be put to use within Umbanda, primarily because the Umbanda ethos is grounded in Catholicism.

In her book *Umbanda Religion and Politics in Urban Brazil*, anthropologist Diana Brown (1994, 71) writes that *pretos velhos* and *pretas velhas* "demonstrate the heroic ability not only to survive but to transcend their experience of slavery, retain their humanity intact, and still be able to care and to give to others despite the horrors of their oppression." But she also notes that some *pretos velhos* and *pretas velhas* have access to *feiticeiro* knowledge of African medicines, which in turn adds an element of menace to the complex characters of wise, charming old slaves remembered in the present.

FIG. 5.1 Tchamba bracelets. Vogan, Togo, December 1999.

FIG. 5.2 Joseph Ahiator's earliest Tchamba temple painting from the 1970s. Aflao, Ghana, February 2000.

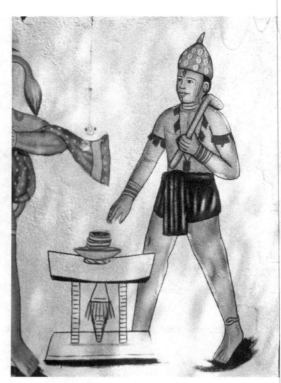

FIG. 5.3 Tchamba temple painting. Adidogome, Togo, February 2000.

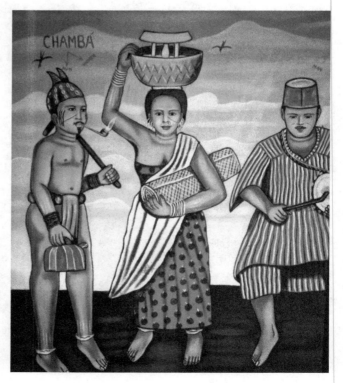

FIG. 5.4 Temple painting of Tchamba with wife and drummer. Adidogome, Ghana, December 1999.

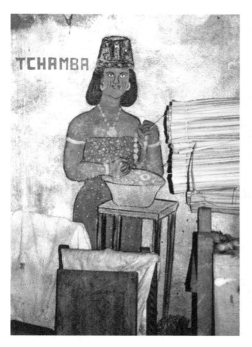

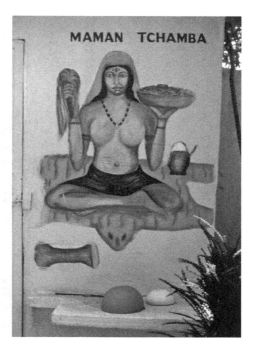

FIG. 5.5 Temple painting of Maman Tchamba with bowl of gold. Aneho, Togo, December 1999.

FIG. 5.6 Maman Tchamba painting outside of Gilbert Atissou's Tchamba shrine. Aneho, Togo, February 2000.

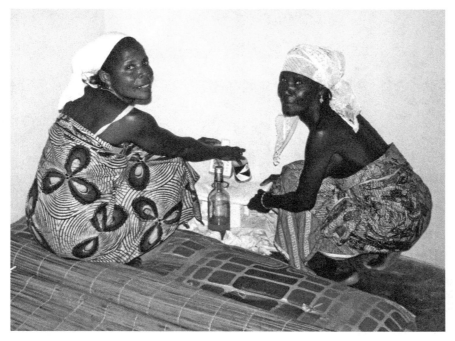

5.7 Nɔtuefe and Adonɔ with their newly begun Tchamba shrine. Adidogome, Togo, January 2000.

FIG. 5.8 Tchamba Hindu chromolithograph. Godomey, Benin, March 1995.

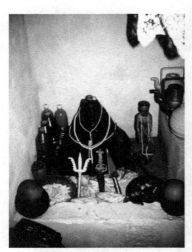

FIG. 5.9 Tchamba shrine. Godomey, Bénin, March 1995.

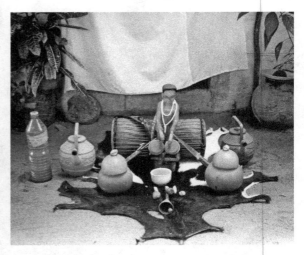

FIG. 5.10 Tchamba shrine displayed outside of temple. Godomey, Bénin, March 1995.

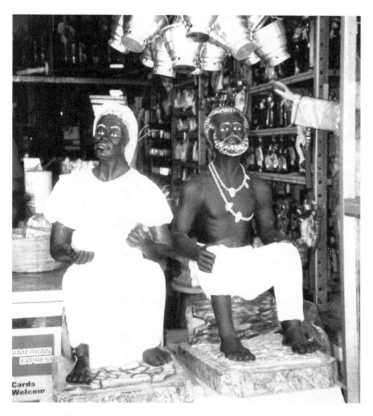

FIG. 5.11 Rei Congo and Mãe Conga in front of store. Bahia, Brazil, January 2002.

FIG. 5.12 Francisco temple painting. Outskirts of Havana, Cuba, April 2002.

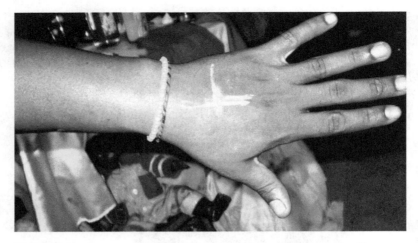

FIG. 5.13 Pemba cross drawn in chalk on hand during Palo ceremony. Havana, Cuba, April 2002.

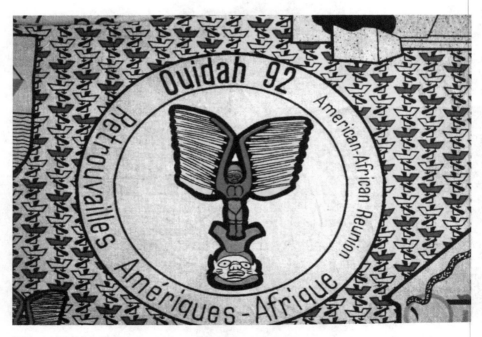

FIG. 6.1 Ouidah 92 Gɛlɛdɛ mask on cloth. Private collection.

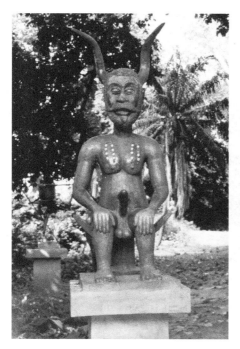

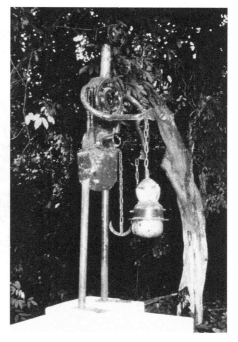

FIG. 6.2 Lεgba by Cyprien Tokoudagba in the Sacred Forest. Ouidah, Bénin, June 1993.

FIG. 6.3 "Syncrétisme" sculpture by Simonet Biokou in the Sacred Forest. Ouidah, Bénin, June 1993.

FIG. 6.4 Tchakatu, sculpture by the Dakpogan Brothers in the Sacred Forest. Ouidah, Bénin, June 1993.

FIG. 6.5 Regina and Elise Tokoudagba, who were commissioned by Foundation Zinsou to repair and repaint sculptures by their father, Cyprien Tokoudagba. Ouidah, Bénin, October 2012. Photo courtesy of John Mark Feilmeyer.

FIG. 6.6 Newly painted Tokoudagba sculpture of a chameleon. Ouidah, Bénin, October 2012. Photo courtesy of John Mark Feilmeyer.

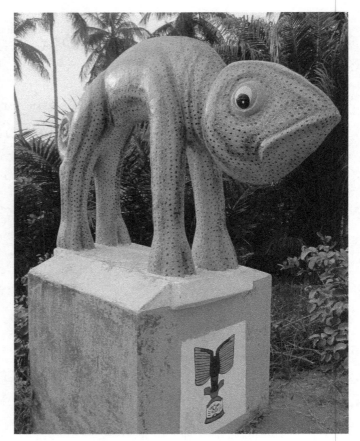

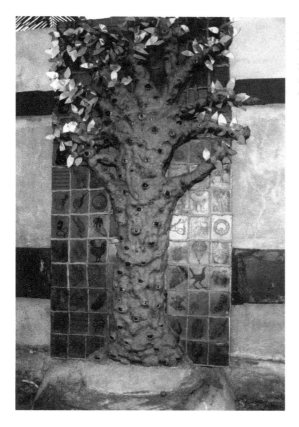

FIG. 6.7 Tree of the Ancestors wall mural in the Zomachi monument by Nancy Josephson and Nancy Hill, with Julian Degan. Ouidah, Bénin, January 2002.

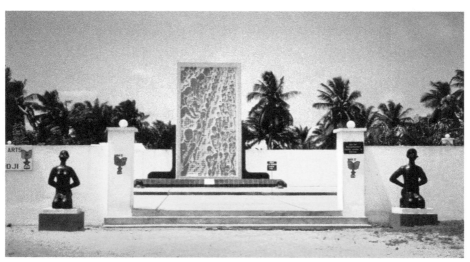

FIG. 6.8 Fortuna Bandeira mosaic in the Zoungbodji monument. Ouidah, Bénin, November 1995.

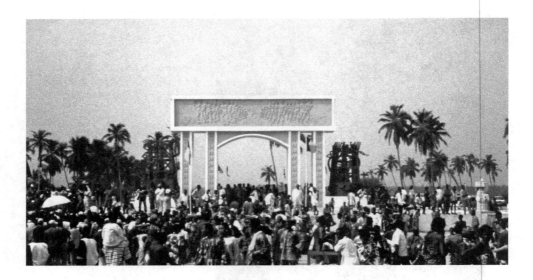

FIG. 6.9 The Door of No Return at the beach on National Vodun Day. Ouidah, Bénin, January 10, 1996.

FIG. 6.10 Wall painting of diaspora Vodun symbols outside of Daagbo Hounon Houna's house. Ouidah, Bénin, December 1995.

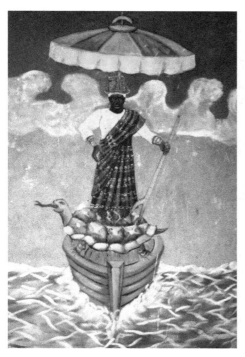

FIG. 6.11 Wall painting of Daagbo Hounon Houna with turtle by Haitian artist Edouard Duval-Carrié. Ouidah, Bénin, December 1995.

FIG. 6.12 Original painting of Avlekete by Haitian artist Edouard Duval-Carrié in Daagbo Hounon Houna's house. Ouidah, Bénin, December 1995.

FIG. 6.13 Shrine made by Haitian artist Edouard Duval-Carrié featuring a portrait of Daagbo Hounon Houna with an airplane on the *asen*. Ouidah, Bénin, January 1996.

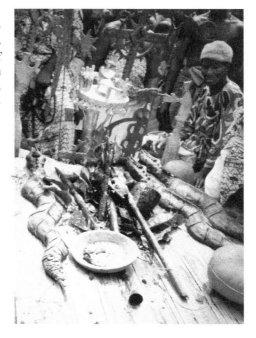

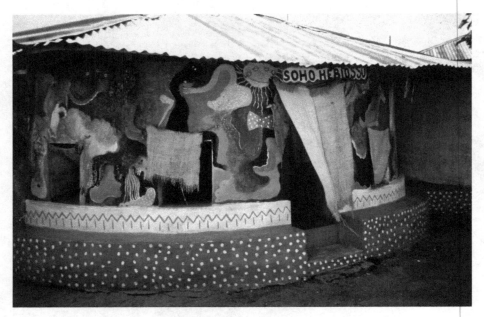

FIG. 6.14 Cuban artist Manuel Mendive's Chango temple painting in Daagbo Hounon Houna's house. Ouidah, Bénin, December 1995.

FIG. 6.15
Boukman
Eksperyens'
wall poster.
Port-au-Prince,
Haiti, 1997.

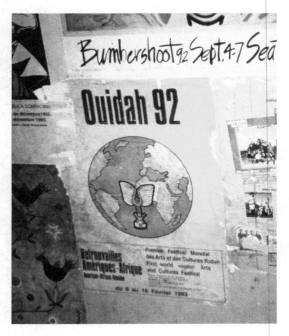

Slave Spirits in Cuba and the Cuban Diaspora

In Cuban literature and film, there is a long-standing history of a stock character, the male slave Francisco. This persona also has a role in contemporary Afro-Cuban worship, particularly within Palo Monte Mayombe, a central-African-based belief system in Cuba and Cuban diasporas that focuses on the maintenance of close relationships with ancestors, natural forces, and the earth.

The development of abolitionist literature in Cuba emerged through the work of Rodrigo del Monte, a Cuban landholding aristocrat who, in the 1830s, promoted social reform by encouraging and sponsoring liberal Cuban authors to write novels expressing their concerns for the island's slave population. Richard Madden, a British ambassador to Cuba, commissioned an abolitionist novel both to compel Spain to abolish slavery in Cuba and to promote British economic interests abroad. The result was Anselmo Suárez y Romero's novel *Francisco*, written in 1839, published in 1880, and considered to be the first Cuban novel (Lesage 1985, 53–58). Its title character may also represent the first instance of a Cuban male slave with the name Francisco. He is the slave of a young landowner, Ricardo Mendizibal. Dorotea, the servant of Mendizibal's wife, is Francisco's love interest and the mother of his child, but Mendizibal is also interested in her. The events of the novel revolve around the contradictory power relations among these characters.

Cuban filmmaker Sergio Giral made the novel into the successful 1975 feature film, *El Otro Francisco* (The Other Francisco). Giral reimagines and reevaluates the novel, its author, and its characters throughout the film, in a critique that redresses the novel's sentimental romanticization of the violent realities of slavery. The film takes to task the bourgeois documentation of the institution of slavery by differentiating the way landowners, intellectuals, and slaves lived within the same moment of Cuban history. Regardless of approach, the main focus of both the novel and film remains centered on the life and times of a slave named Francisco.

Another literary reference to the name Francisco is Lydia Cabrera's 1976 book *Francisco y Francisca: Chascarrillos de negros viejos* (Francisco and Francisca: Funny stories about old blacks). Cabrera (1899–1991), a Cuban anthropologist and authority on Afro-Cuban religions, published over one hundred books. The most famous is *El Monte* (The Wilderness, 1968), the first major anthropological study of Afro-Cuban traditions. She also wrote individual books on the main Afro-Cuban religions, including Palo Monte Mayombe. Her interest in the slave component of these religions and the prevalence of the slave persona therein attests to the importance of Francisco and Francisca. Their role is very similar to that of Brazilian *pretos velhos* and *pretas velhas*.

In 2003 I attended a Palo Monte ceremony about fifteen miles outside of Havana, to honor Francisco, the "Congo slave spirit." There I saw a painting

with the standard depiction of Francisco as an old black Congo slave, seated, with an air of wisdom and patience (fig. 5.12). The painting is also an active shrine in that offerings are placed on the painting itself (between his hands) and thus channeled directly to Francisco. In Palo, Francisco is celebrated on October fourth, Saint Francisco's day on the Catholic calendar.

Art historian Judith Bettelheim (2005, 8) describes a Cuban/Congo slave spirit: "The image of the Congo, sometimes called Francisco, may not only refer to the hardships endured by the mostly rural slave but also alludes to an initiated member of Palo Monte, with its roots in the Congo." She contin-ues by stating that in both Spiritism and Palo Monte "a standardized repre-sentation of a Congo is used on altars and in 'ancestor portraits.'" Francisco's "rural slave" status is accentuated in the painting by his straw hat and his white beard, which allude to his long days spent under the burning sun, his age, experience, and wisdom. Cubans and Haitians alike refer to uneducated, rural Haitian laborers as "Congo." Karen McCarthy Brown points out that within Haitian Vodou, an image of a Congo laborer is known as "Francisco, Francisca or Francesita" (quoted in Bettelheim 2005, 320).

During the same Palo Monte ceremony, I witnessed a more direct refer-ence to Congo, in this case the Kongo Kingdom.[18] At the beginning of the ceremony, the Palo leader drew a cross, which he called Pemba, in chalk on the top part of all participants' hands (fig. 5.13). This ideogram, writes renowned art historian and scholar of African and the African-Atlantic world, Robert Farris Thompson (Thompson and Cornet 1981, 28), is "the Kongo emblem of spiritual continuity and renaissance par excellence." The Kongo cross is often conceptualized within a circle, representing the "four moments of the sun." The trajectory of the sun, rising in the east and setting in the West, reflects passage through the Kongo world of the living, *nseke*, in the top half of the circle, mirrored in bottom half of the circle in the Kongo world of the dead, *mpemba* (see also Thompson 1983, 103–158). The chalk-drawn cross named after the Kongo world of the dead indeed rein-forces Kongo spiritual continuity in a Cuban Palo ceremony for the slave spirit Francisco.

An American-born Cuban Spiritism practitioner well versed in Palo Monte Mayombe told me that Francisco and Francisca are a married slave couple. They wear white clothing and red kerchiefs and sit together on a pair of chairs. He never referred to them as "spirits," but rather insisted that they are "spiritual guides," who can help a person with spiritual problems by guid-ing that person toward the right path. This Spiritism practitioner claims that Francisco and Francisca are "generic names" for "good slaves." He stated that they will "enter your dreams and tell you how to serve them." Once a

person has a relationship with a guide, the guide will reveal his or her real name and real appearance. However, the appearance is always that of a slave, and the slave is always "good." He clarified the "goodness" of these guides by explaining that they hold no anger against their enslavers, and that, in order to be "guided," those in need must be willing to surrender all anger as well. They too must be "good," or help will not arrive.[19]

Cuban slave spirits also exist in Cuban diasporas, such as in Miami. In the Prologue to his book *Wizards & Scientists: Explorations in Afro-Cuban Modernity and Tradition*, ethnographer Stephan Palmié (2002, 1) explains how, during the beginning stages of his field research in Miami, Cecilia and Carlos, Cuban religious practitioners, both suggested independently that Palmié was "driven to their doorsteps by the spirit of a dead slave." Individually, they said that they saw the presence of Tomás, "the spirit of an elder African slave who had lived and died in nineteenth-century Cuba and had come to attach himself to [Palmié's] person, hovering behind [him,] in the way the dead are wont to do" (2). Cecilia described Tomás as a tall, thin, dark-skinned man who wore white pants and a white shirt bound at the waist by a red sash.

Cecilia, Carlos, and others repeatedly told Palmié that Miami was a dangerous place and that Tomás's role was to guide Palmié through the unsafe world in which he was conducting his research. Cecilia felt that Tomás had pushed Palmié toward his research project on Afro-Cuban religion. Carlos recommended that whenever Palmié felt depressed he should "sit down in front of a mirror, drink a glass of rum, and smoke a cigar while reflecting on [his] deepest hopes and worries in life" (2). While doing this, Carlos felt that Palmié would see the image of Tomás in the mirror, revealing himself as Palmié's spirit guide. Palmié tried this but did not see Tomás. However, he did note that because Tomás truly existed for those with whom he worked, he was forced to reconsider Cecilia's and Carlos's accounts

> not as the charmingly exotic outgrowth of some sort of shared religious (and therefore irrational, or, at least, mistaken) belief, but as pertaining to a discourse on history merely encoded in an idiom different from the one with which we feel at home. (3)

Palmié's story was not about Tomás as a slave spirit, per se. In his account, he brought to the fore the difficulty of operationalizing "spirit presence" in academic research. For me, Tomás is very significant in that he represents a Cuban slave spirit important enough to have been brought from Cuba by Cecilia, Carlos, and others as a protective device in the potentially dangerous Cuban diaspora world of Miami.

Haiti's Neg Lamer: A Meta-Slave Spirit

Haitian Vodou is a steadfast yet ever-evolving religious system with strong West and Central African components. In addition to its African foundations, Vodou is simultaneously informed by its historical exposure to and adaptations from Catholicism, Freemasonry, British and Celtic religions, French colonialism, and Taino cultures. It is also informed by newly emerging memories of slavery, as evidenced by a Vodou spirit that has recently been developed to acknowledge the African ancestry of those brought to Hispaniola on slave ships. Neg Lamer (black man of the sea) is a spirit known as a conglomerate of all the slaves who perished during their transport from Africa to Hispaniola, as well as those who survived the transport and lived as slaves.[20]

Vodou priest Mambo Edeline of Jacmel, Haiti, described Neg Lamer as a *lwa* (Haitian Vodou spirit) who emerges from the waves in the shape of a large, strong man, and then descends back into the waves when he has finished his business.[21] Because of his extraordinary force—that of thousands of slaves—she also referred to him as a *pwen cho*, literally, "hot point," but figuratively a "place" that focuses hot energy and power, which can be used for both good and bad. She stressed that he is a personal *lwa* not a *racine* (roots) *lwa*. A personal *lwa* is one that would originally come to a person in a dream or through ancestral connections, while a *racine lwa* is fixed in the orthodox Vodou liturgy. As a personal *lwa*, Neg Lamer would be served by a particular society or house, in this case Sosyete Amba Dlo of Jacmel. Even though he is a personal *lwa*, he does appear as an escort to La Sirene and Met Agwe who are the two most dominant racine *lwa* of the sea. Neg Lamer appeared to Mambo Edeline in July 2004 at the water's edge, where she offered him a small tin plate lined with a dark blue *mushwa* (*mouchoir* in French, handkerchief in English) filled with sea water. On a piece of paper to Neg Lamer, she wrote out her concerns and requests for guidance and action, which she placed in the tin plate before offering it to him. Because she is very faithful to him, she was certain that he would do as asked.

At present it seems that Neg Lamer is not widely served. Mambo Edeline has only served him in two temples in Jacmel, and he seems to be unknown in Port-au-Prince. As a newly emerging *lwa*, Neg Lamer is not the literal Kreyol translation of his name, the Black Man of the Sea, but rather a representation of a four hundred year old accumulative collective of slave spirits.

Another Haitian Vodun priest estimates Neg Lamer may have emerged from the sea as a new Vodou spirit sometime in the 1990s to the early 2000s. He explained that because Neg Lamer is a personal *lwa*, his popularity has great potential to grow. That is, most Vodun practitioners have slave ancestors who might now begin to reveal themselves anew to their descendants. Indeed,

given the long-standing historical remembering of slavery and revolution in Haiti, this new veneration of those lost in the transatlantic trade has found a home and is bound to increase.

End Thoughts

While in Bénin in January 2007, I visited an old friend of mine, Tchabassi, the head Vodun chief in Mono Province in southwestern Bénin, very close to the Togo border (see figs. 1.3 and 1.4 for his Xɛvioso shrine). On one side of his family, his great grandfather owned slaves, and on the other side, his great grandmother was sold in the transatlantic slave trade. He had already been interested in his family's history in relation to slavery, but in the 1980s, when he found a *tchambagan* in the fields behind his house, both his personal and spiritual interests in slavery accelerated. Tchabassi maintains a private Tchamba shrine along with many other Vodun shrines in his compound. During this visit, he reiterated something he had said to me a decade earlier regarding Tchamba. He told me that members of any African family living along this coast were, at some point in time, either enslaved or they enslaved people. He said that Tchamba is the Vodun of enslavement of any kind, anywhere in the world—past, present, and future—and that Tchamba represents anyone anywhere who has ever suffered.

Contemporary Vodun Art

Contemporary Vodun arts are a testament to the strength and flexibility of a belief system that is perpetually reinventing itself. Their embodying aesthetic reflects remarkable adherence to traditional themes and structures that also celebrate signs of change. In the constant negotiation between ideologies that are old and new, local and distant, the artificial boundaries between "traditional" and "contemporary" Vodun arts are dissolved. It is precisely the all-encompassing nature of Vodun that allows such a fusion and supports participation in the international art world.

Ouidah 92

Beninese contemporary art was first noticed by the international art community with the inclusion of work by Bénin's Vodun priest and artist Cyprien Tokoudagba in the 1989 international *Magiciens de la Terre* exhibition in Paris. It gained greater international attention a few years later after the United Nations Educational, Scientific, and Cultural Organization (UNESCO) collaborated in 1992 with the newly democratic Beninese government to document various aspects of the transatlantic slave trade through a commission of hundreds of art works that were installed throughout the city of Ouidah. Unveiled February 8–18, 1993, in Ouidah 92: The First International Festival of Vodun Arts and Cultures, much of this art was based on the commonalities between Vodun and correlative religious systems in the Caribbean and the Americas. Painters and sculptors from across Bénin, as well as Haiti, Brazil, and Cuba traveled to Ouidah to create works addressing Vodun and its various

manifestations in Africa and the African diaspora, as well as to represent aspects of Beninese history, including the transatlantic slave trade. The works on permanent display throughout the city—envisioned as a kind of open-air museum—include Vodun temple murals, large-scale cement and metal sculptures, and commemorative monuments. Paintings, appliqués, collages, masks, and examples of other art forms punctuate the cityscape and are also displayed in local museums.

The arts and practices of Vodun had, in theory, been forbidden under the preceding Marxist-Leninist regime in Bénin. The support of Ouidah 92 by the new government, then headed by President Nicéphore Dieudonné Soglo, marked the first time in postcolonial history that the State played the important role of patron of the arts. Its sponsorship was instrumental in encouraging the revival of Vodun arts in particular.[1]

For Ouidah 92, Vodun priests and priestesses, religious practitioners, government officials, artists, tourists, scholars, and many others traveled to the city from Haiti, Cuba, Trinidad and Tobago, Brazil, the United States, and various European countries. Special guests such as Brooklyn's renowned Vodou priestess Mama Lola and the French photographer, ethnographer, and Yoruba Ifa priest, Pierre Fatumbi Verger, were honored. Prolific American singer, songwriter, and dancer James Brown and Brazilian composer, singer, and Minister of Culture Gilberto Gil also attended. Based on the premise of a reunion of Africa and the African diaspora through the commonalities of Vodun and Vodun-derived religious systems, this international collaboration was successful not merely in authenticating Bénin's new political and religious freedom but in demonstrating it at a global level.

Although some of the artists were practicing adepts of Vodun, the festival was conceived as a commercial rather than a religious enterprise. Intended to promote tourism, it was aimed at an international audience, an international press, and the international art market. Nevertheless, the impetus itself for Ouidah 92 was Vodun, and the spirits played a part in the project at a variety of levels. At the beginning of the festival, Vodun spirits were propitiated to ensure its success, as they are for almost every endeavor in Ouidah. When contemporary arts are produced for an international market, they can still be efficacious.

Even the symbol for Ouidah 92 added a religious facet to the event. The image is based on a Yoruba Gɛlɛdɛ mask representing a Roman Catholic Sarafina angel, in the collection of the Alexandre Sènou Adandé Porto-Novo Ethnographic Museum.[2] The image was reproduced on T-shirts, book covers, posters, and cloth for local people and foreign visitors alike, and was painted on the white bases of all of the newly commissioned large-scale sculptures throughout Ouidah. Since then it has taken on other spiritual manifestations:

many people interpret it not as a Gɛlɛdɛ mask but, among other things, as a symbol of *azè* (roughly, "witchcraft," as demonstrated by a person turning into a bird[3]) or a representation of Shango, the Yoruba *orisha* of thunder and lightning whose main symbol is a double-bladed ax (perceived in the wings of the Sarafina angel) (fig. 6.1).

In essence, Ouidah 92 was more than a celebration of democracy, religious freedom, and cultural pride; more than a means of promoting local artists; and more than a consciously organized attempt to bring tourism to Bénin. It was a reinvention and self-creation of aspects of Beninese history meant to appeal on an emotional level to foreign audiences, especially those of African descent. Some of the arts and monuments described in this chapter must be understood as depicting one of many ways to penetrate the historical, religious, and political manifestations of Ouidah's transatlantic histories and associated ways of addressing memories of slavery. The Ouidah 92 works and their changing meanings help address how histories and dominant old structures remain and coexist with ongoing reconceptualizations of the slave trade within an emerging set of retrospective ideologies. These arts can help uncover aspects of the complex religious system of Vodun and centuries of transatlantic slavery, albeit in somewhat simplified and schematic versions with multiple and changing interpretations, while simultaneously illuminating the dynamics of Vodun arts and aesthetics.[4]

The Festival Sites

The original arts commissioned for Ouidah 92 are located in three main sites in the city: the Sacred Forest, the Slave Route, and the house of the Supreme Chief of Vodun in Bénin, Daagbo Hounon. The changes and continuities that have occurred in these arts over the span of close to twenty years demonstrate ongoing and newly emerging uses, interpretations, and upkeep, including repairs and revisions. Two newer monuments have also been added since the original monuments were in place. Although the goal of promoting a growing tourist industry was not a great success, several artists whose works are displayed in these sites have become internationally recognized in recent years.

Kpassezoumé: The Sacred Forest
The most hallowed place in Ouidah is the Sacred Forest of King Kpasse, or Kpassezoumé (*zoumé* = a secret place, often of dense forest), where all Vodun powers reside—good and bad, ancient and contemporary, distant and local. Sometime between 1530 and 1580, Kpasse became the second king of Savi

(located nine miles north of Ouidah) and founder of Ouidah (Agbo 1959, 13; Cornevin 1962, 73; Assogba 1990, 15). When he learned that two jealous enemies were plotting his demise, he alerted his two sons, telling them that although he would never die, he would disappear one day. If it should happen that he did not come out of his room before sunset, his sons were not to open the door but understand that he was already gone. After nine days they would see a specific sign from their father, which, once understood, would protect them and their families for generations to come. One day these events did come to pass. Today the sign is still a secret associated with the Kpasse Vodun, known only to the direct descendants of the king.

Soon after King Kpasse disappeared, his family living in Savi saw a bird they had never seen before. It led them to the Sacred Forest in Ouidah. Upon entering the sacred grounds of the forest, the bird turned into two growling panthers (male and female). The family was frightened until they heard the soothing voice of the king. He gave them an important message: if at any time they were having problems, they could come to the forest and pray to a specific iroko tree that houses his spirit. The tree was then just a little sprout next to a sacred clay pot. Today, behind the ruins of the old French administrative house in the Sacred Forest, abandoned because the spirits were "too strong" for the French, there are active shrines, including a clay pot, next to the tree in which Kpasse's spirit resides. In 2005 an entryway was built with a painted entablature depicting the growling panthers. Painted sculptures of the growling panthers were also installed just inside of this newly built entrance, reinforcing the story.

Although the Sacred Forest has become a tourist site, it remains a serious place for Vodun worship and ceremonies. During the night and at high noon, all Vodun forces congregate there, often in the form of animals. It is the Supreme Court of Vodun. The late Daagbo Hounon Houna held his most serious dispute negotiations in the Sacred Forest. "In Kpassezoumé," he said, "everyone [spirits, ancestors, humans, and animals] pays attention."

Almost destroyed under the old Marxist-Leninist government, this secluded area is now celebrated with government-sponsored contemporary sculptures of Vodun gods and associated powers. It is where one finds art by Beninese artists Cyprien Tokoudagba, Theodore and Calixte Dakpogan, and Simonet Biokou. What the art "means" in the Sacred Forest is highly contingent upon who tells you, what you know already, what others think you know, and what they want you to know. For example, guides at the site are primarily there to receive tourists, and they have a standard tour geared toward that audience. I asked many people how to interpret the sculptures, and as anticipated, I received a variety of answers. Most often it was only the specifics of the Vodun spirits represented that were different, but in other

cases meanings diverged radically. In talking to the artists about their work, I found that the interpretation of a piece could change depending on the artist's mood or a recent dream, or the artist might see in it something that departed from his initial conception. In reference to the Janus-faced human sculpture that he had created in the Sacred Forest, Cyprien Tokoudagba once told me—in genuine perplexity—"I don't remember what that is supposed to represent."

Born in 1939, Cyprien Tokoudagba's earliest childhood memories in Abomey are of his insatiable desire to create things with his hands. This will to create remained a force within him until his death in 2012. When he began school at age seven, he would doodle instead of paying attention in class. To encourage his participation, the teacher would ask him to draw the subjects under discussion for the benefit of the other students. The boy then began to sketch everything around him: chickens, goats, trees, houses, market stands, and people. He was soon making clay sculptures based on his drawings, and visitors to his home started commissioning him to sculpt specific subjects ranging from chameleons (for the spirit Lisa) to Jesus. At age fourteen Tokoudagba was initiated into Tohosu, the Vodun of royalty, human anomalies, and lakes and streams. Through the initiation process he gained much greater insight into the intricacies of Vodun, which has helped him represent aspects of the religion in his art. He took up painting as a young man, following a short stint in the Beninese army. He made his first painting—of a soldier in uniform—using a chewing stick called *alo* as a brush.

Among the people who came to see Tokoudagba's work, an important Tohosu Vodun priest in Abomey invited him to paint his first Vodun temple. It was through this commission that Tokoudagba became a recognized artist in Abomey. Requests followed for bas-reliefs, sculptures, and wall paintings for other Vodun temples in the city and, as his reputation grew, for temples not only in Bénin, but also in Ghana, Togo, and Nigeria. In 1987 he began work as a restorer for the Abomey Historical Museum (formerly the Royal Palace) where he was able to combine his work in both sculpture and painting. Coming from a long line of familial ties with the Abomey Kingdom, he appreciated the opportunity to work in the palace/museum.

Tokoudagba's international acclaim began, as mentioned earlier, in 1989 at *Magiciens de la Terre* at the Georges Pompidou Centre.[5] This was the first time Tokoudagba painted on canvas rather than on Vodun temple walls, and the transition was seamless. The iconography he employed from the social and religious history of the Abomey Kingdom had an international appeal, which opened his oeuvre to the world market. Since 1989 his work has been shown in France, Germany, England, South Africa, Portugal, Australia, Denmark, the Canary Islands, Mexico, Brazil, Japan, and the United States.[6]

Among these venues was a forward-thinking international exhibition enti-
tled *Africa Remix: Contemporary Art of a Continent*. Under the artistic direc-
tion of Simon Njami and with an international team of curators, the exhibition
opened in July 2004 in Düsseldorf, then traveled to London, Paris, and Tokyo.
The exhibition was an overview of artistic production from both Africa and
the African diaspora over the previous ten years.[7] Tokoudagba's contribution,
included in the "Body & Soul" section, was a large-scale (160 cm × 206 cm)
acrylic on canvas painting of a frog symbolizing Tohosu, his guiding spirit. In
2005, during the London tenure of *Africa Remix*, three more of Tokoudagba's
paintings were on display in an exhibition entitled *The Healers* in which the
participating artists' works were shown not purely for their aesthetic sensibili-
ties but for their symbolic associations with health, disease, and well-being.
Exhibited at the London School of Tropical Medicine and Hygiene, University
of London, *The Healers* brought together artists and medical researchers to
explore new ways that art and culture can be used to transmit public health
messages. One of Tokoudagba's paintings depicted the rainbow serpent spirit
Dan Aida Wedo, known as the oldest Vodun spirit who incarnates the dyna-
mism of the continuity of life and well-being (see Chapter 4).

For the 2006 reinstallation of the Afrika Gallery at Amsterdam's
Tropenmuseum, Tokoudagba was commissioned to make a large-scale
cement sculpture of Lɛgba. Senior Curator Paul Faber invited Tokoudagba to
Amsterdam where he was supplied with all necessary materials to complete
the commissioned piece. The choice to construct a version of Lɛgba was apt
for the gallery's reinstallation: Lɛgba is the first spirit of the Vodun pantheon
to be consulted for any new endeavor.

At the entrance to the Sacred Forest is an earlier Lɛgba sculpture by
Tokoudagba (fig. 6.2). The horned and phallic guardian and gatekeeper of the
forest greets visitors as he keeps track of all of the comings and goings in
and out of this sacred place. Tokoudagba's larger-than-life anthropomorphized
cement statue truly communicates this deity's contrary personality and inher-
ently wayward character.[8] His most distinguishing characteristic is his erec-
tion. According to one tale, Lɛgba was having an affair with both his sister
and his sister's daughter. Caught by the supreme god, Mawu, he was punished
with this eternal condition in which his desire is never appeased (Herskovits
[1938] 1967, 2:203–6). Stories abound about Lɛgba's mischievous nature,
usually relating to his priapism.

The sixteen cowry shells shown on Lɛgba's chest in Figure 6.2 illustrate
two *du* signs of the Fa divination system. According to Herskovits ([1938]
1967, 2:203), sixteen shells represent the eyes of the god Fa.[9] The god could
not open them in the morning without assistance. Using palm kernels, Fa

would communicate to Lɛgba which of the sixteen eyes should be opened and in what order. According to the story, this process developed into the complex system of Fa divination, which uses sixteen palm kernels. A figure of a Fa diviner, also by Tokoudagba, appears opposite Lɛgba in the Sacred Forest.

The work at this site by the Dakpogan brothers attests both to their renown as *artistes-ferailles*—"scrap-iron artists"—and to their family ancestry. The ancestors of the Dakpogan family were blacksmiths who maintained not only the royal forge of Porto-Novo, Bénin, but also the Gu Vodun, god of iron, warfare, and technology. The family compound remains in the Gukome quarter (the quarter of Gu) of Porto-Novo, where the Dakpogan family continues to work the forge, making religious items for Gu as well as everyday household objects. They have also added "art" to their creative repertoire, through the work of the two brothers, Calixte and Theodore, and their cousin Simonet Biokou. Since 1989 the Dakpogan forge has been recognized in the international art market for scrap-iron art, which ingeniously combines scrap metal and recycled car, motorcycle, and bicycle parts to create larger-than-life figures of Vodun gods and scenes of Beninese life. The Dakpogan forge is a land where raffia fibers become bicycle chains and cowry shells become sparkplugs—semantic equivalencies with a cutting edge.[10]

Calixte Dakpogan's work was included in a 2005 tribute to African art—both classical and contemporary—at Monaco's Grimaldo Forum. *Arts of Africa* was curated by Ezio Bassani, a well-respected and well-seasoned Africanist art historian. The overt ironies of the exhibition project nothing new in the history of the collection and display of African art, though they seem more extreme in this case: This highly valued collection of classical and contemporary art objects originating from some of the world's poorest countries in a continent measuring close to twelve million square miles was being displayed in one of the world's wealthiest nations measuring less than one square mile.

Simonet Biokou has branched out into the world of film while remaining within his oeuvre of *artiste-feraille*. In the 1998 film *Divine Carcasse*, Biokou plays himself, a sculptor who transforms a discarded and stripped-down 1955 black Peugeot into a larger-than-life sculpture of the Vodun spirit of Zangbeto, or Guardian of the Night (*za* = night, *gbeto* = man/person). Zangbeto masquerades were suppressed by the French colonial regime and to this day are performed mainly for entertainment, though shrines and temples to honor Zangbeto still exist. At the beginning of the film the car arrives at the Cotonou port for an expatriate philosophy teacher named Simon. The car provides Simon with nothing but trouble so he offers it to his cook, for whom the troubles continue, obliging him to abandon the car. At this point, the fictional story morphs into an ethnographic documentation of the transformation

of a discarded French automobile into Biokou's artistic rendering of a Vodun spirit. Zangbeto is recast here with irony as it is remarketed to a European audience as a critique of the French who once outlawed this spirit.

According to Biokou, it was he who made the first large recycled-metal sculpture, which depicted a soldier.[11] He says his cousins felt that it was not serious work and that no one would want to buy it. A few days later, a man from the French Embassy happened to see the statue, loved it, and purchased it. At that point, Theodore and Calixte Dakpogan took the profession of *artiste-feraille* seriously and started to make more sculptures with their cousin. The brothers were commissioned by the Beninese government to make one hundred such statues for Ouidah 92. Biokou is represented by one piece.

Biokou's sculpture, composed of scrap metal and recycled car and motorcycle parts, depicts a priest holding what appears to be a censer, commonly used in Catholic Mass (fig. 6.3). Upon closer inspection, one sees that the chain to which the censer is attached terminates in the fire-spitting symbol of Xevioso, the spirit of thunder and lightning. As of 2007, the metal that terminated the chain was painted red, possibly to evoke fire. Now that it is red, it stands out, but the meaning is still easy for tourists to miss. This seemingly anomalous detail is neither inconspicuous nor unusual to Beninese viewers. Biokou's sculpture conflates two religious systems, an idea the artist came up with while attending a Vodun ceremony. In explaining this piece, the Sacred Forest guides say, "*Voila le syncrétisme. . . .*"[12]

There is one sculpture made by the Dakpogan brothers that is related not to a Vodun spirit per se but to a type of power or force called *tchakatu*, which can be sent to harm an enemy (fig. 6.4). This sculpture depicts the infliction of *tchakatu*, which can be transmitted in a variety of ways and results in debilitating and ultimately fatal pain inside and outside the body. Victims are said to feel as though their entire bodies were being pierced by shards of glass, nails, and metal fragments.[13] The way this force has been rendered in this sculpture is the closest I have come in my studies of Vodun to what throughout the Americas is called a "voodoo doll," which may possibly have some origin in the force of *tchakatu*. In her book *African Vodun*, Suzanne Blier (1995b, 202 fig. 93) illustrates a *bocio* called "*tsakatou*," which has a peg inserted into its chest, likely demonstrating this affliction.

Additional Vodun spirits represented by contemporary sculpture in the Sacred Forest are Dan, the rainbow serpent; Gu, the god of iron, war, and technology; Loko, the god of the iroko tree inhabited by King Kpasse; Zangbeto, the guardian of the night; and the three-headed Indian god, Densu, known here to be the husband of Mami Wata (Drewal 1988; Rush 1999). There are also sculptures of Vodun adepts, among them a male and a female Sakpatasi,

"wife" or adept of Sakpata, the spirit of the earth and disease.[14] The display includes a variety of other supernatural characters representing specific powers, such as Tokoudagba's cement sculptures of a Janus-faced man and a one-footed man, both covered with packets of power (also rendered in cement).

Over the course of more than a decade, I have witnessed the transformation of the art in the Sacred Forest. My first visit to this site was in 1993. At that time all of Cyprien Tokoudagba's cement sculptures and their cement bases throughout Ouidah were unpainted, but in the Sacred Forest, in particular, their uniform gray color united the sculptures against the lush green backdrop of the natural setting. In 1994, when I returned, all of the cement sculptures throughout the city were painted a forest green, and all sculptures had the Ouidah 92 symbol of a Gɛlɛdɛ mask hand-painted on each of the bases and framed in a white background. The color choice for the Sacred Forest made the sculptures disappear into the naturally forested landscape, except for the parts of the sculpture that were eroded, chipped, or even broken off, revealing the original cement color. Throughout the following years the exposed parts of the broken sculptures were painted green (usually not the same shade) rather than repaired.

Sometimes the broken off parts revealed the metal substructure of an arm of a deity, an accoutrement associated with a king, or an ear of corn associated with a king's proverb. In those cases, the protruding metal was also painted green. This is not a criticism; rather, it is meant to demonstrate how the repairs were conducted. In fact, one of my friends, unemployed at that time, was supplied with green paint and one paintbrush and told to paint whatever parts of the sculptures were exposed. This job was outsourced to my friend by the Beninese artist Yves Appolinaire Pede, who had repaired some of his friend and colleague Tokoudagba's sculptures in the past. My friend, however, had never painted in his life. When finished, my friend was to send a message to Pede in Abomey so that Pede, assigned to repair the art by the original artist Tokoudagba, could travel to Ouidah to check the finished product. Finished, however, it was not. It became clear to me that once the cement sculptures in the Sacred Forest were placed, their painting was out of the hands of the original artist.

In January 2007, my attention was drawn to repairs, or updates, in the Sacred Forest. Tokoudagba's Lɛgba—originally cement colored, then painted green—remained green, but his phallus was capped in fire engine red. Lɛgba and the tales surrounding his priapism are loved by all. Most people—mainly foreign, but Beninese, too—whom I saw in the Sacred Forest were immediately drawn, pointing and giggling, to Lɛgba's enormous red-capped erection. Lɛgba's exaggerated erection *already* garnered immediate attention. But Lɛgba likes to trick and tease; he can never have enough attention. Maybe that was the point of the red "accent"?

The rest of the sculptures in the Sacred Forest had somewhat careless red, and sometimes blue and white, highlights. The original metal colors of the recycled metal sculptures by the Dakpogan brothers and Simonet Biokou were also highlighted with the same red paint as Tokoudagba's Lɛgba, and with a few other colors. The aesthetic choices of the Dakpogan artists are grounded in the qualities and meanings of metal and the forge, not paint. If paint happened to remain on a piece of discarded metal—Honda spelled out on a motorcycle part, for example—the artists left the color there. I have never seen colors added to their oeuvre in person, in their workshop, or in published pieces. But here the original artists were no longer a part of the evolving manifestations of their work.

Although they are not the original artist himself, two of Cyprien Tokoudagba's daughters are actively involved in keeping their recently deceased father's artistic traditions alive. Along with making small-scale reproductions of their father's cement sculptures for sale to tourists, they completed an enormous project in Ouidah during the final months of 2012. The Zinsou Foundation, Bénin's first private foundation dedicated to contemporary African art, commissioned Regina and Elise Tokoudagba to repair and repaint all of their father's sculptures in Ouidah (fig. 6.5). The sculptures Tokoudagba originally created for Ouidah 92 were never painted in the colors he had envisioned. Regina and Elise took it upon themselves to recreate the sculptures in bright colors with the artistic flair they learned from their father. This time the sculptures were painted with a durable oil paint designed to resist the elements, thus avoiding the need for constant upkeep. The freshly painted chameleon, one of their father's favorite animals, graces the Slave Route (fig. 6.6).

The Slave Route of Ouidah

As a reinvention of various aspects of the slave trade from the Ouidah port, the Slave Route is meant to appeal on an emotional level to tourists, especially those of African descent. Beginning where the auction block is said to have been located, it follows the footsteps of the hundreds of thousands of African captives who walked the three miles to the beach and then onto ships destined for the Americas. Lined with contemporary sculptures representing Vodun spirits and Dahomean kings and marked at critical points by single sculptural works or by multiple-work monuments depicting the atrocities of the slave trade, the route narrates the history of Bénin for international and local audiences. There have been two new monuments added in recent years, both of which were envisioned to cater especially to the international visitors. The most recent and significant change is the repainting of Tokoudagba's cement sculptures.

This narrative is both simplified and embellished. The monuments and single sculptures located at the critical sites along the route are engraved with panels of didactic material. Often the histories given and the locations of the sites are not corroborated by or even mentioned in the literature on the subject (Curtin 1969; Law 1991). Some generalizations are understandable, for much truly is unknown about the circumstances of the slave trade from the Ouidah port. In other cases, the histories seem highly unlikely. The "unknown" of the slave trade, however, is of little importance compared to its "living history"— that is, what the markers say today, as improbable as some of them may seem.

The Slave Route of Ouidah reflects centuries of transatlantic interactions that have ultimately reinvented not only the history of Bénin but also its subsequent art forms. As Supreme Chief of Vodun, the late Daagbo Hounon Houna played an active role in this reinvention of history. Since 1993, January 10 has been celebrated as National Vodun Day, during which there is a festival where the main activity in Ouidah is the reenactment of the slave march to the beach. It was led by Daagbo Hounon Houna who, with his followers, stopped, prayed, and made offerings at each site along the route. The procession honored the memory of those ancestors lost in the slave trade and celebrated those who survived and passed down the religion and arts of Vodun that flourish today throughout the African diaspora. Thus the art and monuments can be viewed as both historical markers and active ancestral shrines.

Each National Vodun Day to date has been celebrated not only by Beninese but also by a handful of Haitians, Brazilians, Cubans, Americans, and others who have returned to pay their respects in the land of their ancestors, turning Ouidah into a pilgrimage site for people of African descent, much in the manner of the slave factories of Gorée Island, Senegal, and Cape Coast, Ghana. International recognition of the city's function in this regard reflects broader changes in Africa. One might especially see this particular case of Vodun as the local manifestation of a more global phenomenon of postcolonial nations seeking ways to represent—from their own perspectives—their histories to an international audience, as demonstrated in the following commemorative sites.

Auction Block

The Slave Route officially begins under a large tree where the public auctions are said to have been held. The tree is located just behind the compound of Don Francisco de Souza, who arrived in Ouidah in 1788 and became intimately involved in the transatlantic slave trade. In front of the tree is a Tokoudagba statue mounted atop a base upon which de Souza's role in Ouidah history is engraved. It seems likely that the auctions held during de Souza's tenure as Viceroy took place close to the family compound. It must be

remembered, however, that de Souza's activity covers only about sixty years of Ouidah's centuries of participation in the slave trade. This plot of land, known as Dantissa, and the area just south of it are currently the site of festivals for the Vodun Dan, the rainbow serpent. This area lies between the de Souza compound and de Souza's Vodun temple to Dan, whom he renamed Dagoun (see Chapter 3).

Tree of Forgetting

According to legend, all enslaved women marched around a tree seven times, and all enslaved men nine times, on their way to the Ouidah beach.[15] The intent was to make them forget their origins and cultural identities. Beninese historian Clement Lokossou (1994, 128) compares these forced circuits around the Tree of Forgetting as a type of "zombification." In that process, rumored to exist in Haiti, the work of a sorcerer causes one to lose one's identity and become one of the "living dead." But "zombification" never has been a named concept or process associated with Vodun in Bénin and has only been introduced there through knowledge of Haitian Vodou.

The place where the Tree of Forgetting is believed to have stood is marked with Dominique Kouas's sculpture of a three-headed, three-footed, three-armed Mami Wata and a small symbolic tree. The base of the statue is engraved with the legend of the "Tree," endorsed by former President Soglo. Although Kouas is known locally for some of his large metal sculptures on display in Ouidah, one visit to his house-studio in Porto-Novo demonstrates his stylistic range and his versatility with various media. All of his pieces nevertheless maintain a recognizable signature: like the Mami Wata sculpture, they are big, bold, and geometric, playing with positive and negative space. The artist has since developed a new technique that he calls "peintik," a combination of sculpture, painting, and batik. He often incorporates found objects, Vodun paraphernalia, raffia, cotton, and cowry shells into his "peintik" assemblages. He dedicates his creations to the memory of all of the anonymous African artists of the past centuries, and he continues to make art and exhibit internationally with a handful of other contemporary African artists, many of them his Beninese colleagues.

Zomachi: Memorial of Repentance and Eternal Light

A newer monument, *Zomachi, Memorial of Repentance*, was inaugurated in 1998 along the Slave Route, just south of the Tree of Forgetting. It was sponsored by Professor Honorat Aguessy, a Ouidah resident, Vodun scholar, and supporter of the arts. The name *Zomachi* translates literally as "a place where the fire does not go out," or more figuratively, "a place of eternal light." It is a plot

of land dedicated to local Beninese repentance for the complicity of their ancestors in the slave trade and to petitioning the forgiveness of the descendants of enslaved Africans now living in the diaspora. A ceremony is held every year on the third Sunday of January, annually renewing this plea for absolution.

The wall of the monument and the sculptures inside are in praise of African diaspora achievement. Upon the painted yellow backdrop of the cement enclosure wall there are panels rendering in brown low-relief the march of the enslaved to the beach, brutal European/African encounters, the packed slave ship, and shackles and chains. Each panel is framed in blue, and atop the vertical blue divisions there are cement renderings of eternal flames, painted a deep red-orange. Inside the enclosure there are various sculptures dedicated to African diaspora heroes such as Toussaint L'Ouverture, leader of the Haitian Revolution. His father was from Allada, Bénin, and likely left the continent from Ouidah. Other tributes within the monument are to Martin Luther King, Jr., and Kwame Nkrumah, Ghana's first prime minister (1957) and later president (1960), also known for his advocacy of Pan-Africanism.

In 2000, Professor Aguessy invited American artists Nancy Josephson and Nancy Hill to conceptualize a new artistic addition to the Zomachi monument. Created and installed in January 2002 with the help of Beninese artist Julian Degan, *L'Arbre d'Ancêtres* (*Ancestor Tree*) depicts a seven-foot high greenish-gray low-relief tree with a multitude of branches covered with protruding metal leaves. The trunk of the tree and the branches are punctuated with very realistic looking human and animal glass eyeballs, which bring the tree to life, and—as the title suggests—reify an ancestral presence not just in this particular tree, but in all trees along this Slave Route (fig. 6.7).

The backdrop supporting the tree is made of up about one hundred six-inch square copper tiles into which are etched a wide range of animals, including a chicken, frog, goat, snail, monkey, and antelope. There are also copper tiles etched with a pair of glasses, a high-heel shoe, a hot air balloon, and an apple held in the long-nailed hand of, presumably, a woman. The wide range of iconography represents a group effort of the artists' Chicago friends. Josephson asked them to etch their visions of their own ancestry upon the tiles; the artists then brought the tiles with them to Bénin.

During a phone interview, Josephson referred to the continual and reciprocal connection between people and their ancestors. This relationship is, she says "living, constant, and changing." She envisioned an ancestor tree as a perfect addition to the Slave Route because she says "the ancestors are always looking. . . ." She draws her strength from her own ancestors, and felt that an ancestor tree would be ideal in Ouidah where one is surrounded by "energy of the living past."[16]

In 2007, the monument was being renovated because it, like most of the monuments along the Slave Route, was deteriorating. Unlike Tokoudagba's sculptures, this renovation remains unfinished. Along with the annual repentance ceremony, this site has been incorporated into the National Vodun Day trek to the beach, as it is located between the Tree of Forgiving and the next site.

Zomaï Enclosure

After encircling the Tree of Forgetting, the captives are said to have been led to the Zomaï Enclosure where they waited for the slave ships to arrive. In contrast to Zomachi as "a place of eternal light," the name Zomaï translates as "a place where fire can never go," referring to the darkness of this oppressive state of confinement. The building itself is no longer extant, but the spot is now commemorated with three contemporary works: a central sculpture made by Dominique Kouas, flanked by two bound and gagged figures made by Cyprien Tokoudagba.

Kouas's piece, composed of faces bearing different scarification markings, represents the many enslaved Africans from a variety of ethnic backgrounds who converged in this dark place before they were sent across the ocean. The six Yoruba markings (three on each cheek), and the ten Fon markings called *ḍenô* (two on each cheek, temples, and forehead) are readily discernible. The artist also included a scale to represent the ideal of equality among peoples throughout the world.

Zoungbodji Memorial

In the Zoungbodji quarter, just off of the main road to the beach, the customs post controlled and recorded the movement of enslaved Africans from the Abomey Kingdom to the coast (Soglo 1994, 69). The memorial monument is constructed upon what is believed to be the ancient common grave for slaves who died in the Zomaï Enclosure. There have been no archaeological excavations to prove or disprove this theory.

The entrance is flanked by cement male and female figures made by Cyprien Tokoudagba; they are kneeling, and again their hands are tied and their mouths gagged. To the rear is a large abstract mosaic mural by Cotonou artist Fortuna Bandeira, who used black to represent Africans chained together, their blood depicted in red, against a white background (fig. 6.8). On either side are two works by the Dakpogan brothers: on the right, two chained African figures followed by a pith-helmeted European with a whip—all constructed of recycled metal—and on the left, a sculpture in which two large abstract faces are meant to convey fear, horror, sadness, and despair (not visible in fig. 6.8).

Only one of the human figures within this monument transcends these emotions: Tokoudagba's sculpture of a man with upraised arms broken free of chains. According to the artist, the image represents "death" and, in turn, "freedom" from enslavement.

Tree of Return

Before arriving at the Ouidah beach where they would be loaded onto ships bound for the Americas, the captives are said to have made one last stop along the Slave Route, at the Tree of Return. This point on the route is represented by an actual tree reportedly planted in Ouidah during the reign of King Agaja of Abomey (1708–1732). It is marked by Cyprien Tokoudagba's cement sculpture of the forest Vodun Aziza. Although it seems logistically unlikely, the enslaved Africans are said to have walked around the tree three times to ensure that their spirits, if not their bodies, would return to their native land.

Door of No Return

With the Atlantic Ocean as an ominous backdrop, another monument on the Slave Route is the *Door of No Return*, commemorating where the enslaved were forced onto slave ships. In the center is a massive arch, designed and decorated by Fortuna Bandeira, built atop a large circular platform (fig. 6.9). The cement entablature comprises four bas-relief friezes of two rows of Africans, chained together, converging upon the beach, the Atlantic in front of them. Different perspectives of this same scene ornament the front, back, and two sides of the entablature. The columns supporting the arch consist of pairs of kneeling male and female figures repeated from the bottom to the top. On either side, Dominique Kouas's four abstract metal sculptures depict families and Africans broken free of chains who wave good-bye to the enslaved. Since the inauguration of this monument on November 30, 1995, it has been repainted in a similar color scheme many times. The metal sculptures, however, are currently rusted and deteriorating and some have been updated, removed, or replaced.

The appliqué work, large cement sculptures, and cement bas-reliefs of Yves Apollinaire Pede harken back to the old bas-reliefs in the Palace Museum of Abomey. The artist has a special interest in Kulito (the Fon word for Yoruba Egungun; see Chapter 3), which he finds to be colorful, exciting, and powerful. His bas-reliefs are found throughout Bénin in restaurants and hotels, representing diverse subjects ranging from royal motifs to Vodun symbols. In the cement bas-reliefs built onto the sides of the circular platform of the *Door of No Return*, Pede's imagery ranges from the Gɛlɛdɛ mask that now symbolizes Ouidah 92 to various spirits such as Dan Aida Wedo, Mami Wata,

and Gu. There are also two bas-reliefs of Kulito, and mounted on the platform are two larger-than-life cement statues of Kulito, which represent the spirits of people of African descent who died in the Middle Passage or later in the Americas and who have returned to the land of their ancestors as Kulito.

Following the idea of "return," on National Vodun Day 1999, Hounongon Joseph Guendehou of Cotonou held a special Vodun ceremony at his house, inviting a delegation of visitors from Haiti, Guadeloupe, and Martinique. During a celebratory dancing and drumming session, members from Haiti began to shout "*Ayibobo!*" This Haitian Vodou praise exclamation was immediately picked up and repeated by all of the Beninese participants as if it had already become part of Bénin's Vodun liturgy. The head of the Haitian group, Dr. Henri Frank, in an appreciative response to the activities surrounding National Vodun Day, suggested that the *Door of No Return* be renamed the "Door of Return." Some years later, that idea was realized by an altogether new monument.

Door of Return

This latest monument, constructed in 2004 as the last part of the Slave Route, is approximately two hundred yards to the west of the *Door of No Return*. It was sponsored by the Organisation pour la Promotion de Médecines Traditionnelles (PROMETRA), a Dakar-based international organization dedicated to the preservation and restoration of African traditional science and healing.

Upon entering the walled-in space, a visitor encounters three larger-than-life bronze sculptures of an African mother welcoming her Western-clad son and daughter upon their return to Bénin. Behind this figural grouping is the Museum of the Door of Return. To enter the museum, the visitor passes two bronze sculptures of enslaved Africans breaking free of their chains, a recurring trope in this case actualized by Nigerian artist Benjamin Mafort. The museum itself is an homage to and a celebration of the transatlantic descendants of African slaves.

Encompassing centuries of transatlantic slaving history from the Ouidah port, the Slave Route is based on cumulative histories, yet in the way these are communicated through art, historical accuracy is less important than comprehensive African and African diaspora consciousnesses. Does it really matter whether the slave auctions took place outside de Souza's compound? Does it make a difference if enslaved Africans were forced to walk around a tree either to make them forget their cultural identities or to give them strength for a transatlantic journey? The Slave Route of Ouidah, as a reinvention and a self-creation, recognizes and mourns the history of the slave trade, yet celebrates and, as exemplified particularly by ongoing National

Vodun Day festivities, praises the strength of Vodun and its survival on both sides of the Atlantic Ocean.

The Daagbo Hounon House

Although the Daagbo Hounon house is not recognized by the government as the actual beginning of the Slave Route, some people nevertheless consider it to be so. All Vodun manifestations can be found in his house because, the late Supreme Chief claimed, before the enslaved were put up for sale in the Ouidah auctions, Abomey kings allowed them to stop at the house for one last opportunity to pray to their Vodun spirits on African soil. Their motives for granting this "privilege" were by no means altruistic. What the Abomey kings most sought was foreign spiritual power such as might be held by enslaved ritual specialists. Daagbo Hounon Houna asserted that those exhibiting the traits of extraordinary ritual specialists during their supposed last prayer were not sold at the auction block but were sent back to serve the kings. The fact that King Gezo worked closely with de Souza, his Viceroy of Ouidah, adds credibility to Daagbo Hounon Houna's claim. Plus, considering the great pains the Abomey rulers took to make certain that no one powerful left their domain, this story is imaginable in theory. In fact, there may be examples of enslaved people who demonstrated remarkable spiritual power being retained and sent to the kingdom. But, in reality, the possibility that all of the enslaved first stopped at the Hounon house would have been very difficult logistically, and very well could be read as a contemporary means for Daagbo Hounon to place himself at the forefront of the ongoing reinvention of Ouidah's history. Either way, it is abundantly clear that important ritual specialists did make it from the Ouidah port to the Americas, where they continue their activities.[17]

Daagbo Hounon Houna took great pride in the fact that Avlekete is known as Aïzan Velekete in Haiti. Paintings of both these spirits adorned the walls of his compound that face the street, as did paintings of other Fon Vodun symbols (with blue backgrounds), and their African diaspora counterparts (with pink backgrounds) (fig. 6.10). For example, different depictions of the same rainbow serpent are displayed: the Haitian *lwa* Dambala Aida Wedo derived from the Fon Vodun Dan Aida Wedo, and the Brazilian *orixa* Oxumare derived from the Yoruba *orisha* Oshumare. Other juxtapositions include the Fon Gu and Haitian Ogou, and the Fon Xɛvioso and the Cuban Chango.

In addition, Vodun temple paintings by Haitian artist Edouard Duval-Carrié, Brazilian artist Jose Claudio, and Cuban artist Manuel Mendive adorn the inside and outside of Daagbo Hounon Houna's house, although since his death in 2004 and the enthroning of the new Daagbo Hounon Tomadjèlê-Houkpon (*to* = lake, river, lagoon; *madjèlê* [with *kpon*] = can never measure

up to; *hou* = sea) in 2006, some of the wall murals have been changed and updated. This includes the wall facing the street mentioned earlier where the pairs of transatlantic symbols have been redone in bas-relief and new symbols added that extend much further onto the adjoining compound wall.

Edouard Duval-Carrié is himself an international assemblage. Born in Haiti, he considers himself truly Haitian though he grew up in Puerto Rico, went to high school in New York, attended college in Montreal, lived in Paris, and currently resides in Miami. His family has since returned to Haiti, and the artist has never lost contact with the country of his birth. He plans to move back and wants to build "the ultimate Vodou temple somewhere in Haiti" (quoted in Brown 1995, 75), but has not yet done so.

When he started painting, Duval-Carrié knew very little about Haitian Vodou except that the adepts serve their spirits by making *veve*, abstract drawings in cornmeal. Wanting to render these ephemeral drawings and other spiritual representations in permanent, recognizably anthropomorphic forms, he has painted a variety of Haitian Vodou spirits as well as African Vodun spirits.

The artist was commissioned to compose three Vodun temple murals in Daagbo Hounon Houna's compound for Ouidah 92. He painted Avlekete, the Fon spirit of lakes and streams, outside, next to the wall of juxtaposed African and African diaspora Vodun symbols. Upon entering the compound, after passing a Lɛgba shrine off to the right and a Xɛvioso/Chango temple to the left, one met head-on Duval-Carrié's larger-than-life-sized portrait of Daagbo Hounon Houna and his late wife. This has since been replaced by a painting of the new Daagbo Hounon Tomadjèlê-Houkpon and his female counterpart Naagbo. Around the corner and past a shrine in the middle of the main courtyard dedicated to Gu, the Vodun spirit of iron, warfare, and technology, remains another of the artist's paintings, this one representing the now deceased Supreme Chief on top of his ancestral Vodun, the sea (*hou*). In this wall painting, the deceased Daagbo Hounon Houna displays his power to visit his ancestors in the sea and to walk on the water in the company of his hundred-year-old sacred turtle (fig. 6.11). At present, as a euphemism for his death, it is said that Daagbo has returned to the sea.

Because a new Daagbo Hounon was installed, it makes sense that the portraits on the walls of the compound would be updated. However, Duval-Carrié's painting of Avlekete (fig. 6.12), Daagbo Hounon's most prominent avatar of the Hou Vodun, was not just touched-up, it was also signed by the person who touched it up. That is, the original painting, conceptualized and then rendered by Duval-Carrié's hand, was no longer regarded as Duval-Carrié's work.[18] This was shocking to me, but among local people there was no conflict concerning the fact that the painting was signed by the person who, in my perception, painted *over* Duval-Carrié's original work. People

insisted that the most recent rendering was the work of the most recent artist who painted it. I realized that the Vodun spirit of Avlekete herself was the property of the people of Ouidah, and that her rendering and re-rendering had very little to do with Edouard Duval-Carrié's original transatlantic conception of the spirit but rather quite simply expressed the spirit herself, exactly how she should look. To my flurry of questions, the most common response was, "How else could she be rendered?" In 2010, this resigned painting was completely replaced by a large four-armed bas-relief of a mermaid in black and gold.

For National Vodun Day 1995, Duval-Carrié built a sculptural assemblage on the beach, which also functioned as an active shrine (fig. 6.13). In the center of the piece, he placed an *asen* (object used to honor the dead), depicting the Daagbo Hounon seated and surrounded by people. In front of Daagbo, Duval-Carrié chose to place a diminutive airplane to represent Daagbo's international travels. Indeed, *asen* often contain iconography reflecting the deceased. However, Daagbo was alive and well at the time, and it was Daagbo himself who sacrificed the goat whose blood is visible in Figure 6.13. Alongside the *asen* are a few stylized crosses, a mermaid, three large snakes, and sacrificial offerings.[19]

Brazilian artist Jose Claudio's mural of Daagbo on the beach in Bahia, Brazil, once appeared on the large wall outside the inner sanctuary where the new Daagbo Hounon Tomadjèlê-Houkpon now holds important Vodun meetings. On the far right, a group of musicians were rendered playing their instruments, and on the left, ritual palm fronds called *azan* formed an arch over the threshold that led into Daagbo Hounon's inner sanctum. *Azan* are always used to mark sacred spaces: they are hung over doorways, placed strategically above or on top of shrines, and tied to or hung between sacred trees.[20] Their placement in the painting was deliberate and purposeful, a contemporary Brazilian artist's reinterpretation of an ancient transatlantic sacred marker. The *azan* remain, but the wall mural was "touched up" and the painting of the old Daagbo was replaced by a painting of the new one.

The Xɛvioso/Chango temple, painted by the Cuban artist Manuel Mendive, is possibly the only temple painting in the compound that has remained virtually unchanged since its original rendering (fig. 6.14). Mendive's initiations into the Afro-Cuban religions of Santeria and Palo Monte has influenced much of his work. He is also a graduate of the Academia de Bellas Artes, where he studied studio art and art history (Mosquera 1996, 237–43).

Mendive's artistic style evolved after he traveled to Africa in 1982 and 1983. Instead of painting historical and political allegories or anthropomorphized depictions of Yoruba *orisha* remanifested as Afro-Cuban *oricha* as he

had in his earlier career he began to employ a style in which everything was animated, so that "animals, forces, plants, humans, and mountains commingle[d], los[t] their taxonomy, mix[ed] in a sort of vital continuum" (Mosquera 1996, 242–44). This description seems an accurate characterization of his work in Daagbo Hounon's compound, which has remained unchanged over the years.

Mendive's abstract Xɛvioso temple painting includes, as its identifying mark, the double-bladed ax of the Yoruba *orisha* Shango, a symbol that was carried over to Cuba to incarnate the *oricha* Chango. The predominance of red and white, especially at the base, also indicates that the temple is a realm of this spirit.

In terms of religious continuity and reunion, it is noteworthy that Mendive, a Cuban *santero* and *palero*, was invited to paint a Vodun temple in an area of Africa that is the source of major components of his Cuban religions. In a formal artistic sense, it is also worth noting that among other African influences in Mendive's art, colorful Beninese appliques and bas-reliefs have always been a factor. In his more recent "interdisciplinary projects," the artist painted the bodies of dancers and animals for performances described by Cuban curator, critic, and art historian Gerardo Mosquera (1996, 243) as "a painting of movement and sound, a mix of painting, sculpture, dance, music, pantomime, body art, song, ritual, spectacle, performance, carnival, and procession." Mosquera might almost be talking about a Vodun ceremony.

The Daagbo Hounon compound continues to be an example par excellence of the centuries-strong resonance between African and African-diasporic religious consciousnesses, which have been updated to the present as the times change. The Daagbo Hounon house is also well-maintained, even if, at times, it is in a state of renovation. Unfortunately, this is not the case for most Ouidah arts.

Arts and Tourism?

Due to neglected upkeep and repair of Ouidah's contemporary arts, their condition had declined significantly. At the beginning of 2011—before the Zinsou Foundation project in late 2012—I was witness to this sad state of degeneration. Some statues were not just cracked or broken, but vandalized to the point of irreparability. For example, the Xɛvioso statue in Figure 1.1 was broken off at the torso and smashed. Again, before the Zinsou project, most of the arts along the Slave Route were an embarrassment to what Ouidah 92 originally represented.

Although the Slave Route has been transformed by the newly painted statues, it remains to be seen if the already slow tourist industry will be positively impacted or will continue its downward trajectory. A general

consensus among tour guides in the city is that tourism is minimal and not well-organized. In fact, there are far more guides than tourists. The city is not well maintained (the roads are as neglected as were the arts), and Ouidah residents have become more aggressive toward tourists, charging extremely exaggerated prices, and, at times, presenting an unwelcoming demeanor. Although year round tourism was never notable in Ouidah, the current decline might be grounded in the global economic recession. However, wealthy travelers worldwide have not stopped traveling.

More often than not, tourists visit Ouidah for a day or two after visiting game parks in the north or after a vacation at the beaches in Grand Popo in western coastal Bénin. It is a perfect day trip before catching a return flight home from Cotonou. Most of these tourists are French, with a few Italians, Spanish, Germans, and Americans. Most tourism tends to take place during the Christmas and New Year holiday season. More recently, a handful of Chinese have visited Ouidah, but it is likely that their families currently live in Cotonou, working on the construction projects being undertaken by the Chinese.

There are tourists who come specifically for the National Vodun Day festival on January 10, though, and some of them may stay for up to a week to ten days. The tourists whose primary destination is Ouidah often have an interest in Vodun religion and spirituality. They often seek divination and initiation, which is readily available though expensive. Many also have an interest in the history of slavery from the Ouidah port. People from the Caribbean and the Americas make up the largest part of this group and tend to represent the "African diaspora" as originally envisioned for Ouidah tourism. But National Vodun Day, which was originally celebrated at the Ouidah beach, is now celebrated throughout the country, which is another drain on the tourist presence in Ouidah. For example, in 2011 the festival on the beach of Grand Popo received more media coverage than Ouidah's festival.

Nonetheless, during the first two weeks of January, hotels and restaurants have business, tour guides have clients, artisans who sell their goods do well, and tourist boutiques have their share of sales. Even though tourists do pass through the city during the rest of the year (February through November) the hotels, boutiques, and restaurants do not have a consistent clientele. These tourist-focused businesses are practically empty except for the first few weeks of January, which is the beginning and end of the short tourist season. For this reason, businesses built for tourists have been forced to change their tactic or to close. An example is L'Escale des Arts, which is a space along the Slave Route originally dedicated to the exhibition and sale of arts ranging from African clothing, appliqué, and beads, to Vodun objects and masks. Today the artistic space is almost defunct. Most of the galleries are closed and the few

that remain are only open from time to time. Rather than a venue for the arts, L'Escale des Arts has become a restaurant/bar for visitors and locals alike. Other boutiques which were opened along the Slave Route have been closed due to lack of business. There remain a few sellers of tourist arts who are at the beach every day, but weeks can go by during which they will see not one tourist. For January 10, however, sellers of tourist arts come to Ouidah from surrounding cities and do well in sales. Within days after the festival, though, they are all gone.

Without much competition, the few remaining businesses are able to pay their bills and bring in a small profit, though there is often talk of closing down. But among the few that remain there is a sense of encouragement, collaboration, mutual understanding, and support. Restaurant owners tell boutique owners to send their clients to their restaurants, and boutique owners request the same of the restaurant owners. They commiserate but still have a positive outlook.

The fact remains that the arts are not in good shape and tourism has declined. But people have not given up hope. Some people I know are working very hard to bring foreign travelers to Ouidah to experience local culture, religion, dance, and arts. They are also working on providing organized set of activities for visitors who come to Ouidah for National Vodun Day but have nothing to do before or after January 10. A very successful programmed event might bring in ten to fifteen people, as the experiences of Adjos demonstrate.

Ouidah resident Andoche Adjovi (known as "Adjos") has organized three programmed events to date in January 2007, 2008, and 2009. The first two were called Vodun Houindo, meaning the "base" or "foundation" of Vodun, and the third was a music festival called Ouidah Groove. For Vodun Houindo, Adjos collaborated with four different Vodun priests and priestesses, each of whom was aligned with a different divinity, establishing contractual arrangements with each one. He paid the priests to allow guests to attend, participate in, and film Vodun ceremonies of protection, purification, and initiation. The Vodun complexes included were Gambada, a Vodun associated with protection, healing, and trance with origins in northern Ghana; Mami Wata, a Vodun of wealth and beauty (see Chapter 4); Dan Aida Wedo, the Vodun of the rainbow serpent (see Chapter 4); and Thron, another Vodun of protection with origins in northern Ghana (see Chapter 3).

Adjos and the Vodun priests and priestesses devoted an evening and the following day to each chosen Vodun divinity. That is, the guests were invited to a soirée of drumming and dancing by the adepts of the Vodun followed the next day by various ceremonies of healing, purification, and initiation. The guests were able to participate directly in the healing and purification ceremonies, but for initiation, they were only able to watch the current adepts.

For the second Vodun Houindo festival, the Vodun complexes involved were the same except Gambada was replaced by three Vodun: Lɛgba, Fa, and Hohovi (twins). Although these were paid contractual arrangements, Adjos always chose Vodun complexes that were already in the middle of a series of ceremonies. The only change was that there were some extra guests who were allowed to photograph, film, and participate.

Ouidah Groove was a two-night event dedicated to traditional and modern music. It was organized under the auspices of four production houses: Adjos Production of Bénin, Family Production and Blackvision of Togo, and Korodjo Production of France. The musical groups and dance troupes who performed were from the three neighboring countries of Bénin, Togo, and Ghana.

All three events could be considered successes. However, they were not big successes. Because Adjos lost money in all three festivals, he is restrategizing. His next festival is scheduled for January 2014. Rather than separating Vodun from traditional and modern music, he has decided to join the forces of his two different festivals for this event, which is called Vodun Groove (a combination of Vodun Houindo and Ouidah Groove). Vodun Groove as envisioned will combine traditional and modern arts, music, and dance with the sacred and secular arts, music, and dance. Even though the cyber-infrastructure in Ouidah is weak, he has decided to use the internet to spread the word in hopes of a very successful event. He administers a Facebook page called "Vodun Groove" into which he uploads photos and video of Vodun-related happenings and responds to questions about Vodun. Through this, he has developed a worldwide community of people interested in West African Vodun. As this cyber-community expands, Adjos hopes that Vodun Groove 2014 will bring to Ouidah an international group of people interested in experiencing what they have been exposed to through the Facebook page. Adjos is truly dedicated to supporting, preserving, and sharing his cultural traditions with the world. But he knows that there are underlying problems in Ouidah that his festivals cannot solve. He can only do what he is able to do and hopes that others with a similar mindset will be willing to collaborate.

Ouidah Ongoing

The ongoing convergence in Ouidah of tourism, national identities, religious ideologies, and contemporary artistic productions is emblematic of what is happening elsewhere in the postcolonial world, where nations are reinventing themselves through the rewriting of their own historical narratives. Including the new renovation of its public arts, Ouidah continues to rewrite its history in the form of an open-air museum. As such, this museum never closes its

doors, and it is eternally incorporating the new into its original design. Since Ouidah 92, the city's public arts and associated ideologies have emphasized that, although the particular audiences and goals of postcolonial African art may have changed, its contemporary Vodun arts continue to function at deep cultural and spiritual levels. Anthropologist/historian James Clifford (1997, 8) writes that "museums and other sites of cultural performance appear not as centers or destinations but rather as contact zones traversed by people and things." Such is the place called Ouidah.

I was reminded of the ongoing international impact of Ouidah 92 while visiting the house of the Haitian band Boukman Eksperyans in Port-au-Prince, Haiti. In a hallway, I noticed a wall collage of some of the band's posters for their international concerts. One from Ouidah 92 jumped out at me. On the poster, the now famous Gɛlɛdɛ mask is superimposed upon a world globe, its wings stretching across West Africa into the Atlantic Ocean (fig. 6.15).

Coda

The coastal region of West Africa addressed in this book is a land where the exchange of histories, ideas, and belief systems is played out in art forms; a land where Shango, Jesus, and Shiva are all Vodun; where al-Buraq becomes Mami Wata in flight; where Santa rings in the New Year of an Islamic Vodun; where Hindu and Vodun deities coexist in symbiosis; where an annual procession of Portuguese-gifts-turned-Vodun broadcasts the start of the Vodun season; where the spirits of persons enslaved 150 years ago are paid tribute by the children of their former masters; and where Haitian, Brazilian, and Cuban images, artists, and spirits remain relevant to contemporary Vodun practice. Vodun has survived by adopting and adapting myriad elements into its complex matrix. It has persisted through slavery, proselytism, colonialism, neo-colonialism, and a Marxist-Leninist regime, and is currently pulling through the global economic crisis.

One afternoon I asked Daagbo Hounon Houna what his thoughts were on the encroachment of Christianity and Islam vis-à-vis Vodun. He slowly nodded his head, reached down, and filled his hand with the earth below his feet. With a fistful of earth, he paused for a split second that in his presence seemed an eternity. As he slowly let the earth fall from his hand he looked directly at me and said, "The earth is Vodun. As long as we have the earth we shall have Vodun."

Notes

Introduction

1. See Laennec Hurbon's "American Fantasy and Haitian Vodou" (1994) and Barbara Browning's "Voodoo Economics" (1998).

2. Vodun is not all "good." The "goodness" of Vodun depends on whom you ask. Vodun, itself, is generally accepted as good within the Vodun community. But there are many other "powers," such as *azè* (roughly, witchcraft), which are considered bad. Some people say that *azè* is part of Vodun and others that *azè* is outside of Vodun. Medicinal healing/harming is another type of power that some consider part of Vodun, and others consider outside of Vodun. And then there are many types of "healing" and "harming." A Vodun priest or priestess who is knowledgeable in herbal medicines is trusted to use this knowledge only to help others. However, the ability to heal means knowledge of what caused the sickness or harm. What a priest/ess or healer does with the knowledge is really what differentiates the good from the bad. *Azè* is similar in that some people feel that not all people who practice *azè* (*azèto*) are bad, and that *azè* can be used for good. How, when, and why Vodun can be "bad" is not the subject of this book. However, African Pentecostalists and many Christians regard Vodun as bad and anti-Christian.

3. For reasons of inextricability, it may appear that I am using Vodun religion, Vodun aesthetics, and Vodun arts almost interchangeably. Through context, however, the terms are subtly differentiated in regard to religion, aesthetics, and arts.

4. Verger (1982) has written of this Yoruba appellation of Ouidah. Even after speaking to a number of Yoruba speakers, I was unable to learn how Igéléfé translates from Yoruba; however, it may be a corruption of Glehwé. Yoruba peoples, their language, and their customs are known most commonly as "Nago" by Fon and Yoruba speaking peoples in Bénin. Yoruba peoples are also known as Ayonu (*Ayo* = Oyo, *nu* = the one from). I retain the word Yoruba throughout this writing for sake of consistency. Robin Law (1996) goes into detail on the history of the word "Nago" in his unpublished paper "'Lucumi' and 'Nago' as Ethnonyms in West Africa."

5. During the first twelve years of Dahomey's independence (1960–1972), there were nine coup d'etats and changes of government. It was not until 1972 when a revolutionary, military-controlled government took over, led by Major Mathieu Kérékou, that the country began to stabilize. The Kérékou regime attempted to restructure the government, the economy, and the society along Marxist-Leninist

lines, supported by Bénin's intellectuals, many of whom were French educated. Under Kérékou, the country was re-named the People's Republic of Bénin. In 1991, Nicéphore Soglo was elected president of the first freely elected democratic government in close to twenty years. The country has since been called the Republic of Bénin. This democratic election plays a big part in the current religious consciousnesses, and in the associated arts found along coastal Bénin discussed in Chapter 6. Mathieu Kérékou was re-elected president in 1996 and again in 2001. Thomas Yayi Boni, a Beninese banker and politician, is the current President of Bénin. He took office on April 6, 2006, after winning elections held in March of the same year. He won the 2011 elections and is currently serving his last term as president.

6. For simplicity and clarity, I use the English term Beninese, instead of the French terms Béninois or Béninoise/s.

7. The Gbe languages belong to the Kwa branch of the Niger-Congo languages, and break up into five major dialect clusters: Ewe, Fon, Adja, Gen, and Phla-Pherá.

8. Historians date first Portuguese contact in the 1580s; however, within in local Ouidah history, the contact is said to have taken place in 1548, as discussed in Chapter 3.

9. Centered in Abomey, the Dahomey Kingdom was founded in 1645 by King Houegbadja and lasted through 1900, when King Agboli Agbo was removed from the throne by the French (Assogba 1994, 19–25).

10. For a range of early travelers' accounts through recent ethnographies, see: Adam and Boko 1983; Argyle 1966; Bay 1998, 2008; Blier 1990, 1991, 1995a, 1995b; Burton [1864] 1966; Chadouin 1891; Dalzel 1793; Duncan 1847; Foa 1895; Forbes [1851] 1966; Glele 1974; Hauzoume 1956; Herskovits [1938] 1967; Herskovits and Herskovits 1958; Lafitte 1875; Le Herissé 1911; Lombard 1967; M'Leod 1820; Mercier 1954; Pliya 1970; Quenum 1938; Skertchly 1874; Snelgrave [1734] 1971.

11. See Law 2004 for the most comprehensive history of Ouidah. For further study on Ouidah also see: Adandé, Adandé, de Souza, and Sossouhounto 1995; Berbain 1942; Chatwin 1980; Fakambi 1992; Quenum 1938; Sinou and Agbo 1995.

12. For further study on African Vodun see: Adams 1980; Aguessey n.d.; Bay 1985, 2008; Blier 1995a, 1995b; Brand 1981; Chesi 1980; Crowley 1986; Djivoh and Drego 1986; Edah n.d.; Henning and Oberlander 1996; Hübner 1996.

Chapter 1

1. Port cities, in general, tend to have an international mix of peoples and cultures. The coast of Bénin and Togo is not singular, but the mix of people is quite extraordinary.

2. Parts of this material on diasporas and aesthetics appeared in a different form in Rush 2010.

3. What follows is not a thorough assessment of Glissant's oeuvre. Rather, this is meant to show the commonalities between the Caribbean and coastal West Africa, and in turn, to suggest the potential of looking at Glissant for an inspiration in theorizing coastal West Africa. There is a large body of critical literature—both praise and critique—surrounding Edouard Glissant. I have read a large portion of these writings; however, I cannot claim expertise. I depend on the writings of Michael Dash (1995) and Celia Britton (1999), as well as Betsy Wing's (1997) "Translator's Introduction" for guidance.

4. In *Discours Antillité*, Glissant does critique the concept of rhizome as being overly abstract.

5. See Burton ([1864] 1966, 79, fn) for a very early reference to and documentation of *azan*, or "fringe of dried palm-leaf," as a marker of something sacred. Robert Farris Thompson (1993, 26–27) has recorded *azan* in an altar in Surinam. In Metraux's ([1959] 1972, 373) "Voodoo Glossary," *aizan* is defined as "Fringe made with fibers of palm (*Oreodoxia regia*). Has the power of keeping away evil. . . . The aizan is often hung on the lintel of humfo doors, on the poteau-mitan or on other sacred objects. Sometimes it is used to cover offerings."

6. There were no deaths by lightning reported to Tchambassi during the fourteen month span, thus no accumulation can be seen.

Chapter 2

1. For further study on Xɛvioso see: Gilli 1976; Kpodzo and Aziabli 1984, 1985.

2. Dangbe is not to be confused with the rainbow serpent Vodun, Dan Aida Wedo, discussed in Chapter 4.

3. The Huedanu (*nu* = peoples in Fon language) are closely linked with the Pedahto (*to* = peoples in Pedah language), all of whom are united by the *ɖɛnô* scarifications, explained in footnote 4 of this chapter. Pedah is a language spoken by Pedah peoples in Bénin and Togo. The ancestors of the Hueda peoples of Bénin are Pedah peoples of western Bénin into Togo. However, most Hueda people in Bénin no longer speak Pedah. They refer to themselves as Huedanu in order to distinguish and separate themselves from the Pedah. Nonetheless, the all-inclusive term for this whole group of people is Pedah, with Hueda being a subgroup. Andoche Adjovi, personal communication, October 2009. See Law 2004, 20–25 for a thorough discussion on origins of the word Huedah, and specifically page 24 for various versions of the possible origins of the Dangbe Vodun.

4. A person whose face is scarified with these markings is referred to as *ɖɛnô* (*ɖɛ* = verb of the tongue or what the tongue says as a blessing, *non* = the one with or responsible for). These scars are commonly referred to in French as "deux fois cinq," indicating the two vertical marks repeated five times on the face (Andoche Adjovi, personal communication, October 2009). The scarification markings are

readily visible on peoples' faces. On the python, however, they are not easily seen as they are small markings along the sides of the python's mouth, but they will be shown to a curious visitor if requested.

5. The first time I wrote about this proverb, I did not have the spelling correct, so this serves as a corrective to that initial writing (Rush 1998). I had never seen the *agbégbé* and thought it was something that was only talked about. I have since seen many *agbégbé* vines and have a much better understanding of the meanings of the words in the proverb.

6. The following is a very cursory synopsis of the events revolving around the writing of the *Doctrina Christiana*. See Labouret and Rivet (1929) for more exegesis and detailed references.

7. The language of Allada is Ayizo, which is in the same language family as Fon, Aja, Ewe, and other related languages. Suzanne Blier (Blier 1995, 373n39) notes the historic and linguistic importance of this early reference in situating Vodun in this language family, though regrettably the exact location within this language family is indeterminable.

8. See map of Arnold de Langren, 1596, for the oldest reference on a map to the Kingdom of Allada. Cited in Labouret and Rivet (1929, 5).

9. For further study on Mawu-Lisa see Bossou 1985, Datonou and Agbihounko 1986.

10. Vodou in Haiti, Candomblé and Umbanda in Brazil, Santeria and Palo Monte in Cuba, Voodoo and Santeria in the US (Brown 1991; Cosentino 1995; Herskovits [1938] 1967; Metraux [1959] 1972; Thompson 1983, 1995; Verger 1957, 1982).

11. There are various ways to spell Yɛhwe. When I refer to it, I consistently spell it Yɛhwe; however, when I quote another author, I use his or her spelling.

12. This article is in a special issue of the periodical *La Voix de St. Gall* called *Les Vodun, messagers divins, données phénoménologiques*, published by the distinguished Seminary St. Gall in Ouidah. There are many other issues published by the St. Gall Missionary in Ouidah addressing Fon, Mina, and Ewe culture and religion, including three full issues on Vodun and others on twinning, African names, usages of water in ceremonies, funerals, burials, ancestor worship, births, proverbs, etc. The journal is a very useful source for further research on many cultural aspects of mostly Fon, Mina, and Ewe traditions, though Yoruba culture is included in some issues, as well as additional culture groups throughout central and northern Bénin and Togo.

13. The Temple of Yɛhwe is an offshoot of Le Péristyle de Mariani, which was founded by Max-G. Beauvoir in 1974 in Mariani, Haiti.

14. Edna Bay, personal communication, September 2010.

Chapter 3

1. For a detailed discussion of the history of the forts in Ouidah see Sinou and Agbo (1995, 90–98) and Law (2004, 31–41).

2. See Verger (1954, 1957, 1968, 1982).

3. There are many versions of this famous encounter. Most historians claim it could not have happened before the 1580s; however, the Kpate family claims that this encounter happened in 1548. There are also many interpretations of what exactly Zigbo ran off screaming, and how it should be translated. For a summary account of the first Europeans arriving along the Ouidah coast, see Cornevin (1962, 239–56).

4. I have many photos of these objects, but I was never able pick them up for close examination to assess their approximate age. In Ouidah history, whether these are the original sixteenth century gifts is irrelevant; what matters is that they contain Kpate's spirit.

5. I have found no clear-cut explanation of the origin of the name "Cha Cha," nor who coined it or when. In reference to the origin of the name "Cha Cha," Sinon (1996, 113) writes "*personne n'a pu vraiment definir l'origine*" ("no one could really define the origin"). I was told other interpretations including mispronunciation of the words *caca* and *ja ja*, both of which refer to quickness in Fon and Portuguese, respectively.

6. Throughout Chatwin's book the name de Souza was replaced with da Silva. Although parts of his book are fictionalized, Chatwin does an exceptional job of piecing together the life of Don Francisco "Cha Cha" de Souza.

7. The story related here is a synopsis of the general narrative recounted most often concerning the Dagoun Vodun. The specifics were verified in an interview with Prosper de Souza, a well-respected, well-educated, articulate man currently living in the de Souza compound, who has a wealth of knowledge and a strong interest in preserving his family's history.

8. See de Souza (1992) for a more in-depth analysis of the de Souza family.

9. See Verger (1954), de Souza (1992), and Drewal (2008) for more information on Bouriyan histories, song lyrics, musical instruments, and performance traditions in both Brazil and Bénin.

10. Although this section focuses upon Fon-Yoruba interconnectedness grounded generally on a westward movement of Yoruba influence along the coast, it is not meant to imply that that these exchanges are unidirectional. Yoruba influence can certainly be found eastward along the coast as well as northward. Influences of peoples north and east of Yoruba and Fon are most certainly found along the coast as well.

11. This divination tray is commonly referred to as the "Ulm" tray in reference to the city of Ulm where the object has been located since the middle of the seventeenth century (Bassani 1994, 79).

12. This king is referred to by other names including Toxonu, Alkémy, Alkenu, or Tezy in various sources (see Lombard 1967, 48). Following Yai's example, I will identify this king by the name Tezifon.

13. These observations in Ouidah would probably be similar in the Yoruba communities in Cotonou, Porto-Novo, Abomey, and other cities and villages throughout this area extending into Togo.

14. An entire issue of *African Arts* journal was dedicated to Egungun studies in 1978. *African Arts* 11(3) was edited by Henry Drewal, with contributions by Drewal, Drewal and Drewal, Houlberg, Pemberton, Poyner, Schlitz. Also see: Kalilu 1993; Thompson 1976; Wolff 1982.

15. I was witness to Egungun as far west as Lomé, Togo, right on the Togo-Ghana border, but I was told that there are some Egungun families in Ghana and even further into Ivory Coast. John Nunley (1981) has recorded Egungun in Sierra Leone. See Omari (1989) for transatlantic Egungun in Brazil.

16. *Kulito* are also referred to as *kutito* and *kuito* along the coast while more commonly called *kututo* and *kuuto* near Abomey (Segurola 1963, 315).

17. Oro, another Yoruba spirit-power, is more feared than Egungun. As guardian and protector of the night, Oro is never seen, only heard. Before Oro "comes out," citizens are forewarned to go home and close all doors and windows to their homes. The "voice" of Oro manifests itself in a series of high- and low-toned bullroarers that play simultaneously in different parts of a neighborhood. No one would talk to me in detail about Oro. When I came to understand the fear and power surrounding Oro, especially vis-à-vis women, I stopped asking questions out of respect.

18. I am not certain which king this was; however, it was very possibly Gezo or Glele.

19. For further study on Ifa, Fa, Afa divination see: Adekambi and Okpeifa 1981; Alapini 1952b; Bascom 1969; Bassani 1994; Epegba and Neimack 1995; Hounwanou 1984; Koudolo 1991; Maupoil 1988; Surgy [1957] 1981.

20. For further study on Eshu, Eshu-Elɛgba, Lɛgba see: Agboton n.d.; Cosentino 1987; Pelton 1989; Pemberton 1975; Wescott 1966.

21. For further study on transatlantic Ogun, see Barnes 1989.

22. Babatunde Lawal, personal communication, March 1997.

23. I have noticed more than one instance in which "tch" replaces a "sh" sound in a Fon word derived from a foreign language. For example, *ashe* from Yoruba becomes *atche* in Fon. Then *atche* is often shortened to *tche* in daily Fon conversation. *E na tche nu we* means "it will bless you" (used to say thank you), with *tche* coming originally from *ashe*.

24. I have selected only three photo comparisons for this ceremony. I have three other photographs from this ceremony that match Verger's photos almost exactly, making it a series of six matching photos.

25. This is the same linguistic phenomenon already examined, though in this case the "e" is dropped as it travels eastward from Ghana through Togo into Bénin, and then Nigeria.

26. In his book *Voodoo*, Gert Chesi (1979) photographed many Thron temples along coastal Togo, which he refers to as Koundé temples. The mother of Papa Koundé is Nana Ablewa, which is the same name as for the female adept in Attingali, discussed later in this chapter.

27. Unpublished proceedings from the Symposium National sur le Culte Vodun, May 28–June 1, 1991, Cotonou, Bénin.

28. This is a very abbreviated synopsis of the complex process of Thron installation.

29. See Morton-Williams (1956, 315–334); Chappel (1997, 94n1).

Chapter 4

1. Parts of this material on chromolithography appeared in different forms in Rush 1999, 2008a, 2008b.

2. Similarly, in Allen F. Roberts' 2009 essay "Tempering 'the Tyranny of Already': Re-signification and the Migration of Images," he presents case studies that illustrate how images and visual practices migrate and resignify among several parts of the world. Through these detailed examples he demonstrates "hermeneutics in the making" (120) in the Democratic Republic of the Congo, Iberia, Haiti, India, and Bénin.

3. The walls of the Hindu temples I visited were covered with a wide variety of Hindu chromolithographs, and large, active Hindu shrines were arranged with statues of the same Hindu gods. People attending the services—Togolese, Beninese, Ghanaians, and resident Indians—were devout and learned practitioners of Hinduism. The priests I spoke with concerning Hindu gods being incorporated into Vodun worship felt that the images were obtained through market stands and calendars, and then shared among fellow Vodun adepts, which accounted for the "misinterpretation" of the gods. The priests seemed very certain that no one in any of their congregations was a Vodun adept.

4. Asigamé literally means "in the big market." Although redundant in terms of a local translation, I refer to this place as the Asigamé Market.

5. For further study on Mami Wata see: Drewal 1988, 1996, 2008; Gore and Nevadomsky 1997; Houlberg 1996; Jenkins 1983, 1984; Rush, 1999, 2008a, 2008b.

6. As discussed in Chapter 3, in the Mina language, an "e" is often placed before a noun that in Fon would be without the "e." Edan in Mina is Dan in Fon.

7. *Sika* translates as gold in Mina. *Vi* translates as child. However, *-vi* at the end of a name is a diminutive. Thus, Sikavi translates literally as "gold child" but really means "the little gold one."

8. Market sellers at Asigamé Market, Lomé, Togo, personal communication, January 2005.

9. See Roberts 1992 and Rush 2002.

10. I am using the spelling "Foulani" as it is painted on Vodun temples for this particular Vodun. Here, the term "Foulani" is in reference to Fulbe peoples, and is commonly spelled Fulani in English and Peul in French.

11. Sometimes posters of this scene are entitled "*Shri Hanuman, Ahiravan badh*," or "Lord Hanuman, the slaying of Ahiravan" as demonstrated by the figure in Philip

Lutgendorf's essay "Evolving a Monkey: Hanuman, Poster Art and Post-Colonial Anxiety" (2003, 80 fig. 3)

12. Another Ghanaian example of this image of Hanuman, the Indian monkey king, is illustrated in *Africa Explores* (Vogel 1991, 127). I have also seen this image reproduced in a handful of Mami Wata temples in Aneho, Togo, and environs.

13. See Blier (1995a, 62) for a concise chart of principal Vodun.

14. Please note that Dan [Aida Wedo] is in not related to Dangbe, the founding Vodun of the city of Ouidah. Although there continues to be confusion and conflation between these two separate serpent spirits, the Dangbe head priest in Ouidah and Dan priests and priestesses throughout the region went to great pains to make sure I did not mix up their two entirely separate serpent cults. Herskovits ([1938] 1967, 2:248) also notes the distinct difference, saying, "The Dahomean differentiates clearly between the *da*, who figures inclusively in the worship of all vodu and the *dangbe* snake, whose principal temple is in Whydah."

15. Also known as Dangnon, translated as "good hair."

16. In this painting, the image of Shiva is reversed from the lithograph, however the Mami Wata ur-image is not reversed.

17. The far left side of the mural has a depiction of Tchamba, illustrated and discussed in Chapter 5.

18. The relationship between Gniblin and Egu remains unclear. In *Cultures Vodun: Manifestation—migrations—métamorphoses*, Honorat Aguessy (n.d., 58), in a list of Vodun from the Mono province in Bénin, writes that Gniblin is the Vodun of the sacred forest. In his article "Les prêtres du dieu Nyigble dans la Forêt Sacrée de Bé," Abbé G. Kodjo Aziamble (1981) describes Nyigble (presumably just a different spelling of Gniblin) as the protector of the Sacred Forest of Bé and an important Vodun in the history of the quarter of Lomé called Bé. In *Voodoo*, Gert Chesi (1979, 26) describes Gniblin as the most powerful fetish who came from Adja and rules over the holy forest of Bé.

19. Although this would appear to mean "the mother of Dan Aida Wedo," the term "Mami" is not gendered. Thus a spirit who is a "Mami" is a Mother, but is not necessarily female. Similarly, the suffix -*si* (from *asi*) means "wife." Mamisi or Sakpatasi, although literally "wife of Mami" or "wife of Sakpata," refers to an adept of either gender.

20. In January 2005, after talking with M. Ahiator about his dreams, I commissioned him to make another rendering of the nineteen-headed King of Mami Wata mural to be painted on cloth for Henry Drewal's exhibition *Sacred Waters: The Many Faces of Mami Wata and Other Afro-Atlantic Water Spirits*, which opened at the UCLA Fowler Museum of Cultural History in 2007. This commission was based on a suggestion Ahiator had made to me in 1999 when I was working with him. Because he knew of my strong desire to learn about India Spirits, Ahiator suggested that he paint wall murals for me on cloth to hang in my bedroom so that I could study during my sleep. He feels that exhibition viewers can travel to 'India' if they study his painting.

21. Since his death, his daughter Gagnon ("money is good"), whom he trained, is in charge of the temple. The original paintings are still there, but they have been painted over with much brighter, louder colors than the originals. This may be based simply on the availability of paint.

22. In 2005, and again in 2010–11, I saw many stands at the main market in Vogan, Togo, containing locally carved tridents, very similar to the Indian trident Atissou had.

23. The name Rhada might have come from the Hindu story in which Rhada is Krishna's primary love interest.

24. Chesi (1979, 98–99) also photographed a young boy participating in a small ceremony based on the dreams of the boy's mother. The table set up as the backdrop to the traditional ceremony was adorned with perfumes, powders, and a crucifix placed in front of two vases of colorful artificial flowers which had propped up upon them a chromolithograph of Ganesh and one another of Shiva.

25. A strong Indian presence in the Caribbean began after the abolition of slavery in 1838 when African slaves were replaced by indentured laborers mostly from India (Bettelheim, and Nunley, and Bridges 1988, 120).

26. For Barro's obituary see Cosentino 1999.

27. Eileen Moyer, personal communication, July 1997.

28. John Peffer, personal communication, August 1997.

29. Pamela Franco, personal communication, April 1998.

30. For further study on sequins in Haitian art, see Girouard 1994, 1995.

Chapter 5

1. Tchamba is the subject of my next book where the data in this chapter will be greatly expanded. Of considerable significance in this forthcoming work will be the presentation of a wide variety of personal family histories of domestic slavery from the perspectives of the progeny of slave owners and slaves. Parts of the chapter appeared in another form in Rush 2011.

2. The Nyantroukou, along with the Dassa, Holli, Ifé, Itcha, Mahi, and Oyo, are listed by Cornevin (1962, 44, 202–205) in a subsection entitled "Yoruba-speaking groups," although he mentions that both the Holli and the Nyantroukou are "marginal" in the Yoruba collective.

3. Kabre is also commonly pronounced as Kable or Kabye.

4. Perhaps the term *kabreto* has lost its currency in association with domestic slavery due to the thirty-eight year regime of late Togolese dictator Eyadema. Because Eyadema was Kabre, a southerner (Mina or Ewe) could have been detained, or worse, by Eyadema's military if heard speaking badly about Kabre peoples.

5. In addition to the few pages I devoted to Tchamba (Rush 1999, 70–72), there have been four short studies: Judy Rosenthal, *Possession, Ecstasy, and Law in Ewe Voodoo* (1998); Tobias Wendl, "Slavery, Spirit Possession, and Ritual

Consciousness: The Tchamba Cult Among the Mina of Togo" (1999); Alessandra Brivio, "Nos grands-pères achetaient des esclaves: Le culte de Mami Tchamba au Togo et au Bénin" (2008), and Dana Rush, "In Remembrance of Slavery" (2010). According to Wendl, it is "the descendants of former slave masters who are afflicted by the spirits of their former slaves" (111). Rosenthal's study, focusing on Ewe Vodun in Togo, addresses the topic of Tchamba in the chapter entitled "Romance of the North" in terms of its "quasi-historical and . . . imaginary geography and genealogy of the slave trade with its attendant mixings of populations and lineages in marriage, procreation, and production of the sacred" (23). In her article, Brivio analyzes how slave spirits evoke a mythical heroic past of both slave traders and slaves themselves, in terms of the ambivalence of current memories of slavery.

6. The same verse is repeated throughout the song using the names of other regions and ethnic groups, such as Moba, Mossi, Anago, or Hausa, in place of Tchamba.

7. Some of the words I translate may not have exact origins in the ethnic groups to whom I refer. Because Tchamba crosses southern ethnic borders, some words associated with the Tchamba might originate in Fon, Mina, Ouatchi, or Ewe but are generally mutually understood.

8. I collected these histories mainly along coastal Togo and into southeastern Ghana in a series of interviews during December 1998 through March 1999. The interviews I collected in Bénin were usually with people originally from Togo, but who had moved due to political unrest.

9. *Adonkor* (or *donkor*) is the Ewe word for slave. In Ouatchi, the word used for slave is *kluvi*. These terms refer to slaves rather than "bought persons" and are understood by Mina, Ouatchi, and Ewe speakers. Neither *adonkor* nor *kluvi* are terms generally known by Fon speakers.

10. Mami Wata practitioners can have pierced noses. Even though there is a relationship between Mami Wata and Tchamba veneration, it does not appear that the nose rings Mamisi wear are linked to a "northern" identity.

11. When I was fortunate enough to have access to old Tchamba shrines, photography was generally forbidden.

12. Because Tchamba veneration is mostly among Mina, Ouatchi, and Ewe speakers, I use the word Afa here rather than the Fon word Fa (see Chapter 3).

13. Although I tried, I was unable to meet with any members of the Dogbe-Tomi family. I was told that many of them had moved to Europe and only came back to Lomé periodically.

14. For some reason, the translation of this name was stressed repeatedly through the interviews; therefore, I will repeat it here: (*zo* = fire, *waye* = trick; "clever as fire").

15. Godomey is located on the eastern outskirts of Cotonou.

16. Spiritism (*Espiritismo*) is a religio-philosophical system developed by Allan Kardec in the mid-nineteenth century focusing on the existence of and communication with spirits. Allan Kardec is the pseudonym of the French

teacher, educator, and philosopher Hippolyte Léon Denizard Rivail (born, Lyon, October 3, 1804; died, Paris, March 31, 1869). He is recognized today for systematizing Spiritism with his five books on Spiritist Codification.

17. Hale uses the word "sorcerer" in his article. I prefer the word "healer," but in this text remain with Hale's word choice.

18. The Kingdom of Kongo was located in western Central Africa in what is now northern Angola, Cabinda, the Republic of the Congo, and the western portion of the Democratic Republic of the Congo. It was founded in the early fifteenth century and had contact with the Portuguese in the late fifteenth century, when Catholicism was introduced and readily adopted due to Kongo's iconological and cosmological emphasis in the form of the cross (Thompson and Cornet 1981).

19. Personal communication with a practitioner who prefers to remain anonymous, May 28, 2007.

20. Thanks to Tim Landry for discussing Haitian Vodou and Cuban Palo Monte with me.

21. The mambo's name and the name of her Society (Sosyete) have been changed to protect requested anonymity. The rest of this section is based on personal communications I had with two Haitian Vodou priests living in the US, who also requested anonymity.

Chapter 6

1. See Herskovits ([1938] 1967) for the important role of the Abomey kings in precolonial artistic patronage.

2. I was denied permission to photograph this mask. The image is known to have been mass-produced on a calendar in the 1980s, but I have not yet located a copy. Slides of the entire collection of Gɛlɛdɛ masks from the Porto-Novo Ethnographic Museum are archived at the Smithsonian Institution's National Museum of African Art in Washington D.C.

3. The closest English translation of the Fon word *azè* is "witchcraft." An *azèto*, "the one with *azè*," or a "witch," is a person who can change into a bird (usually an owl) during his or her sleep and cause great harm to others. To say that "someone has a bird" is to call that person an *azèto*. Thus the human figure with angel's wings on the Gɛlɛdɛ mask has been interpreted as a person in the process of transforming from a bird into a human or vice-versa.

4. Parts of the chapter appeared in another form in Rush 2001.

5. In a discussion about his reactions to *Magiciens de la Terre*, he explained that among all of the people he met abroad, he found closest solidarity with Cuban artist José Bedia because they both understood that art can have power.

6. Although Cyprien Tokoudagba is now internationally recognized, Edna Bay was the first to publish an article on him in 1975, well before his appearance in *Magiciens de la Terre* in 1989. See Bay 1975.

7. The term "African diaspora" is used here to refer to artists who were born in Africa and now reside outside of the continent. Later in this chapter I use the same term in reference to people who were enslaved and taken from the African continent to work in the Americas and their descendants.

8. This is very similar to the Lɛgba Tokoudagba realized in Abomey twenty years earlier. See Bay 1975. There are also striking similarities between Tokoudagba's rendering of Lɛgba and an Exu shrine in Salvador, Brazil, illustrated in Galembo (1993, 134); that Exu image is also horned and phallic.

9. Robert Farris Thompson (1983, 26 plate 13) illustrates a cement "Eshu Boi" with cowries inserted into his chest. This figure, in the Museu de Policia in Rio de Janeiro, Brazil, was probably made before 1941. Thompson notes that in "Dahomean Yorubaland there are freestanding images for Elɛgba with mystic signs of the divination deity marked in inserted cowries on the chest of the image," which he compares to the cement Rio Elɛgba.

10. See Roberts 1996 for a comparative discussion of recycled arts in Bénin and Sénégal.

11. The Dakpogan brothers and Biokou were initially impressed by the recycled artworks of Romuald Hazoumé who has come to be very well known in the international market. Hazoumé is best known for his *masques bidon*, which he makes out of plastic jugs and other recycled objects (see Magnin 1996, 132–33).

12. "Syncretism" is a term used commonly in Bénin. As a practice, it is generally frowned upon and resolutely denied by most devout Catholics and Muslims. Vodun practitioners, however, are very open to syncretism and claim that Beninese Catholics and Muslims commonly blend their foreign faiths with Vodun.

13. There are stories of people who had such extreme cases of *tchakatu* that they could not be cured through traditional methods. In one case in particular, it is claimed that a man went to a Western hospital, and the surgeon found broken glass, razor blades, and nails inside his body.

14. For further study on Sakpata see Avoundé 1984.

15. Fon peoples designate women and men as creatures with seven and nine ribs respectively. See Hazoumé's 1938 novel *Doguicimi* (43, 76n4).

16. Nancy Josephson, personal communication, March 10, 2008.

17. See Edna Bay's (2001) "Protection, Political Exile, and the Atlantic Slave Trade: History and Collective Memory in Dahomey." Here, rather than addressing how the transatlantic trade effected the victims themselves, Bay engages the less talked about but equally important questions of how the trade impacted African societies.

18. For illustrations of the both the original and the updated signed version, see Rush 2010, 74.

19. For further study on *asen* see Bay 1985, 2008.

20. See note 5 in Chapter 1 for more on *azan*.

References

Adam, Kolawolé Sikirou, and Michel Boko. 1983. *Le Bénin.* Cotonou, Bénin: Sodimas.

Adams, Monni. 1980. "Fon Appliquéd Cloth." *African Arts* 13 (2): 28–41, 87.

Adekambi, M. Adéniran, and E. Ashelui Okpeifa. 1981. "L'investiture du 'Ifa-Priest' chez les Yorouba de Ketu." *La Voix de St. Gall* 38:13–21.

Agbo, Casmir. 1959. *Histoire de Ouidah du XVI au XX siècle.* Avignon, France: Les Presses Universelles.

Agboton, Ambroise Padonou. n.d. *Légba-Kinkan: La divination par les seize cauris.* Cotonou, Bénin: Imprimerie Minute.

Aguessy, Honorat. n.d. *Cultures Vodoun: Manifestations-migrations-métamorphoses (Afrique-Caraibes-Ameriques).* Cotonou, Bénin: Institut de Développement et d'Echanges Endogènes (IDEE).

Alapini, Julien. 1952a. *Les initiés.* Avignon, France: Maison Aubanel Père.

———. 1952b. *Les noix sacrées: Etude complete de Fa-Ahidégoun génie de la sagesse de la divination au Dahomey.* Monte Carlo: Regain.

Als, Hilton. 2004. "The Islander." *New Yorker*, February 9, 42–51.

Argyle, William J. 1966. *The Fon of Dahomey: A History and Ethnography of the Old Kingdom.* Oxford: Clarendon Press.

Arnett, William, and Marcilene K. Wittmer. 1978. *Three Rivers of Nigeria.* Atlanta: High Museum of Art.

Assogba, Romaine-Philippe Ekanyé. 1990. *Le Musée d'Histoire de Ouidah: Découverte de la Côte des Esclaves.* Saint Michel, France: Editions.

Avoundé, Gervais. 1984. "Le Vodun 'Sakpata' dans la plaine de l'Ouémé et la région de Zogbodomé." *La Voix de St. Gall* 43:18–23.

Aziamblé, Abbé G. Kodjo. 1981. "Les prêtres du dieu Nyigble dans la Forêt Sacrée de Bé." *La Voix de St. Gall* 38:22–26.

Babb, L. A., and S. S. Wadley, eds. 1995. *Media and the Transformation of Religion in South Asia.* Philadelphia: University of Pennsylvania Press.

Barnes, Sandra T. 1989. *Africa's Ogun: Old World and New.* Bloomington: Indiana University Press.

Bascom, William. 1969. *Ifa Divination: Communications between Gods and Men in West Africa.* Bloomington: Indiana University Press.

Bassani, Ezio. 1994. "The Opon Ifa (ca. 1650): A Model for Later Iconography." In *The Yoruba Artist: New Theoretical Perspectives on African Arts*, edited

by Rowland Abiodun, Henry J. Drewal, and John Pemberton III, 79–90. Washington, D.C.: Smithsonian Institution Press.

Bay, Edna. 1975. "Cyprien Tokudagba of Abomey." *African Arts* 8 (4): 24–29, 84.

———. 1985. *Asen: Iron Altars of the Fon People of Bénin.* Atlanta: Emory University Museum of Art and Archaeology.

———. 1998. *Wives of the Leopard: Gender, Politics, and Culture in the Kingdom of Dahomey.* Charlottesville: University Press of Virginia.

———. 2001. "Protection, Political Exile, and the Atlantic Slave Trade: History and Collective Memory in Dahomey." *Slavery and Abolition* 22 (1): 22–41.

———. 2008. *Asen, Ancestors, and Vodun: Tracing Change in African Art.* Urbana: University of Illinois Press.

Bell, Clive. (1914) 2010. *Art.* Charleston, SC: BiblioBazaar.

Benitez-Rojo, Antonio. 1996. *The Repeating Island: The Caribbean and the Postmodern Perspective.* Durham, NC: Duke University Press.

Berbain, Simone. 1942. *Le comptoir français de Juda (Ouidah) au XVIIIe siècle.* Mémoires de l'Institut Français d'Afrique Noire, No. 3. Paris: Librarie Larose.

Bertho, J. 1949. "La parenté des Youruba aux peuplades de Dahomey et Togo." *Africa* 19:121–32.

Bettelheim, Judith. 2005. "Caribbean *Espiritismo* (Spiritist) Altars: The Indian and the Congo." *The Art Bulletin* 87 (2): 312–30.

Bettelheim, Judith, John Nunley, and Barbara A. Bridges. 1988. *Caribbean Festival Arts: Each and Every Bit of Difference.* Seattle: University of Washington Press.

Blier, Suzanne Preston. 1988. "Melville J. Herskovits in Dahomey." *Res* 19 (Autumn): 124–42.

———. 1990. "King Glele of Danhome: Divination Portraits of a Lion King and Man of Iron." *African Arts* 23 (4): 42–53, 93–94.

———. 1991. "King Glele of Danhome, Part II." *African Arts* 24 (1): 44–45, 101–3.

———. 1995a. "Vodun: West African Roots of Vodou." In *Sacred Arts of Haitian Vodou*, edited by Donald J. Cosentino, 60–87. Los Angeles: Fowler Museum of Cultural History.

———. 1995b. *African Vodun: Art, Psychology, and Power.* Chicago: University of Chicago Press.

———. 2004. *Art of the Senses.* Boston: MFA Publications.

Bosman, Guillaume. (1705) 1967. *A New and Accurate Description of the Coast of Guinea.* New York: Barnes and Noble.

Bossou, Jacob-André H. 1985. "Le Culte SOGBO et ses rites initiatique." *La Voix de St. Gall* 44:5–15.

Britton, Celia. 1999. *Edouard Glissant and Postcolonial Theory: Strategies of Language and Resistance.* Charlottesville: University Press of Virginia.

Brivio, Alessandra. 2008. "Nos grands-pères achetaient des esclaves: Le culte de Mami Tchamba au Togo et au Bénin." *Gradhiva au musée quai Branly* 8:65–79.

Brown, Karen McCarthy. 1995. *Tracing the Spirit: Ethnographic Essays on Haitian Art*. Seattle: University of Washington Press.

———. 2001. *Mama Lola: A Vodou Priestess in Brooklyn*. Updated and expanded edition. Berkeley: University of California Press.

Browning, Barbara. 1995. *Samba: Resistance in Motion*. Bloomington: Indiana University Press.

———. 1998. "Voodoo Economics." In *Infectious Rhythm: Metaphors of Contagion and the Spread of African Culture*, 87–104. New York: Routledge.

Burton, Sir Richard. (1864) 1966. *A Mission to Gelélé, King of Dahomey*. Edited by C.W. Newbury. London: Routledge.

Cabrera, Lydia. 1954. *El Monte: Igbo fina Ewe Orisha, Vititinfinda*. Havana: Ediciones C.R.

———. 1976. *Francisco y Francisca: Chascarrillos de negros viejos*. Miami: Coleccion Del Chicherekú.

de Certeau, Michel. 1984. *The Practice of Everyday Life*. Berkeley: University of California Press.

Chatwin, Bruce. 1980. *The Viceroy of Ouidah*. New York: Penguin Books.

Chaudoin, E. 1891. *Trois mois de captivité au Dahomey*. Paris: Hachette.

Chesi, Gert. 1979. *Voodoo: Africa's Secret Power*. Worgl, Austria: Perlinger-Verlag.

Christoph, Henning, and Hans Oberlander. 1996. *Voodoo: Secret Power in Africa*. New York: Taschen.

Clifford, James. 1997. *Routes: Travel and Translations in the Late Twentieth Century*. Cambridge, MA: Harvard University Press.

Cole, Herbert. 1969. "Art as a Verb in Igboland." *African Arts* 3 (1): 34–41.

Cornevin, Robert. 1962. *Histoire du Dahomey*. Paris: Editions Berger-Levrault.

———. 1981. *La république populaire du Bénin: Des origines dahoméennes à nos jours*. Paris: G.P. Maisonneuve and Larose.

Cosentino, Donald J. 1987. "Who Is That Fellow in the Many-Colored Cap: Transformations of Eshu in Old and New World Mythologies." *Journal of American Folklore* 100:261–74.

———, ed. 1995. *Sacred Arts of Haitian Vodou*. Los Angeles: UCLA Fowler Museum of Cultural History.

———. 1998. *Vodou Things: The Art of Pierrot Barra and Marie Cassaise*. Jackson: University Press of Mississippi.

———. 1999. "In Memoriam: Pierrot Barra, 1942–1999." *African Arts* 32 (4): 16–17.

Costello, Dairmuid, Arthur Danto, Nicholas Davey, Anna Dezeuze, Martin Donougho, Thierry de Duve, James Elkins, Francis Halsall, John Hyman, David Raskin, Dominic Willsdon, and Richard Woodfield. 2006. "The Art Seminar: Round Table Discussion." In *Art History Versus Aesthetics*, edited by James Elkin, 51–89. The Art Seminar, no. 1. London: Routledge.

Couchoro, Félix. 1929. *L'Esclave*. Paris: Depeche Africaine Press.

Crowley, Daniel J. 1986. "Fon Brass Tableaux as Historical Documents." *African Arts* 20 (1): 54–59, 98.

Curtin, Philip D. 1969. *The Atlantic Slave Trade: A Census*. Madison: University of Wisconsin Press.

Curtin, Philip, and Paul Lovejoy, eds. 1986. *Africans in Bondage: Studies in Slavery and the Slave Trade*. Madison: University of Wisconsin Press.

Dalzel, Archibald. 1793. *The History of Dahomey, An Inland Kingdom of Africa*. London.

Dash, J. Michael. 1995. *Edouard Glissant*. Cambridge: Cambridge University Press.

Datonou, Dieudonné, and Hyacinthe Agbihounko. 1986. "Notion de Vodun et de Mawu." *La Voix de St. Gall* 45:5–25.

Deleuze, Gilles, and Felix Guattari. 1987. *A Thousand Plateaus: Capitalism and Schizophrenia*. Minneapolis: University of Minnesota Press.

Djivoh, Mellon, and Joseph-Marie Drego. 1986. "La relation entre le Vodun et son adept." *La Voix de St. Gall* 45: 26–40.

Drewal, Henry J. 1978. "The Arts of Egungun among Yoruba Peoples." *African Arts* 11 (13): 18–19.

———. 1988 "Performing the Other: Mami Wata Worship in Africa." *The Drama Review* 32 (2): 160–85.

———. 1996. "Mami Wata Shrines: Exotica and the Constitution of Self." *African Material Culture*, edited by Mary Jo Arnoldi, Chrisraud Geary, and Kris L. Hardin, 308–33. Bloomington: Indiana University Press.

———. 2008. *Sacred Waters: Arts for Mami Wata and Other Divinities in Africa and the Diaspora*. Bloomington: Indiana University Press.

Drewal, Henry J., and Margaret Thompson Drewal. 1978. "More Powerful Than Each Other: An Egbado Classification of Egungun." *African Arts* 11 (3): 28–40.

———. 1983. *Gelede: Art and Female Power among the Yoruba*. Bloomington: Indiana University Press.

———. 2005. "Senses in Understanding African Art." *African Arts* 38 (3): 1, 4–5, 88.

du Bois, W. E. B. [1903] 1994. *The Souls of Black Folk*. Mineola, NY: Dover Publications.

Duncan, John. 1847. *Travels in Western Africa, in 1845 and 1846, Comprising a Journey from Whydah, Through the Kingdom of Dahomey, to Adofoodia, in the Interior*. London.

Edah, Paulin. n.d. *Lumière sur le Monde de Vodoun*. Cotonou: Organisation Béninoise pour la Recherche et la Definition de a Tradition Divinitoire.

Eicher, J. B., and T. V. Erekosima. 1996. "Indian Textiles in Kalabari Funerals," *Asian Art and Culture*. Washington, D.C.: Smithsonian Institution Press.

Elkins, James, ed. 2006. *Art History Versus Aesthetics*. The Art Seminar, no. 1. London: Routledge.

Epegba, Afolabi A., and Philip John Neimark. 1995. *The Sacred Ifa Oracle*. New York: Harper Collins Publishers.

Fakambi, Justin. 1992. *Ouidah 92: Routes des esclaves au Bénin (ex-Dahomey) dans une approache régionale*. Cotonou, Bénin: Imprimerie Graphic Express.

Feagin, Susan, and Patrick Maynard. 1997. *Aesthetics*. Oxford: Oxford University Press.

Foa, E. 1895. *Le Dahomey*. Paris.

Forbes, Frederick Edwyn. (1851) 1966. *Dahomey and the Dahomans; Being the Journals of Two Missions to the King of Dahomey and Residence at His Capital. . . .* London: Frank Cass and Co.

Galembo, Phyllis. 1993. *Divine Inspiration: From Benin to Bahia*. Albuquerque: University of New Mexico Press.

Gell, Alfred. 1998. *Art and Agency: An Anthropological Theory*. New York: Oxford University Press.

Gero, Robert. 2006. "The Border of the Aesthetic." In *Art History Versus Aesthetics*, edited by James Elkin, 269–89. The Art Seminar, no. 1. London: Routledge.

Getsy, David J. 2006. "Other Values (or Is It an African or Indian Elephant in the Room?)." In *Art History Versus Aesthetics*, edited by James Elkin, 269–89. The Art Seminar, no. 1. London: Routledge.

Gilli, Bruno. 1976. *Heviosso et le bon ordre du monde: Approches d'une religion africaine*. Memoire d'Ecole des Hautes Etudes en Sciences Sociales. Paris: Ecole des Hautes Etudes.

Giral, Sergio (director). 1975. *El otro Francisco*. Instituto Cubano del Arte e Industria Cinematográficos (ICAIC), black and white, 35mm film, filmed in Cuba.

Girouard, Tina. 1994. *Sequin Artists of Haiti*. New Orleans: Contemporary Arts Center.

———. 1995. "The Sequin Arts of Vodou." In *Sacred Arts of Haitian Vodou*, edited by Donald J. Cosentino, 357–82. Los Angeles: UCLA Fowler Museum of Cultural History.

Glélé, Maurice Ahanhanzo. 1974. *Le Danxome: Du pouvoir Aja à la nation Fon*. Paris: Nubia.

Glissant, Edouard. [1981] 1997. *Le discours Antillais*. Paris: Gallimard.

———. 1990. *Poétique de la relation*. Paris: Gallimard.

———. 1993. *Tout-Monde*. Paris: Gallimard.

Gomez-Peña, Guillermo. 2000. *Dangerous Border Crossers: The Artist Talks Back*. London: Routledge.

Gore, Charles, and Joseph Nevadomsky. 1997. "Practice and Agency in Mammy Wata Worship in Southern Nigeria." *African Arts* 30 (2): 60–69, 95.

Guédou, Georges A. G. 1985. *Xó et Gbè langage et culture, chez les Fon (Bénin)*. Paris: Société d'Etudes Linguistique et Anthropologiques de France.

Hale, Lauren Lindsay. 1997. "*Preto Velho*: Resistance, Redemption, and Engendered Representations of Slavery in a Brazilian Possession-Trance Religion." *American Ethnologist* 24 (2): 392–414.

Hall, Stuart. (1990) 2000. "Cultural Identity and Diaspora." In *Diaspora and Visual Culture*, edited by Nicholas Mirzoeff, 21–33. New York: Routledge.

———. 1996. "New Ethnicities." In *Stuart Hall: Critical Dialogues in Cultural Studies* edited by Kuan-Hsing Chen and David Morley. New York: Routledge.

Hazoumé, Paul. 1938 *Doguicimi*. Paris: Larose.

Herskovits, Melville J. (1938) 1967. *Dahomey: An Ancient West African Kingdom*. 2 vols. Evanston, IL: Northwestern University Press.

Herskovits, Melville, and Francis S. Herskovits. 1958. *Dahomean Narrative: A Cross-Cultural Analysis*. Evanston, IL: Northwestern University Press.

Houlberg, Marilyn. 1996. "Sirens and Snakes: Water Spirits in the Arts of Haitian Vodou." *African Arts* 29 (2): 3–35, 101.

———. 1978. "Egungun Masquerades of the Remo Yoruba." *African Arts* 11 (3): 20–27, 100.

———. 1978. "Notes on Egungun Masquerades among the Oyo Yoruba." *African Arts* 11 (3): 56–61, 99.

Hounwanou, Rémy T. 1984. *Le Fa: Une géomancie divinitoire du Golfe du Bénin (practique et technique)*. Lomé, Togo: Les Nouvelles Editions Africaines.

Hübner, Irene. 1996. *Geest en Kracht: Vodun uit West-Afrika*. Berg en Dal, The Netherlands: Afrika Museum.

Hurbon, Laennec. 1994. "American Fantasy and Haitian Vodou." In *Sacred Arts of Haitian Vodou*, edited by Donald J. Cosentino, 181–204. Los Angeles: UCLA Fowler Museum of Cultural History.

Inglis, Stephen R. 1995. "Suitable for Framing: The Work of a Modern Master." In *Media and the Transformation of Religion in South Asia*, edited by Lawrence A. Babb and Susan S. Wadley, 51–75. Philadelphia: University of Pennsylvania Press.

Jenkins, Della. 1983. *The Art of Mamy Wata: A Popular Water Spirit Found among the Igbo of Southeast Nigeria*. Unpublished MA thesis, University of California, Santa Barbara.

———. 1984. "Mamy Wata." In *Igbo Arts: Community and Cosmos*, edited by Herbert M. Cole and Chike C. Aniakor, 75–77. Los Angeles: University of California Press.

Kalilu, R. O. Rom. 1993. "Costumes and Origin of Egungun." *African Studies* 52 (1): 55–70.

Koudolo, Svetlana. 1991. *La participation des institutions d'Afa et du Vodu dans les processus de la socialisation des enfants (en milieu Ewe.)* Lomé: Ministere de l'Education Nationale et de la Recherche Scientifique.

Koussou, Basile Toussaint. 1983. *Se et Gbe: Dynamique de l'existence chez les Fon*. Paris: La Pensée Universelle.

Kpodzo, Vérité, and Johannes Aziabli. 1984. "Le Vodu 'Xɛvioso' dans l'aire culturelle Ewe du Sud-Togo." *La Voix de St. Gall* 43:5–17.

———. 1985. "Actions, manifestations et éthique socio-religieuse du vodun Xɛvioso chez les Eve." *La Voix de St. Gall* 44:16–26.

Labouret, Henri, and Paul Rivet. 1929. *Le royaume d'Ardra et son évangélisation au XVIIe siècle*. Paris: Institut d'Ethnologie.

Lafitte, M. L'Abbé. 1875. "Excursions et récits Qouenou, Cabécèree du commerce a Whydah," *Les missions catholiques: Bulletin hebdomadaire de l'Oeuvre de la propagation de la foi* 7:539, 542–44.

Law, Robin. 1977. *The Oyo Empire c.1600–c.1836: A West African Imperialism in the Era of the Atlantic Slave Trade*. Oxford: Clarendon Press.

———. 1991. *The Slave Coast of West Africa 1550–1750: The Impact of the Atlantic Slave Trade in an African Society*. Oxford: Clarendon Press.

———. 1996. "'Lucumi' and 'Nago' as Ethnonyms in West Africa." Paper presented in panel "The Yoruba Factor in the Atlantic Slave Trade," at the African Studies Association Meetings in San Francisco, CA, November 24.

———. 2003. "On Pawning and Enslavement for Debt in the Precolonial Slave Coast." In *Pawnship, Slavery, and Colonialism in Africa*, edited by Paul E. Lovejoy and Toyin Falola, 55–70. Trenton, NJ: Africa World Press.

———. 2004. *Ouidah: The Social History of a West African Slaving 'Port' 1727–1892*. Athens: Ohio University Press.

Lawal, Babatunde. 1996. *The Gèlèdé Spectacle: Art, Gender, and Social Harmony in an African Culture*. Seattle: University of Washington Press.

Le Herissé, A. 1911. *L'ancien royaume du Dahomey: Moeurs, religion, histoire*. Paris: Emile Larose.

Leiris, Michel. 1952. "Notes sur l'usage de chromolithographies catholiques par les vodouisants d'Haiti," *Les Afro-Americains*, edited by Institut français d'Afrique noire. Mémoires de l'Institut français d'Afrique noire, no. 27. Dakar: IFAN.

Lesage, Julia. 1985. "The Other Francisco Creating History." *Jump Cut: A Review of Contemporary Media*, no. 30: 53–58.

Lewis, Earl. 1995. "To Turn as on a Pivot: Writing African Americans into a History of Overlapping Diasporas." *American Historical Review* 100 (3): 765–87.

Linebaugh, Peter, and Marcus Rediker. 2001. *The Many-Headed Hydra: Sailors, Slaves, Commoners, and the Hidden History of the Revolutionary Atlantic*. Boston: Beacon Press.

Lokossou, Clement. 1994. "La Route de l'Esclave et les circuits touristiques." In *Le Benin et La Route de l'Esclave*, edited by Comité National pour le Bénin du Projet "La Route de l'Esclave." Cotonou: Comité National pour le Bénin du Projet "La Route de l'Esclave."

Lombard, Jacques. 1967. "Contribution a l'histoire d'une ancienne société politique du Dahomey: La royauté d'Allada." *Bulletin de l'Institut Français de l'Afrique Noir*, T. XXIX, ser. B, no. 1–2: 40–66.

Lovejoy, Paul E. 1982. "The Volume of the Atlantic Slave Trade: A Synthesis." *The Journal of African History* 23 (4): 473–501.

———. 1983. *Transformations in Slavery*. Cambridge: Cambridge University Press.

Lutgendorf, Philip. 1995. "Another Ravanna, Another Rama." Paper presented at the XIIth International Ramayana Conference, Leiden, The Netherlands, August 28–30.

———. 2003. "Evolving a Monkey: Hanuman, Poster Art and Post-Colonial Anxiety." In *Beyond Appearances? Visual Practices and Ideologies in Modern India*, edited by Sumathi Ramaswamy, 80. New Dehli: Sage Publications.

M'Leod, John. 1820. *A Voyage to Africa, With Some Account of the Manners and Customs of the Dahomian People*. London: John Murray.

Madokpon, Rogatien, and Olivier Guiassou. 1985. "Le 'Yehue Dan-Toxosu' chez les Saxué du Sud-Ouest Bénin." *La Voix de St. Gall* 43:24–29.

Magnin, André, ed. 1996. *Contemporary Art of Africa*. New York: Harry N. Abrams, Inc.

Maupoil, Bernard. 1988. *La géomancie à l'ancienne Côte des Esclaves*. Paris: Institute d'Ethnologie.

Mbembe, Achille. 2001. *On the Postcolony*. Berkeley: University of California Press.

———. 2006. "Variations on the Beautiful in Congolese Worlds of Sound." In *Beautiful/Ugly: African and Diaspora Aesthetics*, edited by Sarah Nutall, 60–93. Durham, NC: Duke University Press.

Mercier, Paul. 1954. "The Fon of Dahomey." In *African Worlds: Studies in the Cosmological Ideas and Surreal Values of African Peoples*, edited by Daryll Forde, 210–34. London: Oxford University Press.

Metraux, Alfred. (1959) 1972. *Voodoo in Haiti*. Translated by Hugo Charteris. New York: Schocker Books.

Montilus, Guérin. 1972. "L'homme dans la pensée traditionnelle Fon." Cotonou, Bénin. Mimeograph.

Morgan, David. 1998. *Visual Piety: A History and Theory of Popular Religious Images*. Berkeley: University of California Press.

Morton-Williams, Peter. 1956. "The Atinga Cult among the South-Western Yoruba: A Sociological Analysis of a Witch-Finding Movement." *Bulletin de l'Institut Français de l'Afrique Noir*, T.XVIII, ser. B, no. 3–4: 315–34.

Mosquera, Geraldo. 1996. "The Presence of Africa in the Visual Arts of Cuba." In *Santería Aesthetics in Contemporary Latin American Art*, edited by Arturo Lindsay, 225–58. Washington, D.C.: Smithsonian Institution Press.

Narayan, R. K. 1972. *The Ramayana*. New York: Penguin.

Nevadomsky, Joseph. 1997. "Contemporary Art and Artists in Benin City." *African Arts* 30 (4): 54–63, 94.

Nunley, John. 1981. "The Fancy and the Fierce." *African Arts* 14 (2): 52–58.

Omari, Mikelle Smith. 1989. "The Role of the Gods in Afro-Brazilian Ancestral Ritual." *African Arts* 23 (1): 54–61, 103–4.

Palmié, Steven. 2002. *Wizards and Scientists: Explorations in Afro-Cuban Modernity and Tradition*. Durham, NC: Duke University Press.

Pelton, Robert D. 1989. *The Trickster in West Africa: A Study of Mythic Irony and Sacred Delight*. Berkeley: University of California Press.

Pemberton, John. 1978. "Egungun Masquerades of the Igbomina Yoruba." *African Arts* 11 (3): 40–47, 99.

———. 1975. "Eshu-Elegba: The Yoruba Trickster God." *African Arts* 9 (1): 20–27, 70, 90–92.

Pinney, Christopher. 2001. "Piercing the Skin of the Idol." In *Beyond Aesthetics: Art and the Technologies of Enchantment*, edited by Christopher Pinney and Nicholas Thomas, 157–80. Oxford: Berg Publishers.

———. 2004. *Photos of the Gods: The Printed Image and Political Struggle in India*. London: Reaktion Books.

Piot, Charles. 1996. "Of Slaves and the Gift: Kabre Sale of Kin During the Era of the Slave Trade." *The Journal of African History* 37 (1): 31–49.

Pliya, Jean. 1970. *Histoire Dahomey, Afrique Occidentale*. Paris: Les Classiques Africaines.

———. 1971. *L'arbre fétiche*. Yaondé, Cameroon: Editions Cle.

Poyner, Robin. 1978. "The Egungun of Oyo." *African Arts* 11 (3): 66–76, 100.

Prudencio, Eustache. 1967. "Ouvre les yeux, étranger." *Vents du Lac* (Poèmes I). Cotonou: Les Editions du Bénin.

Quénum, Maximilien J. 1938. *Au pays des Fons: Us et coutumes de Dahomey*. 2nd ed. Paris: Larose.

Quénum, Venance S. 1982. *Ouidah: Cité historique des "Houeda."* Ouidah, Bénin: Musée d'Histoire.

Roberts, Allen F. 1992. "Chance Encounters, Ironic Collage." *African Arts* 25 (2): 54–63, 97–98.

———. 1996. "The Ironies of System D." In *Recycled Re-Seen: Folk Art from the Global Scrap Heap*, edited by Charlene Cerny, 82–101. New York: Harry N. Abrams for the Museum of International Folk Art in Santa Fe.

———. 2009. "Tempering 'the Tyranny of Already': Re-signification and the Migration of Images." In *Religion and Material Culture: The Matter of Belief*, edited by David Morgan, 115–34. New York: Routledge.

Rosenthal, Judy. 1998. *Possession, Ecstasy, and Law in Ewe Voodoo*. Charlottesville: University Press of Virginia.

Rubin, Arnold. 1974. *African Accumulative Sculpture: Power and Display*. New York: Pace Gallery.

Rush, Dana. 1999. "Eternal Potential: Chromolithographs in Vodunland." *African Arts* 34 (4): 60–75, 94–96.

———. 2001. "Contemporary Vodun Arts of Ouidah, Bénin." *African Arts* 34 (4): 32–47, 94–96.

———. 2002. Review of *Wereld In Beweging: Gelede-marionetten van Anago-Yoruba*, by Hans Witte. *African Arts* 35 (1): 11, 92–93.

———. 2008a. The Idea of 'India' in West African Vodun Art and Thought." In *India in Africa, Africa in India: Indian Ocean Cosmopolitanisms*, edited by John Hawley, 149–180. Bloomington: Indiana University Press.

———. 2008b. "Somewhere Under Dan's Rainbow: Kossivi Ahiator's 'India Spirits' in His Mami Wata Pantheon." In *Sacred Waters: The Many Faces of Mami Wata and Other Afro-Atlantic Water Spirits*, edited by Henry John Drewal, 466–76. Bloomington: Indiana University Press.

———. 2010. "Ephemerality and the 'Unfinished' in Vodun Aesthetics." *African Arts* 43 (3): 60–75.

———. 2011. "In Remembrance of Slavery: Preliminary Study of Tchamba Vodun Arts." *African Arts* 44 (3): 42–57.

Salmons, Jill. 1977. "Mammy Wata." *African Arts* 10 (3): 8–15.

Schlitz, M. 1978. "Egungun Masquerades in Igama." *African Arts* 11 (3): 48–55, 100.

Segurola, R. Père B. 1963. *Dictionnaire Fon-Français*. Cotonou, Bénin: Procure de L'Archidiocèse.

Sinou, Alain, and Bernardin Agbo. 1995. *Le comptoir de Ouidah: Une ville africaine singulière*. Paris: Editions Karthala.

Skertchly, J. A. 1874. *Dahomey as It Is: Being a Narrative of Eight Months Residence in That Country with a Full Account of the Notorious Annual Customs, and the Social and Religious Institutions of the Ffons; Also an Appendix on Ashantee and a Glossary of Dahoman Words and Titles*. London: Chapman and Hall.

Smith, H. Daniel. 1997. "Introduction: The Impact of 'God Posters' on Hindus and Their Devotional Traditions." In *Changing Myths and Images: Twentieth-Century Popular Art in India*, edited by Gerald. J. Lawson, Pratapaditya Pal, and H. Daniel Smith, 17–23. Bloomington: Indiana University Art Museum.

Snelgrave, Captain William. (1734) 1971. *A New Account of Some Ports of Guinea, and the Slave Trade*. London: Frank Cass and Co.

Soglo, Gilles. 1994. "Notes sur la Traite des Esclaves à Gléxwé (Ouidah)." In *Le Bénin et La Route de l'Esclave*, edited by Comité National pour le Bénin du Projet "La Route de l'Esclave." Cotonou: Comité National pour le Bénin du Projet "La Route de l'Esclave."

de Souza, Simone. 1992. *La famille de Souza du Bénin-Togo*. Cotonou, Bénin: Les Editions du Bénin.

Stoller, Paul. 1997. *Sensuous Scholarship*. Philadelphia: University of Pennsylvania Press.

Suárez y Romero, Anselmo. 1890. *Francisco*. New York: N. Ponce de Leon.

Surgy, Albert de. (1957) 1981. *La géomancie et le culte d'Afa chez les Evhé*. Paris: Publications Orientalistes de France.

———. 1995. *La voie des fétiches: Essai sur le fondement théorique et la perspective mystique des practiques des féticheurs*. Paris: L'Harmattan.

Sutherland, Peter. 1999. "In Memory of Slaves: An African View of the Diaspora in the Americas." In *Representations of Blackness and the Performance of Identities*, edited by Jean Mateba Ranier, 195–211. Westport: Praeger Publishers.

Thompson, Robert Farris. 1983. *Flash of the Spirit: African and Afro-American Art and Philosophy*. New York: Random House.

———. 1995. *Face of the Gods: Art and Altars of Africa and the African Americas*. Munich: Prestel for The Museum for African Art, New York.

Thompson, Robert Farris, and Joseph Cornet. 1981. *Four Moments of the Sun: Kongo Art in Two Worlds*. Washington D.C.: National Gallery of Art.

———. 1971. *Black Gods and Kings: Yoruba Art at UCLA*. Los Angeles: University of California Press.

Verger, Pierre Fatumbi. 1954. *Dieux d'Afrique: Culte des Orishas et Vodouns à l'ancienne Côte des Esclaves en Afrique et à Bahia de Tous les Saints au Brésil*. Paris: Paul Hartemann.

———. 1957. *Notes sur le culte des Orisa et Vodun a Bahia, La Baie de Tous les Saints, au Brésil et à l'ancienne Côte des Esclaves en Afriques*. Mémoires de l'Institut Français d'Afrique Noire, no. 51. Paris: Librarie Larose.

———. 1968. *Flux et reflux de la traite des negres entre Le Golfe de Bénin et Bahia de Todos os Santos du XVIIe au XXIXe siecle*. Paris: Mouton and Co.

———. 1982. *Orisha: Les dieux Yoruba en Afrique et au nouveau monde*. Paris: A. M. Métailié.

Vogel, Susan Mullin. 1991. *Africa Explores: 20th Century African Art*. New York: The Museum for African Art.

Wendl, Tobias. 1999. "Slavery, Spirit Possession, and Ritual Consciousness: The Tchamba Cult Among the Mina of Togo." In *Spirit Possession: Modernity and Power in Africa*, edited by Heike Behrend and Ute Luig, 111–23. Madison: University of Wisconsin Press.

Wescott, Joan. 1962. "The Sculpture and Myths of Eshu-Elegba," *Africa* 32 (4): 336–353.

West African Museums Project, Dakar, and Musée d'Histoire de Ouidah. 1995. *Ouidah à travers ses fêtes et patrimonies familiaux*. Cotonou, Bénin: Les Editions du Flamboyant.

Westermann, Dietrich. 1905. *Worterbuch der Ewe-Sprache*. Berlin: Reimer.

Wing, Betsy. 1997. "Translator's Introduction." In *Poetics of Relation* by Edouard Glissant. Translated by Betsy Wing, xi–xx. Ann Arbor: University of Michigan Press.

Wolff, Norma H. 1982. "Egungun Costuming in Abeokuta," African Arts 15 (3): 66–70, 91.

Yai, Olabiyi Babalola. 1994. "In Praise of Metonymy: The Concepts of 'Tradition' and 'Creativity' in the Transmission of Yoruba Artistry over Time and Space." In *The Yoruba Artist: New Theoretical Perspectives on African Arts*, edited by Rowland Abiodun, Henry J. Drewal, and John Pemberton III, 107–118. Washington, D.C.: Smithsonian Institution Press.

Index

Photographs are in unpaginated galleries. Entries refer
to photographs by the figure number in bold (e.g., **fig. 4.13**).

CPSIA information can be obtained
at www.ICGtesting.com
Printed in the USA
BVHW011837020920
587951BV00004B/419

9 780826 519085